SELLING STOCK
PHOTOGRAPHY

SELLING STOCK PHOTOGRAPHY

LOU JACOBS, JR.

AMPHOTO
AN IMPRINT OF WATSON-GUPTILL PUBLICATIONS/NEW YORK

Lou Jacobs, Jr., a well-known writer and photographer, is the author of more than 20 books on photography. He is a past president of the American Society of Magazine Photographers (ASMP) and is currently a member of its board of directors. His most recent Amphoto titles include *Selling Photographs* (1988) and *Available Light Photography* (1991). Jacobs has taught photography courses at UCLA, Cal State Northridge, and Brooks Institute of Photography, and has written extensively for photographic magazines. A graduate of Carnegie Mellon University and Art Center College of Design, he lives with his wife, Kathy, in Cathedral City, CA. During their frequent travels, Jacobs shoots stock pictures that are sold through several agencies.

Editorial concept by Robin Simmen
Edited by Liz Harvey
Designed by Areta Buk
Graphic production by Hector Campbell

First published in 1992 by AMPHOTO,
an imprint of Watson-Guptill Publications,
a division of BPI Communications. Inc.,
1515 Broadway, New York, NY 10036

Library of Congress Cataloging in Publication Data

Jacobs, Lou.
 Selling stock photography: how to market your photographs
for maximum profit / by Lou Jacobs, Jr.
 Includes index.
 ISBN 0-8174-5825-5
 1. Freelance photography. 2. Commercial photography. I. Title.
TR690.2.J23 1992
770'.68'8—dc20 92-14436
 CIP

Manufactured in the United States of America

1 2 3 4 5 6 7 8 9 / 00 99 98 97 96 95 94 93 92

ACKNOWLEDGEMENTS

My sincere thanks to the American Society of Magazine Photographers (ASMP) for permission to quote from the *ASMP Stock Photography Handbook*; to Craig Aurness for permission to quote from *Westlight International Stock Photography Report*; to Jim Pickerell for permission to quote from his book, *Negotiating Stock Photo Prices*; and to *Photo District News* for permission to quote from various news articles. Thanks also for the help of the individual stock photographers and stock-agency owners and representatives I interviewed.

CONTENTS

INTRODUCTION

Occasionally I meet a photographer who has a bunch of pictures he or she hopes to sell as stock. I'm told, "I shot a lot of slides in Tibet, Cambodia, and India last year, but I'm not sure what to do with them. Would a magazine buy some of them? Do you think a stock-picture agency would be interested?" Other times I meet someone who has been taking pictures of children for decades as an avocation and wants to know what kind of markets he or she might find for them. "I have dozens of yellow boxes stored away, and I think a lot of my shots are salable," the person may tell me. Most often, however, I meet people with collections of scenic slides taken all over the world.

If I see the pictures and they are of professional quality, I might recommend that the person read the *ASMP Stock Photography Handbook* (American Society of Magazine Photographers, second edition), a guide to the stock business and stock agencies. I explain that it isn't easy for the casual shooter to find markets or connect with an agency, even with outstanding photographs, unless the individual has guidance and is persistent and lucky.

WHAT IS STOCK?

Basically, a stock picture is one that was taken earlier and is on hand to license—not sell outright—to a client. There are hundreds of kinds of stock images, ranging from jazz musicians to views of the Grand Tetons to shots of families picnicking by a stream. As a pleasurable hobby, stock photography won't earn you much money. You have to approach stock as a business. In a September 1991 *Photo District News* article, Marty Loken, the owner of the Allstock agency in Seattle, said that in order to thrive in stock photography, even on a part-time basis, you have to be serious and organized. "The most successful stock photos," he added, "are ones that illustrate timeless concepts." These include trust, security, health, and teamwork. "You have to find *new* ways to illustrate these concepts," he noted.

It is possible to shoot a salable (leasable) stock photograph by chance, but it is rare to find a market for random images—or a stock agency to handle them for you. If you have drawers full of "great" pictures of general subjects, you must edit them. Then you have to find an agency or clients, which requires market research. With the right efforts you may very well find buyers for your work or you may connect with a stock agency, which can give you a sense of satisfaction plus money from sales. If you merely have a stimulating time shooting good scenics a few times a year, what are your chances for success? That depends on how motivated you are and whether you learn the fundamentals of what sells and where. Keep in mind that you'll have to market your own stock until you have enough images to interest an agency. First, however, you must learn what kind of stock pictures sell.

The stock-photography business has been around for some time, at least since the H. Armstrong Roberts agency was started in the early 1900s. (The agency is still flourishing, and I interviewed H. Armstrong Roberts III. See Chapter 13.) From the 1960s on, more agencies and individual photographers began concentrating on stock, and some began to specialize in scenics, celebrities, science, and other subjects that could be sold repeatedly to publications. Now stock photography is a major source of income for many shooters and stock agencies.

Professional photographers once did their stock shooting while on magazine assignments. They sold outtakes and used their spare time to make pictures for prospective buyers. When the demand for stock increased dramatically during the past few decades, some professionals turned to photographing people, places, and things specifically for sale as stock, and today the best-selling stock is custom-made. In fact many professionals shoot stock nearly full-time and earn substantial income from stock. Many stock agencies have become big operations with branches in the United States and affiliates abroad to meet the needs of editorial, advertising, and corporate markets. The *ASMP Stock Photography Handbook* lists more than 100 stock agencies and reports the following significant changes in stock photography:

Greatly increased quality. Stepped-up client requirements and the entry of top-notch photographers in the field have resulted in more pictures with impact.

Bigger market. More and more publications and businesses now use stock pictures because many are readily available and often cost less than assigned pictures.

New marketing techniques. Photographers and agencies send out four-color catalogs or promotional material. In addition quantities of stock

images can be viewed on computers using CD-ROM discs, and, for viewing only, sample pictures can be photocopied in color for a small fee or sent in black and white via a fax machine to prospective buyers.

New agencies and photographers. Competition among them has increased considerably as markets have multiplied.

Exclusive contracts. To avoid conflicts and to tie up certain talent, some agencies want to restrict photographers to exclusivity. Other agencies say that they don't want their market research passed around.

More setup stock. Photographers are shooting more self-created pictures to meet new market tastes.

In addition the stock business is now far-flung. Stock photographers live almost everywhere, and agencies are situated in both large cities and smaller ones in between. And to meet the increased demand, professional stock photographers work steadily, continually replenishing their files.

Several stock-agency "want" lists, compiled from client requests, include quite a variety of photographic subjects sought out by all sorts of markets:

- Bean plant from seed to maturity
- Canvas-back ducks in natural setting
- Child, 5 to 10 years old, in bed, thermometer in mouth
- Children wearing rain gear
- Depressed teenagers
- Hikers cooking dehydrated foods
- People drinking in bars and submitting to DWI tests at roadblocks
- Racehorse crossing finish line
- Salmon spawning, underwater shots preferred
- Use of robotics in manufacturing
- Welfare office with people waiting
- Young people making and eating popcorn

Some of these topics are esoteric, while others are commonplace and easy to find and shoot. This cross-section shows how diverse the stock-photography field is.

HOW TO SUCCEED IN STOCK

A number of factors combine to make attractive, salable stock images. These include clichéd and sentimental subjects, simplicity of content, striking color or contrasts, moods, dramatic camera angles, appealing

facial expressions, special locations, and famous faces. Sales of attractive pictures or subjects also depend on where they'll be used. For instance in advertising a street scene or a landscape may be most desirable if it is unrecognizable while the same subject, shot just as skilfully, may appeal to a magazine only if the location is identifiable.

As you consider stock as a business, you should give some thought to these points:

- Decide what kind of stock pictures you like to shoot and the amount of time and effort you can spend to turn a hobby into a profession.
- Examine the types of photographs you see in print. Can you shoot similar pictures as well?
- Do some research about the kind of markets that buy stock. At the same time, think about how you can reach clients and sell rights to pictures on your own or through a stock-picture agency.
- Learn how to protect your rights, and how to negotiate proper reproduction fees.
- If you want stock-agency representation, you should know what to expect from the agency and what you'll need to deliver.

You must be fully aware of the business side of photography or you'll be exploited accidentally or on purpose. My book can't guarantee to make you a better photographer or businessperson, but it can definitely help you avoid disappointment by raising your consciousness about good business practices, negotiating rates, and protecting your rights. Good marketing methods, thorough recordkeeping, and carefully drawn agreements are the foundations of success.

I've been in the business of shooting and selling photographs to magazines, industry, book publishers, and other clients since I became a professional in the early 1950s. Over the years I've learned a lot about getting along with picture buyers, guarding my ownership rights, and the need for ethics in the photography field. I've taught classes in photojournalism and business practices at three colleges and written many articles for magazines as well as an earlier book, *Selling Photographs* (Amphoto, 1988), which covers the whole field of media photography. In addition I've been closely involved with the American Society of Magazine Photographers (ASMP), which continues to have a strong positive influence on photographers and the publishing industry.

This book is intended for everyone who takes and sells, or wants to sell, stock pictures for fun and profit, casually or with full-time dedication. If you have the talent and motivation and learn the business ropes, you have a head start toward shooting, organizing, and marketing stock pictures as an enjoyable career.

1 GETTING STARTED IN STOCK

For decades various companies have been collecting and selling stock photographs. Publications and other businesses that wanted pictures of cute babies, happy couples, elephants pulling up tree stumps, or views of the Grand Canyon were able to order them from catalogs or make requests by mail and over the telephone. During the 1940s and 1950s, black-and-white prints were sold (actually leased) over and over. This practice continued until color transparencies began to dominate.

The dictionary defines stock as "a supply of goods kept on hand for sale." Photographers and picture agencies make pictures available to buyers just as songwriters offer their tunes to performers and license their songs for recordings, orchestral concerts, radio, and television. In each case the "goods" can be rented or leased many times until prospective users are tired of the item and demand something new. As a result photographers have to replenish their stock of images by shooting new ones to keep their files active. On the surface the process sounds simple. But in actuality the laws of supply and demand create complexities that require experience and resourcefulness on the part of the photographers so they can deal with shooting and marketing.

There are now thousands of stock photographers and picture agencies eager to supply all kinds of clients, from Sunday-school newspapers to huge encyclopedias. It isn't unusual for a stock file or library to have 100,000 or even 1,000,000 pictures on hand. And since the publishing world devours photographic images, you and your competition have to continually generate additional pictures to satisfy demand and assure future income. Although the relentless production of stock pictures may sound like a chore you want to avoid, you may also find that continually shooting stock is a challenge that takes you places, introduces you to new people and experiences, and makes life more fun.

No cite.

EXISTING SUBJECTS VERSUS SETUPS

Many stock-picture situations are somewhere, just ready to be taken. This could mean that the next time you're on a trip and you shoot a great waterfall or a ski lift full of eager skiers, you'll find a market for some of the shots later on if you're lucky. Luck, as you may have heard, is "when preparation meets opportunity." You might be unlucky if the light is wrong on the waterfall or you don't have the right lens focal length to get a dramatic ski-lift picture. In order to shoot *existing* stock photographs that you'll be able to sell, you have to know:

- Whether the subject is potentially salable
- What season and what time of day the subject looks best
- What camera format and what lens to use
- What preparations are needed to photograph the subject adequately
- How to simplify the composition to dramatize it.

There are photographers who travel, shoot what appeals to them with plenty of variety, and submit well-edited pictures to clients or stock agencies. If the photographers know the markets, this approach may be successful. Other photographers look for subjects from a "want" list that an agency or client supplies. These dedicated individuals go places simply to shoot subjects that they know, or feel, are in demand.

Another approach to stock is creating picture situations yourself. Suppose you want to shoot an office with lots of people doing computer work individually, in small groups, and in wide-angle shots. You may arrange to use, with or without paying a fee, a friendly company's office on a Sunday. And you might even be able to pay some of the people who work there as models for a few hours. In this way you can make a series of stock pictures of business-office activities and personnel for potential markets that often buy such representative images.

You might want to consider yet another option. Hire several models and set up relatively simple scenes, such as a couple holding hands as they walk in the woods, children eating breakfast without brand-name products visible, and senior citizens playing cards. Stock images like these can be done in a studio or in an actual setting. Which kind of stock you prefer to shoot may depend on your aptitude, on what you feel is more salable, or on future experiments.

FINDING THE APPROACH THAT BEST SUITS YOU

The definition of a "casual" stock shooter is somewhat controversial. I think everyone can agree that a *really* casual approach to stock is

demonstrated by photographers who travel occasionally, shoot only what appeals to them, and pay little or no attention to what the marketplace may want. When shooters of this type send picture lists to prospective clients, they may as well be buying lottery tickets. Casual photographers also send pictures to one or more stock agencies and often receive rejections. Less casual shooters take pictures part-time, do some market research to more accurately aim work at clients, pay some attention to agency want lists, and try to find the most appealing way to shoot a subject that also allows for variations.

Whether or not a stock agency is interested in these less casual shooters depends on its philosophy. Some agencies handle photographers whose pictures are outstanding in quality and subject choice, whether or not they consistently shoot in quantity. Other agencies restrict the number of photographers they represent and are interested in only those who shoot and submit a minimum number of pictures per month. As Craig Aurness, owner of the Westlight agency in Los Angeles says in the Westlight *International Stock Photography Report,* "There are far more good, qualified stock photographers than there is room for them within good stock agencies, and even more photographers who think they have good images but whose work falls short of what already exists in most agencies' files."

Does all of this mean that if you don't shoot almost full-time and aren't on a par with the best known photographers you can think of, you may as well just enlarge prints for friends and family? No, but it does mean that you must think about how much time you can spend shooting the most salable subjects and whether you'd be better off selling your own work or trying to find a stock agency to do this for you.

ESTABLISHING A BUSINESS

Business means earning some profit, though not necessarily a whole living, from shooting and marketing stock photographs. Experience shows that you can be a dilettante who sells a few pictures and calls your photography a business, while it actually remains a hobby that earns you only a few dollars. To establish a business you need to adapt the basics to your own circumstances.

Current Internal Revenue Service (IRS) rules require that your office be a separate room or area *used solely for business purposes* if you want to deduct a portion of your residential rent or mortgage and normal office expenses on your tax return. For your own convenience, you'll need space for a desk and a filing cabinet, storage for books and records, and

perhaps a separate table for spreading out and editing slides and prints. In addition to adequate space, I put cheerful lighting and equipment, such as a lightbox, computer, telephone, answering machine, and fax machine (if business volume warrants it) high on my list of musts for a home office. I also like to be able to see the outdoors through a window, and I augment daylight with lamps on extension arms over the desk, computer printer, and worktable. To shoot relatively small stock setups, you can use one end of a separate office as a shooting space. This way, the room will be devoted exclusively to business (see Chapter 3 for information about equipment). Wherever you set up a place to work, try to avoid a room that may depress you.

Think modestly and be flexible at first. Your clients are likely to be in other towns, but even if they aren't you won't need posh surroundings and furnishings to make a good business impression. Having a professional-looking space that suggests stability is more important than having a pool table to amuse visitors (although that isn't a bad idea). You can amortize the cost of starting a business, even a part-time one, over five or more years. Expenses can include furnishing an office and shooting space, refurbishing or building a room, buying photographic and business equipment and books, getting special training, and arranging for professional services. For more detailed advice, consult a qualified accountant both before and during the establishment of a business. Find out if there is a limit on your expenses, as well as how long you can go without making a profit and still claim business deductions. The answers relate to your own earning circumstances.

It is impossible to estimate how much profit you can expect from selling stock photography. In the beginning you are likely to shoot part-time and work at something else for the major portion of your income. Grossing $1,000 from stock in the first year might seem like a satisfying start, but you'll have to do a lot better than that to remain "in business." As the number of pictures you have for sale increases, your income should increase—if your marketing skills grow, too. Just how much you might gross or net in five years, for instance, depends on your aptitude and on the amount of time that you spend shooting and selling versus making a living otherwise. You may be satisfied if your part-time efforts gross a third of your total income, especially if you're doing assignment photography the rest of the time. If you eventually shoot and market stock full-time, you'll have to gross enough to keep you happy and your business expanding.

If you are already a full-time shooter, getting into stock photography should be easier. You might be able to take all kinds of pictures at locations or facilities where you shoot assignments. A friend of mine

who specializes in shooting electronic manufacturing and research has built a huge file of high-tech images that he took while illustrating brochures and annual reports. Sometimes he travels out of state and takes a day or two after completing a job to shoot other subjects that he feels will be salable as stock. This enables him to underwrite a number of his expenses and to take full advantage of photo opportunities.

In addition to knowing what subjects to shoot, photographing them well, and marketing them sensibly using promotional material and perhaps visiting clients in person, you must *understand copyright, protect your rights, and negotiate skillfully with buyers.* (I cover these principles of good business practice more fully in Chapter 7, but I mention them here to emphasize their importance.)

Recently I met a young man who spent a lot of vacation time shooting villages in Mexico and had a large collection of excellent transparencies made over a couple of years. He wasn't sure what to do with them, so he sent letters and subject lists to a dozen publications, big and small, that he felt were interested in the economics and rural life of Mexico. Two potential buyers responded, asking him to send them selections of pictures. After receiving the slides one editor returned them a few weeks later with regrets, saying they were fine but didn't fit his needs. The other editor had to be nudged for a reply and when it came, the offer was for six slides at a ridiculously low fee for each and for all rights. Although the photographer was discouraged about the fee, he was elated to find a buyer and gave the publication the go ahead. This was a costly mistake, but it took time to discover why.

A more experienced colleague later informed the photographer that he should've negotiated for a much higher fee to cover all rights. This was because even though he had pictures similar to the ones he had sold, the best were no longer available for future sales. He'd undermined potential markets by making a nearsighted deal with a buyer who took advantage of him. It is harmful to your self-image to make desperate sales for what seems like expedient reasons.

I want to help you avoid giving away what you should be leasing or selling by encouraging you to ask for better fees. Your work deserves them. Nobody settles for low fees and stays in the stock business long without burning out. Stock photography, no matter how concentrated your efforts, has to be produced and leased on a consistently professional level. Negotiating for better rates and rights usually involves risk because you might lose a sale, but your future will be more secure in the long run. Vigilance and awareness of professional methods are the platforms for success.

2 SHOOTING STOCK SUBJECTS

While this book emphasizes the business aspects of stock photography more than how to shoot stock pictures, it can be helpful to summarize techniques for recognizing and taking salable stock pictures. What kind of stock photographs sell? All kinds do. There is a demand for stock subjects from A to Z, as the lengthy stock list at the end of this chapter shows (see pages 27–31). Where are stock photographs used? In advertising, magazines, newspapers, textbooks, newsletters, brochures, guidebooks, nonfiction books, corporate annual reports, calendars, and cultural-organization publications (among others), as well as on posters and greeting cards. (See page 32 of the *ASMP Stock Photography Handbook* for a list of organizations that publish guidebooks to stock markets.) If you sell your own stock photography, you should become familiar with these end users. They can often be easily researched at a good public library.

Another research method, suggested to me by Jim Pickerell, author of *Negotiating Stock Photo Prices* (self-published, 1991) is to "save all the junk mail you get and ask your friends to do likewise. Brochures, freebie magazines, etc., have lots of stock pictures in them, especially when they're aimed at middle- and upper-income families. You'll get ideas for subjects to shoot." I've been carefully looking at such publications, and in a magazine devoted to investing I recently found a cluster of symbolic stock shots: a sky of puffy clouds over a field of grain, a closeup of medication capsules, a closeup of an electronic circuit, and a power plant with tall smokestacks.

"You have to consider two different market areas for stock," Pickerell continued. "Advertising and corporate is the largest and the best paying, and in this market buyers want only positive situations. Nothing negative. To quote from a guy I met at a stock shoot in a hospital, 'There are no sick

people in hospitals.' They're all supposed to look happy, all recovering, enjoying their stay. Keep that in mind for the advertising-corporate field.

"The other market is in the textbook and editorial area. They don't pay as well, but they do use a lot of photos. Sometimes clients in these areas will illustrate negative concepts, such as sad people, drug users, more reality. If you're shooting business executives, for instance, and you have your positive mood shots, you could try to get some showing stress or frustration because there could be requests for them. Focus on your markets, do the positive things first, then try more nitty-gritty approaches. You won't make as much money from the latter, but having them in file is worthwhile.

"A stock agent put it this way: 'There are basically two types of stock photographers, those who shoot what they love and those who analyze the market and listen to the agents. Few in the first category do well because 90 percent of what they shoot seems to be landscapes, other scenics, or downbeat social conditions. These subjects represent a very small percentage of total stock sales, and files are usually full. Photographers in this category are being rejected by stock agents every day.

"'In the second category, photographers treat stock as a business. Often they bring all their artistic talent and skills learned as an assignment photographer to their work, and they listen to their agents so they shoot what is marketable. Agents seldom find enough of this type of individual.'" Pickerell paused and added, "If you want to help your readers, you should try to prevent them from becoming 'category one' photographers, which may be their natural inclination. Not many can do just what excites them and stay in stock." First, you need to be able to recognize the market possibilities for editorial and advertising subjects in general.

EDITORIAL SUBJECTS

The subjects you choose for stock and how you shoot them depends on your personal photographic style and your interests, as well as on what sells. A friend who owns a hot-air balloon with his son leases rights to his enormous collection of terrific balloon slides. Another friend who decided that Alaskan pictures had a promising market spent a summer there and built up an excellent file of many places and events.

Think about what your interests are. They may guide you to useful photographic targets. However, keep in mind that almost everyone likes to shoot landscapes and scenics, so these images will be harder to market. Pictures of out-of-the-way places and unusual aspects of more familiar spots will probably be more marketable.

Of course, any individual photographer will have the time to shoot only a fraction of the potential subjects the world offers. In contrast the Time-Life Picture Library and such magazines as *National Geographic* have built up extensive stock files from the work of hundreds of photographers over many decades. Relax. As an average photographer, shoot what you feel is salable and try to make opportunities to photograph people, places, or activities that your research shows could be of interest to editorial markets or are becoming topical.

The more printed matter you see, whether at home, at the library, in waiting rooms, on newsstands—wherever you go—the more ideas you collect about what kind of stock sells. Think practically. If you can't afford a trip to Kenya or Antarctica, decide where you can go to shoot subjects, other than scenics, that interest you. In addition, without the need for much travel, you may also decide to set up stock situations (see Chapter 3). Setup shots require dedication and awareness of what to shoot, but they can often be done in your own vicinity after careful preparation.

PAY ATTENTION TO PUBLISHED STOCK PICTURES

While studying stock photographs, you should take note of credit lines. When a photographer's name is connected with a stock-picture agency, such as Jason Effstopp/Pixfile, a double credit indicates that photographs came the agency. You'll see many shots from individual stock files, but it is difficult to tell if the photograph is a stock shot when only the photographer's name is credited. You can safely assume that the photographs were taken on assignment if a photographer is given credit at the beginning of an article or on the title page of a book. When you see an article or book illustrated with pictures by several photographers and stock agency names are included with some, you can figure that most or all of the other pictures came from individual stock files. As you take a close, careful look at stock photographs, think about variations of them, as well as different subjects that you could shoot.

It is often hard to guess if pictures come from stock if they are of obscure places that are difficult to reach, or if the pictures are specialized, such as ones that show penguins or Watusi chieftains. For example, a few years ago a friend illustrated an article on highly crafted dollhouses for a classy magazine. After a year he sold some of the pictures as stock to other magazines, in which they may have appeared to have been assigned. When a publication is thin and has few staff members, chances are that its pictures are acquired from stock agencies and freelancers, or from writers who supply photographs with articles. Sometimes uncredited pictures are giveaways from such sources as

industry, tourist bureaus, and government agencies. (Pictures-for-free are an "unfair competition" problem that you can complain to state travel bureaus about.)

Publications and corporations often assign photographers to shoot specific subjects, but the days of big-budget editorial assignments are fewer. *National Geographic* is almost alone in sending photographers just about anywhere, no matter how expensive, because it wants exclusive images. Other magazines assign pictures on a more limited basis and supplement them with stock. News stock comes from such agencies as Sygma and Gamma-Liaison, which are primarily oriented to events and people. These agencies have photographers in many countries who cover topical subjects that are newsworthy and then quickly ship the pictures to the agency or client. After pictures fill an assignment, they usually become salable stock. In the mid-1960s, for example, I photographed the riots in Watts, California, for Black Star. The agency immediately sold some of the pictures in Europe and for years afterward filled requests from all kinds of American clients for stock images.

Many assignment photographers also shoot stock on locations, and stories they cover help build stock files. Perhaps you already have a media-photography business underway. If so you should recognize the possibilities—if you haven't already begun organizing a stock collection. By analyzing stock pictures in publications, you'll have a better idea of what sells. Of course you don't want to shoot exactly the same kind of pictures, but examining them will give you direction. Suppose that you see photographs of campgrounds along the Gulf Shore of Alabama in a regional travel magazine; you might find photographing campgrounds in another part of the country salable to publications there.

For knowledge of the stock business and leads to buyers, take a look at stock photo newsletters, which offer guidance (see Chapter 6). If you're associated with a stock agency, pay attention to their want lists. And as you do research and shoot over a period of time, keep in mind a prime rule about stock photography: You must have patience. The timespan between taking pictures and selling them can be months or years. Keep shooting. Patience pays off.

ADVERTISING SUBJECTS

Stock images sold for advertising purposes are priced higher than those sold for editorial markets. However, the subjects in demand for ads are more limited, releases are needed for recognizable people and pets, and the number of potential buyers is smaller. The kinds of stock images

most salable to advertising agencies are generic and "lifestyle" oriented.
These include home life, leisure, and high tech. Generic subjects and
situations are general subjects photographed without identifiable brands
or locations. The *ASMP Stock Photography Handbook* calls these universal,
ideal, or classic subjects "that trigger common emotional responses,"
and adds, "Like a classic actor, the photograph would be capable of
playing any number of roles and, as a consequence, would enjoy steady
employment." Many popular, often cliché, stock photographs are suitable
for ads (see Chapter 3 for information about how to set them up).

Study advertising photographs wherever you find them. Analyze how
they were made and what they symbolize. Obviously pictures made in a
studio using models and props to show off specific products, such as
breakfast food or cars, aren't stock. But they're meticulously
commissioned and shot, and photographers have large budgets.

In contrast ads for such services as insurance, in which the company
offers peace of mind, may be illustrated with images bought as stock,
perhaps a tranquil scenic or a calm lifestyle shot. The same serene
scenic could also be used as a background for an advertisement
featuring hiking shoes or framed as an enlargement on the wall of a
corporate office. Other standard stock images include children playing
against simple backdrops and someone gardening surrounded by
colorful flowers. All of these are advertising stock possibilities—when
you have releases—that can be acceptable to many types of buyers.

DESIGNING GOOD STOCK IMAGES

Landscapes, cityscapes, and seascapes are among the most popular
stock subjects to shoot and to publish. Remember that including people
in scenics helps give them human interest and scale. For example, in a
landscape of a country road winding through trees tinged with fall
colors, a horse and buggy or children with fishing poles might be
appropriate, but a cement-mixing truck would be jarring unless it helps
make a point. What you choose is only the first step in controlling your
picture's impact. What follows are other important elements that all
good stock photographs share.

SIMPLICITY OF COMPOSITION

Contest-winning pictures, many magazine covers, illustrations for articles,
or images from scenic picture books are usually done with a poster-like
composition that is a big asset to stock photographs. Posters and

billboards must read quickly as viewers pass by. As a result backgrounds are simple or plain; people and things in the composition are arranged to catch the eye, and one element usually dominates; subordinate elements support the composition and add to the information or graphic impact it offers. Bright colors may be used to draw attention, along with dramatic perspective, attractive people, and sometimes a strong camera angle.

Simplicity is the key to the fast-impact poster look. Effective stock images fill the frame in an interesting way without distractions. If you want to further explore visual themes, consider taking a course in basic design or read some books about graphic design. Look critically at your own pictures as well as others you see; decide how they could be simplified and improved.

Avoid going out of date. The most useful stock pictures appear valid now and will stay that way because they don't contain anything that will become dated. For people in scenics and for setup stock photographs, you need to choose clothing, models, furniture, props, and other elements that provide a believable effect. Try to select pleasant-looking people. They don't have to be classically beautiful or handsome, just appealing. Styles change all the time, so avoid extremes, such as very tight skirts or pants, baggy shirts, and oddly designed shoes. In addition women wearing very short skirts, bare-chested men in leather jackets, women with long, kinky hair, and men with bizarre haircuts tend to date pictures that you hope will be salable for a decade or more. This is also true for high-tech furniture and props that were in vogue during a specific period of time. Best-selling stock images have a universal appearance that ages gracefully.

VERTICAL AND HORIZONTAL FRAMING

Indoors or out, whether you set up stock situations or find them in real life and actual places, remember to shoot both vertical and horizontal pictures whenever possible. Many photographers are used to holding a 35mm camera horizontally and forget to look for vertical compositions. But verticals are necessary for magazine covers, greeting cards, brochures, and full pages in books. Train yourself to shoot both verticals and horizontals when the subject seems effective both ways. Change shooting spots, change lenses, move in closer, or use an interrupting object. Stretch your imagination. Be versatile.

It is also important to shoot plenty of film. When shooting conditions are ideal or good, professional stock photographers take many similar pictures of a given situation. They vary the composition and bracket

exposures when doing so seems useful. A lot of variations on a theme provides a means of making multiple sales. Some photographers say that the best dupes are made in the camera, and professionals often make dozens of similar exposures of any potentially great stock situation. When photographing nature subjects, shoot a large number of frames of a dramatic scene. On a stock setup, use your camera's motor drive to get a good supply of the best possibilities. Film and processing costs are inexpensive compared to the fee you might receive for an outstanding stock image.

SUNNY, NOT OVERCAST

It is inevitable that when you travel, you'll come upon an excellent potential stock scenic or street scene when there is no sun or it is raining. In the western United States, where I've concentrated my stock shooting, days are often sunny (except in the Northwest). But in Monument Valley or at Lake Tahoe, enormous clouds may cover the sun for minutes or hours. No matter how cleverly I try to compose when a scene is overcast, the pictures usually don't have the appeal they do in bright or hazy sunlight. I often used to shoot pictures of mountains or other scenics without sun, but now I pretty much shoot them only in atmospheric light or when I'm doing interesting closeup details. Stock agencies tell me they want sunny scenics and usually return those done in flat light.

If I find a scenic situation on a cloudy day that seems to be a natural for clients, I try to come back when the sun is shining. If that isn't feasible, I'll just shoot a frame or two to show friends and relatives; I won't waste my time further unless the place has a moody look to it. Ask your own stock agency or clients how they feel about overcast scenics. There are so many variations of daylight that your experience might be more fortunate than mine.

Sunrises and sunsets are an overproduced but irresistible species, so shoot them. You'll always find sunsets in stock-agency catalogs because they need new ones regularly. Just try to make your shots sensational.

ROOM FOR TYPE

Many stock applications include messages in type. If the situation you're shooting could be a magazine cover, poster, or advertisement, leave room for type. There are type lines in many places on a magazine cover and you can't anticipate them all, but you can leave room at the top of a

picture for the magazine's name. You can't be sure where type may be added in an advertising photograph or a poster, but you should leave room along one or more edges. If the client likes your shot well enough, the type may be adapted to your composition.

Not every picture situation lends itself to space for type. If you feel you'll upset the composition of a shot by leaving excess room around one or more edges, shoot both the tight compositions you prefer and variations with extra space somewhere. Trust a magazine, advertising-production department, or a designer to make adjustments. More sky, grass, or even trees can be added to a scenic image via a computer process that can also be used to put people where there are none or to eliminate such offensive objects as wires. However, this process can be expensive and is used only when the image is otherwise ideal.

TECHNICAL EXCELLENCE: THE BOTTOM LINE

The information here may be obvious, but it can help you understand the expectations of stock agencies and clients. Successful professional photographers compete with each other and with part-timers who shoot and submit pictures to editors and art directors. The more you demand professional-quality slides or black-and-white negatives of yourself, the more readily your work will be accepted. Buyers insist on technical excellence in the following areas.

SHARPNESS

Scenics that are sharp from foreground to infinity will delight stock users. If you can't achieve full depth of field, decide whether sharpness is preferable in the foreground or in the distance, and focus accordingly. The eye is used to seeing closer objects sharply and distant ones slightly out of focus. That may be acceptable unless sharpness in the background is essential. Action subjects that are sharp in the foreground and at middle distance and that have out-of-focus backgrounds are usually fine unless the setting is important. Using an ISO 200 film outdoors helps guarantee greater depth of field in properly focused scenes with adequate light.

For scenic photographs, and any time you want to ensure the sharpness that buyers love, mount your camera on a tripod. I used to feel that if I could shoot handheld at 1/250 sec. or faster, I would be safe. But in the past decade, using a tripod has become a religion with me. Improvement in sharpness is ordinarily noticeable, and on a tripod

it is easier to stop down and use slow shutter speeds to achieve full
depth of field. In addition a tripod encourages you to compose more
carefully and to shoot more small variations for more image choices
later. It also enables you to move away from the camera to wait for
clouds to pass or to talk to models, and the composition doesn't change
in the viewfinder. It is impossible to exaggerate the advantages of
shooting with a tripod. "Think tripod" even when you feel lazy.

COLOR

Photographers tend to take for granted the color in their pictures
because today's films are so good and record the world so faithfully.
Color is a strong element of salable stock photography because it
provides emotional impact and symbolism as well as beauty. Color can
also influence the mood of an image, such as a cold, blue wintry day or a
bright-green forest scene. In an art class you may have learned about
primary and secondary colors, the kinds you mix with pigments. Red,
yellow, and blue are the primaries; mix them and you get orange, green,
and purple. These are the secondary colors. All colors and variations of
them have psychological and social associations.

Red is a hot color that suggests danger, valor (bloodshed), and
extreme emotions (of the heart). In a photograph, red is often seen first
because it is an advancing color and can overpower the image if it isn't
used carefully. Red has a strong poster effect in many stock
photographs. Yellow, on the other hand, is a happy color that is
associated with sunlight and cheer. Pale yellow makes a fine portrait
background, and bright yellow may draw the eye to someone in a
photograph whom you want to emphasize. Blue symbolizes the
calmness of sky and water, as well as feeling sad. Blues, greens, and
earth colors are the primary hues of nature, against which people often
contrast manmade objects.

Red and yellow combine to form orange, the color of sunsets and fire.
Yellow and blue make green, the color of growing things and money.
Red and blue make purple, which suggests royalty and mystery. When a
warm rust color and a cool blue appear opposite each other, they
become contrasting hues that call attention to the subjects. Pictorially,
many color combinations can be very attractive.

All the main hues have various associations for people, which are
modified by individual experience as well as tradition. While
photographing nature, you can use only the colors at hand, but you can
improve a situation by using tinted filters and by having people wear
contrasting colors when appropriate. In setup stock shots color choices

are extensive and often limited only by the photographer's taste. Pastels are popular for clothing or backgrounds, and are often contrasted with brighter hues. A majority of excellent stock photographs include harmonious colors. A minority may be more daring with bright contrasts and dramatic combinations, such as purple and yellow.

As you photograph people playing, picknicking, or working, as well as scenics at various times of the day, pay attention to color combinations that attract you. You can also add to them, to enhance the mood of a picture. Color is both personal and dynamic. Read books or articles on color theory to learn more about potential human reactions to color in photographs.

EVEN LIGHTING

Indoors, acceptable lighting may vary considerably. In most cases it should be smooth, but existing light in many indoor situations is likely to be spotty or too contrasty. Unless you're shooting realistic editorial stock shots in which natural light adds to the authenticity, you'll need to fill shadows, to brighten people or objects important to the viewer. For black-and-white pictures, you might be able to use electronic flash or quartz lights handily. But for color images and most setup stock shots, you'll probably prefer electronic flash (see Chapter 4).

Smooth lighting effects with flash or floods are best achieved with diffused light,often from reflectors. Although not every situation calls for reflected or bounced light, many do, especially when you're augmenting existing light. If you need practice to achieve pleasant, moody, or dramatic lighting, try flash setups with and without people and shoot variations. Use umbrella reflectors or sheets of illustration board or whatever you like. Don't spare the film. The experience is valuable.

BLACK-AND-WHITE TONALITY

All of the above characteristics apply to creating effective black-and-white photographs, too. In black and white, the equivalent of color is tonality. This refers to a good gradation of tones, detailed whites, and rich blacks that give beauty and contrast to prints. Try for full tonality as you expose, add lighting when necessary, and be critical about the black-and-white prints you submit to agencies or clients. The key to a good print is a deep black at one end of the scale, a full scale of grays, and a faintly detailed white at the other end. You'll find it helpful to make your own black-and-white prints or at least to know how to do so in order to evaluate prints made by a custom lab.

THE BEST STOCK SUBJECTS TO SHOOT AND MARKET

The following list includes both generic and specific subjects that are often used to illustrate such printed matter as articles, calendars, brochures, and advertisements. The list is here to stimulate your creativity and initiative. "General" after a topic indicates many variations are possible. The cities and countries named represent thousands more.

As you begin to recognize stock pictures in print, notice their simplicity: for example, a red barn against a blue sky or a young couple on the beach with softly blurred surf behind them. Great stock pictures have immediate pictorial impact. In the best photographs it is usually obvious that the photographer waited for just the right moment of light and just the right composition and action. The visual patterns and facial expressions captured are eye-catching.

Study the stock pictures in stock-agency catalogs. Jim Pickerell says, "Agency catalogs give you insight about the kind of pictures being requested by clients. But most agencies won't send catalogs to photographers they don't represent; they're meant for prospective buyers. If you have a friend who's a graphic designer, publication editor, or works in an advertising agency, these people can make stock catalogs available, or at least loan them to you." The following list is typical of the lists represented by stock agencies. Pick and choose from this list for your own guidance.

Abstract patterns
Accidents, general
Actors/actresses
Aerials
Aerospace industry
African arts
Agriculture, general
Aircraft and airport activity
Air pollution
Air travelers
Alaska, people, scenics
Ancient ruins
Animals, general
Antiques
Apartment living
Archeological activities
Archery
Architecture

Artifacts
Arts and artists, general
Arts and crafts, general
Astronomy
Athletics, general
Atomic energy
Auctions
Authors
Babies
Bakeries and bakers
Ballet
Barges
Barns
Bars
Bicycles, racing, riding
Biology, general
Birds, general
Birthday parties

Boats, building, cruising
Books and bookstores
Bridges
Building construction
Buildings, general
Buses and bus stations
Business meetings
Cafes
Cameras
Canals
Carnivals
Carpentry
Cars
Caves
Celebrations and ceremonies
Cemeteries
Chemists
Childbirth
Children, general
Churches
Circuses
Clouds
Coal
Coastlines
Colleges, general
Computers and operators
Conferences
Construction and workers
Conventions
Cooks and cooking
Country roads, houses, stores
Couples
Creative images
Crop harvests
Crowds
Dams
Dancers and dancing
Demonstrations
Dentists and dentistry
Department stores
Deserts
Dishes and dishwashing

Docks and dock workers
Doctors
Drilling rigs
Drive-in theaters
Dust storms
Earthquake damage
Eating, general
Electronic equipment
Emotions
Energy
Entertainment
Environmental topics
Eskimos
Exercise
Factories
Fall colors
Fashion
Fast-food shops
Fairs and festivals
Families
Farms, equipment, farming
Ferries, cars, people
Firefighting
Fire stations
Fireworks
Fishing, commercial
Flags
Flea markets
Flowers, garden, wild
Flying, private and for hire
Food processing
Football, games and players
Forest fires
Forests, patterns
Fountains
Freeways
Friends
Fruits, general
Funerals
Gambling
Games, table
Gardens and gardeners

Gas stations
General stores
Geology and geologists
Gift shops
Ghost towns
Glaciers
Gliders
Gold, panning, mining
Golf and golfers
Graffiti
Grand Canyon
Grandparents
Grand Tetons
Great Lakes
Handguns
Handicapped, general
Harbors
Health food and stores
Helicopters, general
High schools, general
Highways, construction
Historic buildings
Holidays, general
Hospitals
Hot-air balloons
Hotels, general
Houses, general
Hydroelectric dams
Ice and snow
Indian crafts, dancing
Indigents
Indoor activities
Industry, manufacturing
Insects, general
Interiors, homes, offices
Irrigation
Islands, general
Jails
Jazz performers
Jewelry, making, wearing
Jugglers
Junkyards and junked cars

Kites, flying
Kissing
Laborers
Landscapes and scenics
Laughter
Lava flows
Law enforcement
Leaves
Leisure activities
Libraries, general
Lighthouses
Lightning
Little League activities
Livestock, general
Locks and ships
Lodges and resorts
Log cabins
Loggers and logging
Lovers
Lumber mills
Mailboxes
Manufacturing
Marathons
Marching bands
Masks
Massage
Mass transit
Medical subjects
Merry-go-rounds
Messengers
Military, general
Miners and mines
Mobile homes
Models, general
Money, general
Mood photographs
Moonrises
Mosques
Motels
Mothers, with children
Motorcycles
Motor homes

Mountains and climbing
Murals
Museums, general
Musical instruments
National parks
Native Americans
Nature, general
Neighborhoods
Nuclear energy, plants
Nude beaches
Oceans
Office buildings, workers
Oil industry, pipelines, refineries, rigs, spills, storage
Olympic events
Opera, houses, performers
Orchards, general
Outdoor activities
Painters, house, paintings
Paper mills
Parents and children
Parking lots, garages
Parks, general
Patterns
People, couples, families, groups
Performers
Pets, general
Photographers, general
Picnics
Playgrounds
Police
Politics, general
Pollution, general
Portraits, general
Post office, general
Poverty
Powerboats
Pregnancy
Prisons
Races
Radar installations
Radio stations

Rain, rainbows, rainstorms
Ranches, general
Recreational vehicles
Recreation, general
Reflections
Religion, general
Reptiles
Research and researchers
Resorts, general
Retail stores
Rice fields
Rivers, general
Roads, repairing, signs
Rock climbing
Rock formations
Rodeos
Ruins
Running
Salespeople
Salmon, general
Sand, castles, dunes
Santa Claus
Scarecrows
Scenics, general
Schools, children, teachers
Science, general
Sculpture and sculptors
Seascapes
Seasons, general
Secretaries
Shells
Ships and shipping
Shopping, activities, malls
Signs, painters
Ski resorts
Small towns, general
Smoking
Snakes, general
Snow, formations, plowing, snowstorms
Sports, competitive, leisure
Stained glass

Stairways

Stars

Still-life images

Stock markets, brokers

Street musicians

Students, general

Summertime

Sunbathers

Sunrises and sunsets

Supermarkets

Surf and surfing

Swap meets

Swimming and swimmers

Tapestries

Tattoos

Taxicabs

Tea and teapots

Technology, telecommunications

Teenagers, general

Telephones, general

Telescopes, general

Tents

Textiles

Theaters, general

Tide pools

Tobacco, general

Transportation, aviation, bicycles, cars, ships, trains

Trees

Underwater, fish, plants

Universities, general

Urban renewal

Vegetables, farming, gardens, harvests, preparation

Vendors

Victorian furniture, homes

Vineyards

Volcanoes, eruptions

Walking, general

War

Waterfalls

Water, general

Waterskiing

Weavers

Weddings

Western skies

Windmills

Wine and wineries

Wood products, carving

Yachts and yachting

Youth, general

Zoos

There are two ways to use this list. First, check to see if you already have any of these subjects in your files. Edit those pictures carefully (see Chapter 5). After you've read this book, you can decide whether you want to sell them yourself or offer them to a stock agency when you have enough images to get started.

Second, use the list to generate your own list of subjects to shoot. Underline those subjects included above that seem most feasible to photograph in the near future. Many subjects may be taken where you live or nearby, depending on local variety. Decide which picture situations that require travel would be worth the effort and expense to enhance your stock files. Follow your instincts and be practical, too. You are your own boss and can make your own decisions.

3 SHOOTING SETUPS FOR STOCK

Half or more of today's successful full-time stock shooters plan and set up their pictures in a variety of ways, rather than looking for them while traveling or depending on outtakes from assignment photography. These photographers prefer this approach because all the elements of custom-made stock are in their control, arranged in a studio or on location. Susan Turnau of the Sharpshooters stock agency in Miami, Florida, points out that about 60 percent of the agency's file material consists of setup photographs that are often its best sellers. "However," she adds, "I've noticed that a lot of people don't know how to shoot it properly. The pictures look very set up, and they're not as successful as the ones that look spontaneous. The photographer needs a sense of what's realistic and how to achieve it without looking contrived." Apparently while setup stock photography offers more control, it isn't necessarily easier than shooting natural or existing situations.

SETUP SUBJECTS THAT SELL

If possible, examine some stock-agency catalogs; these are full of excellent examples of setup shots of everyday events and subjects in a variety of settings. These photographs illustrate cliché situations. Notice especially "people" pictures in which the camera is fairly close and an activity is emphasized. The following are examples from one catalog:

- A gray-haired woman with a small child looking at flowers in what may be a greenhouse
- A woman in her garden talking on a portable telephone
- An office staff around a conference table
- An older man talking to a bank teller

- A woman wearing a face mask and cap and holding a metallic instrument in a rubber-gloved hand
- A father hosing down his car with two small daughters nearby
- An umpire calling a child out at the plate
- A grandfather showing two children how to fish
- An Oriental child and a Caucasian child painting in what looks like a classroom.

A typical stock catalog includes numerous skillfully setup pictures of family life, play, and recreation, as well as shots made in business and workplace settings. Most of the images are attractive and innocuous; few are avant garde or experimental, although I do have a catalog that shows dreamy pictures of couples taken with a haze filter, graphic shots of parts of buildings, and some posterized nature scenes.

Trends in stock subjects and in photographic approaches tend to change every few years. While you want to illustrate cliché situations, try to do them in as fresh and contemporary a way as possible. Think in terms of the ideas, concepts, and emotions that you want the pictures to reflect. Many shots might suggest relationships between people. To achieve this, direct your models to show the caring, interest, and other qualities that help give your images an appealing look and reflect your individual approach. *But don't be so carried away by terrific stock shots that you try to literally copy them by arranging models in the same poses in very similar settings.* You could be guilty of copyright infringement if your version is too close to a published one. Instead, interpret the concept in your own way.

On the subject of copying other photographers' pictures, Jim Pickerell, who has years of experience shooting stock setups, said, "Whether you'll be accused of copying depends on how close you get to the original. If it's a grandma on a swing with a child, and you use a similar swing, dress the people the same, use the same camera angle and lighting, your result could be so close it might be considered an infringement. But there are a lot of different ways the grandma could be sitting and relating to the child, and you could devise other camera angles, clothing, backgrounds, and lighting to make your own picture. *Concepts aren't copy-rightable, but the individual execution of a concept is.* Give a situation your own twists, and it will remain a cliché but not a copy."

PLANNING A SHOOTING SESSION

First you must decide on what kind of pictures you want to take, the concepts or ideas you want to illustrate. Begin with the most accessible

locations and models but limit your ambitions at the beginning. For instance, if you gathered a mother, father, two children, and two grandparents and decided to photograph them in a kitchen, playroom, and backyard, you could have enough models to shoot for a week. "Realistically," Jim Pickerell explained, "I find that most amateur models and lots of professionals wear pretty thin in four hours of shooting. If you're using kids, two hours is usually the limit. If you have a number of people available, schedule them in a series of smaller shoots. Decide what you want to do tomorrow and next week. Avoid having many more situations than you can shoot in a practical timespan."

Walter Hodges, a professional stock photographer from Seattle, Washington, told me, "I always plan stock setups. This is a business, and business runs on production—simple as that. I hire models, find locations, get photos. I have a production manager whose job is to set up these shots, just like it was an assignment. We research, do a storyboard of the subjects we want to cover, work up a budget, plan the logistics necessary to pull everything off in the amount of time we have allotted. We make contingency plans for when things may go wrong. We scout locations with color-negative film; we cast the models and locate the right props. We talk to our stock agents about what they need in this particular area.

"I may shoot anywhere from 20 to 60 rolls of film in half a day. I try to get at least 10 good setups surrounding a given idea and work on perhaps four good ideas a day. On a stock shoot I want at least 25 usable images from the four ideas, including many variations in terms of cropping, color, and subtle changes in the subject matter. I'd be very happy with 50 usable images per day. Perhaps out of that 50 will come 5 to 10 killer shots. Needless to say this is one hell of a job to pull off, and I'm just now getting a handle on how to do it without going crazy."

CHOOSING LOCATIONS

Actual locations where you have a free hand to bring in electronic flash or quartz lights to augment the available light can serve you well. There are numerous locations with enough existing light to which you can add your own, and you don't have to build a set if you can use the real thing. For example, in a domestic situation props, such as dishes, napkins, toys, and garden tools, may already be on hand. If so, check to see that they look new enough. If not, you may have to go shopping. Preplanning maximizes your shooting time and helps guarantee success.

According to Jim Pickerell, "A lot of business-situation pictures can be done with a desk, a chair, a computer, and an office background." When

fluorescent lighting dominates a scene, use a magenta 20 or 30 filter or overpower it with electronic flash. I've mixed fluorescents with quartz lighting, which warmed the scene and eliminated any greenish tint.

Pickerell continued, "Family-life situations can be shot in many homes. Try to adapt the existing rooms and furnishings. Simplify as much as possible, sometimes by moving close to the models and eliminating extraneous background. Of course, if you have a studio, you can avoid wallpaper, tables, lamps, and other furnishings you don't like in existing homes. In a studio you can arrange a plain background, put a soft light pattern on it, and it's guaranteed not to be noticed." Professional stock photographers often maintain studios just for stock shooting when their volume is large enough.

Writing a Picture Script. Suppose that you're going to photograph two people together in several domestic settings. Make a picture script, which is a list of the picture possibilities. Underline the ones with the highest priorities because a comprehensive list usually includes more than you can comfortably shoot at one time. A picture script might indicate such related situations as:

- Mother and daughter mixing cookie dough
- Child tasting dough from spoon
- Cleaning bowl and utensils at sink
- Dropping cookies on cookie sheet
- Mother and child placing cookie sheet in oven
- Tasting finished cookies.

These are merely a few possibilities from a single stock setup. As you decide which situations to plan for a shooting session, list every picture possibility you can imagine. Although you might never get to them all and some might prove to be impractical, the picture script stimulates your imagination, helps expedite your work, and shows your professionalism. Practice writing some scripts for stock setups. Remember, you'll also use the scripts as a basis for gathering props and considering location details.

HIRING OR FINDING MODELS

Stock setups require people who look real. Children can be cute, which they usually are. Pretty women may be attractive, but models who are too glamorous or sexy can be a drawback for some generic situations. Adults can be photogenic or simply pleasant to look at. Ethnic types are welcome, especially when several are mixed in the same pictures. Check for models among your friends, relatives, and acquaintances first. They may agree to help you get your business off the ground. Some may work for prints and praise; you may have to pay others on an hourly

basis. This amount will be determined by where you live and what you learn from colleagues about their fees for models. Regardless of what you pay amateur models, always make sure that they sign model releases (see Chapter 11).

Similarly, the fees you pay professional models vary according to geographic area and who you hire. Some charge from $25 to $75 an hour, sometimes more, occasionally less. Models trying to break into the business and actors and actresses are often more relaxed and expressive than pros. In addition they might work for lower fees if they aren't busy and want some portfolio prints. Sometimes you find people who'll work for prints alone if you do a few extra shots for their portfolio.

Should you offer a model a percentage of what you get from sales over a certain amount? Experienced photographers say this is an acceptable practice if the sale is $1,000 or more. A vast majority of stock sales are less than that amount, but you may have a problem when a stock agency doesn't report sales accurately enough for you to be certain which images have been leased. As Jim Pickerell explained, "It is better to pay people up front and be done with it. However, I recently heard from a friend who tells models, 'If I have a big sale, I'll share it with you,' without being specific. When a model noticed her image in an advertising campaign for a bank, she contacted my friend who was more than happy to pay her a percentage because he made a lot of money from the pictures. But I think he is rare, and most pros tell me they won't hire models who insist on a percentage. The logistics are too difficult to handle."

Walter Hodges has another point of view. He explained, "I tell my models I'll do three things in return for their time. I'll give them copies of some of the pictures, I'll shoot promotional pictures for free, and when it's possible to keep track of an image, I'll give them 10 percent of my share of the sale. Sometimes they see an image in print that I didn't know about and they call me. I pay them a percentage on the spot. One of my two agents tracks sales using model-release numbers I put on my slides, so that makes it easier."

You also need to discuss the wardrobe with models; what they should wear is often based on what they own. As shooting stock setups becomes more important to you, you may go with models to buy specific clothing. Keep in mind that a used-clothing shop may have selections you wouldn't find in a department store, and its prices are much lower. Clothing should be somewhat generic and not too unusual—the kind that won't go out of style quickly. Consider color schemes, too. Children wearing bright clothing are appealing, but in general let good taste guide you. Do you want a refined look with conservative colors for a

particular shot? You might find that pastels, "earth" colors, or contrasting colors are more suitable for other shots. In most cases you can ask models to bring alternative clothing if you haven't had the chance to check what they're wearing before the shoot.

CAMERAS AND LIGHTING

Most stock pictures are shot on 35mm color-transparency film, although some photographers use a 2 1/4-inch format and some shoot black-and-white images at the same time. Use shooting techniques that are most familiar to and comfortable for you. I do, however, suggest using a tripod when possible. When light levels are fairly low and your camera is mounted on a tripod, your pictures will be sharper. Furthermore, you can compose a shot on a tripod, walk away to talk to someone, and come back to a camera in place. Even when you shoot stock outdoors in brighter light, using a tripod is advantageous.

Several lighting styles are acceptable to a variety of buyers. Light may be unobtrusive and almost shadowless via the use of reflectors, or it may be more realistic. Jim Pickerell observed that "a few years ago most stock setups were evenly lighted for all details. Light was soft and not very noticeable. Then there was a period of very dramatic shadows. Now, as you see in television commercials and magazine ads, there is more of an available-light feel to it. Even though lighting is fully controlled, it may look more casual and spontaneous than before.

"When you do see shadows, note that none is too dark and none is in the wrong place. Watch how lighting's handled in magazine stories and advertising to keep up with current styles." Recent stock-agency catalogs show soft lighting and some more contrasty lighting. I've come across backlighting with soft fill, as well as bright pastels shot on overcast days. Many of the photographs look as if they were made in available light, but the time and place were carefully chosen.

ADAPTING PHOTOGRAPHIC ASSIGNMENTS AS STOCK SETUPS

Photographic assignments that require setups on location can often be a source of stock photographs, depending on the kind of subjects you shoot and the time you have. Jim Pickerell described an experience he had. "Shooting a slide show for a government agency, I arranged access to the seconds (pictures almost as good as those a client chooses) because the government takes all rights. I can offer them a little better price when I get seconds, and in the few situations that really worked as

stock, I had the option to also set up what I know I can sell," he said. "On a two-day shoot I did everything necessary for the AV show and got maybe a dozen useful stock-file situations."

Pickerell told me another story that typifies how you can make profitable arrangements on assignment or directly as a stock shoot. "A client came to me to illustrate a brochure," he explained. "They asked what I would charge to take pictures of a judge on the bench in a courtroom. When I realized they had access to the people and location, I told them, 'I won't charge you a photography fee at all if you get all the models I need to do a series of courtroom situations. Besides the judge I want a jury, attorneys, a plaintiff, a defendant, witnesses—the works. You pay model fees, I'll pay all my photographic expenses, and I'll merely charge you my normal stock rate for any usage you make.' They liked the idea because it would cost them less than they'd expected. So we had a total of about 20 models, including kids and adults. There was a full jury, and everyone signed model releases. The client only wanted black-and-white but I shot it all in color, too.

"Over the last four or five years, the client has used the pictures in many ways, so I've been paid perhaps four times what I could've charged for a normal day rate had I done a conventional assignment. Each time they have a new brochure, they pay stock fees to use the pictures again. I've also sold many shots from that set to other clients, mainly for editorial use, so the total amount I've received from a half-day shoot is more than I could ever ask to do an assignment."

DEVELOPING YOUR OWN STYLE

Photographic skills and common sense help you gain expertise shooting stock setups. The *ASMP Stock Photography Handbook* advises not to try to compete in this area solely for the money. And Susan Turnau of the Sharpshooters agency thinks that something else is essential if you hope to succeed shooting stock. "I say with conviction that photographers have to develop a style. They have to reach for the top in excellence because if they are just functional photographers, they aren't going to be able to compete," she explained. "The market is really glutted with average pictures, and to make a real living today, they have to be top-flight." This view may discourage or encourage you, depending on your eagerness and ability to produce setup stock images. Start modestly. You may like being in control.

4 CHOOSING EQUIPMENT AND FILM

Professional photographers use several camera formats, but the most popular is 35mm. Specialists in scenics and closeups may prefer $2\,^1/_4 \times 2\,^3/_4$ cameras because larger transparencies offer more sharpness and detail, which may impress clients who can also see the images more readily. Photographers who use 4×5 cameras need plenty of time to take pictures, and they avoid mobile subjects since they can't see the image they're shooting as they make exposures. Larger-size color images are a joy to view and reproduce more sharply than smaller ones, but the difference isn't always noticeable. In addition the versatility of the 35mm and other portable formats offer is worthwhile.

Try to keep your equipment as simple as possible. Talk to other photographers who shoot stock and get their recommendations. Do plenty of hands-on research with cameras and lenses, and experiment with films. Practice shooting until your technique becomes second nature. Time and effort help you choose tools that allow you to concentrate on creativity, and experience minimizes your concern about technical glitches. In your quest for cameras, lenses, and accessories, remember that you ultimately make the pictures.

35MM SLR CAMERAS

Because these cameras are so familiar to most photographers and are available in so many brands and models, you can go wrong only if you

select a camera that is too heavy or too complicated for you, or too expensive for your needs. Tastes in photo equipment vary from individual to individual, but in a 35mm camera I want professional quality and reliability, comfortable weight, exposure automation, auto-winding capability, a wide choice of lenses, and an affordable price. Most SLR camera makers also offer autofocus models that include automatic exposure, automatic winding and rewinding, and several metering options. Numerous SLR camera models offer all of these features at a wide assortment of prices.

You may already be using an adequate, or better, 35mm camera without all the bells and whistles. If it takes consistently sharp, well-exposed color pictures, includes handy features you find convenient, and is versatile enough to shoot the stock pictures you prefer, stick with it. It is important to be comfortable with your camera; it shouldn't handicap you by being too bulky, too awkward to operate, or too outdated.

When you decide to get a new 35mm camera, you can trust the automatic focus, exposure, winding, and flash sync in today's models. More automated models are higher priced, but the convenience is worth the money and enables you to concentrate on composition, facial expressions, subjects in motion, and general pictorial values.

The more mobile your subjects, the more you need an autofocus camera. Many models have the ability to lock focus on a fast-moving person, animal, or car, and almost instantly set the exposure and fire. This automated operation may also include flash, either as the main light or to brighten shadows. It is impossible to match such a combination of automatic modes with manual focus.

If you shoot mostly scenics and other stationary subjects, autofocus is unnecessary—especially if you often use a tripod. You have time to manually choose the point of focus for maximum depth of field if you need it. This means that millions of manual-focus SLR cameras are quite suitable for numerous stock situations. Remember also that you can easily switch from autofocus to manual focus on most modern SLR cameras. This choice enables you to determine which subjects you want in sharp focus.

Automatic or not, most modern SLR cameras give you more freedom to think about imagery without technical distractions. Remember that focus and exposure controls are in your hands when you prefer to be in charge. A friend with a very advanced and expensive 35mm SLR camera told me, "I started focusing and using the exposure system manually because that is what I was used to, but occasionally I turned on the autofocus and autoexposure features until I knew I could trust them, and trust my own judgement to control them. Now I only go back to a

manual mode when I want to be sure of the settings. Manual is more time-consuming and generally no more reliable."

I've read about and compared all the leading SLR camera brands and models, and I feel that you can choose almost any one of them and be satisfied—if you match camera features and versatility with your anticipated photographic requirements. For example, if you don't intend to shoot really fast action, a 1/2000 sec. shutter speed will serve you well; a 1/8000 sec. shutter speed will be overkill. Slow shutter speeds for automatic time exposures are also helpful to have for low-light situations. If you don't need automatic bracketing, you'll pay less for a camera without it. And if one or two frames per second is fast enough for your purposes, don't be seduced by a two-pound model that winds twice (or more) as quickly. Be sensible, and try to avoid being status-conscious, too. Some SLR cameras can strain your bank account and neck muscles at the same time.

Point-and-shoot 35mm cameras aren't suitable for stock photography. They lack pictorial controls, their lenses may not be sharp enough, and a single-focal-length lens is inadequate. Zoom-lens models are better, and the most elaborate of these are impressive. But parallax can be a problem, and you're limited to their built-in focal lengths. Many models make changing film in mid-roll difficult. Most distressing of all, point-and-shoot cameras allow you few exposure options to compensate for contrast or anything else. Shooting without the capability to manually alter meter-indicated exposure is a handicap when overriding the meter is indicated. Point-and-shoot automation is wonderful, but the photographer has to be in charge of the camera's electronic systems to be sure that they operate at optimum efficiency. Point-and-shoot cameras rule this out.

Lenses for 35mm SLR Cameras. A vast number of lens types and focal lengths are available for almost every SLR camera brand on the market. Armed with lenses from ultrawide-angle to the practical telephoto, you are ready for any subject, even those you don't anticipate.

Prime lenses have a single focal length, unlike zoom lenses, which have variable focal lengths. I am a zoom-lens fan, but I realize that many other photographers are comfortable with their favorite prime lenses, such as the 35mm, 105mm, or 180mm. At one time prime lenses were superior in sharpness to zoom lenses, but the gap has narrowed considerably. Computer designs, new materials, and ingenious production methods result in quite sharp zoom lenses ranging from wide-angle to telephoto. But for some available-light situations, you may need a prime lens with $f/1.5$, $f/2$, and $f/2.8$ apertures. In addition such lenses as a 15mm fisheye, a 55mm or 100mm true macro, and a

perspective-correcting lens for shooting architecture are available as prime lenses only.

For more than a decade I've been shooting stock mainly with zoom lenses because they are more convenient than prime lenses. A zoom lens neatly varies composition in so many situations when you don't want to, or perhaps can't, take the time to change positions. Tiny alterations of focal length can lift many ordinary images, giving them more impact. The pictorial flexibility available with zoom lenses is an essential to me. They offer special aid and comfort in all sorts of stock situations. Shooting stock with a 35mm SLR camera provides maximum mobility when you handhold it, but no matter what lens is used, working with a tripod offers greater sharpness. When I handhold the camera, I set as fast a shutter speed as practical to help reduce evidence of camera movement. None of the agencies I work with have complained about photographic quality, nor have they asked about my lenses.

Camera manufacturers and independent companies make zoom focal-length ranges in increasingly lightweight mounts that are getting shorter. One of my favorite zoom lenses, an 80–200mm lens made in the late 1970s, is about 8 $1/2$ inches long and weighs 2 pounds. I replaced it a few years ago with a 70–210mm zoom lens that is 4 inches long and weighs 14 ounces. Both lenses produce excellent, sharp images.

You should be able to photograph almost any stock subject with some or all of the following zoom ranges: 21–50mm, 28–80mm (or 85mm), 35–70mm, 70–150mm, 70–210mm, and 100–300mm. There are plenty of other similar ranges to choose from. I've listed only those zoom lenses that I feel are practical for handholding. Wide-span zoom-lens ranges, such as 28–135mm, seem bulky and heavy to me, but check for yourself. Before you buy a zoom lens, mount it on your camera and get the feel of it. Let the camera and lens hang from your neck or shoulder for a few minutes. A lens that is hard to hold steadily and is tiring to carry isn't an asset for shooting stock.

MEDIUM-FORMAT CAMERAS

Cameras in the 2 $1/4$ × 2 $1/4$ and 2 $1/4$ × 2 $3/4$ formats offer a larger image through the viewfinder and larger color transparencies, but are heavier and bulkier than 35mm cameras. A stock photographer and colleague who once shot scenics with a 4 × 5 view camera has been happy for years with a 2 $1/4$ × 2 $3/4$ model, and he doesn't mind that it weighs several pounds because it is usually on a tripod. As he told me, "I like using rollfilm because it's faster and costs less than 4 × 5, it's a pleasure

to have an automated exposure system if I want it, and I can quickly change camera backs to shoot black-and-white and color pictures of the same subject." Shooting from a platform atop his van, he uses lenses equivalent to those I have for a 35mm SLR camera. There is a precision about the medium format he loves, the larger viewfinder image is a pleasure, and he usually isn't in a hurry.

Medium-format cameras can be handheld, but they are heavy. Most are reflexes, but a few offer eye-level viewfinders. Some are more compact and shoot $2 \frac{1}{4} \times 1 \frac{5}{8}$-inch pictures, which make them easier to handle—but still not as handy as most 35mm SLR cameras. Many medium-format cameras have sophisticated automatic features, some of which, such as automatic film transport, are valuable for fashion photographers who follow models on the move or for stock photographers of wildlife or active people.

LARGE-FORMAT CAMERAS

View cameras produce wonderful negatives and transparencies that are easy to look at and make advertising clients stop and notice. These cameras are particularly suitable for static scenics, still lifes, portraits, and fine-art subjects. At one point stock buyers wanted 4 × 5 pictures. But as 35mm color and black-and-white films were improved, the old "bigger is better" tradition declined. However, lots of 35mm stock slides are enlarged to 70mm to impress clients and provide extra sharpness (even though original 35mm slides are quite acceptable for a majority of stock-photography buyers).

If you want to shoot 4 × 5 or larger negatives and transparencies of nature subjects for your stock files and you have personal and/or practical reasons, be aware of the time and mobility handicaps, and enjoy. Many buyers like to work from very sharp, large-color images, especially for framed enlargements, posters, and billboards. Large-format photography requires a certain discipline that I associate with making fine-art black-and-white pictures, and if you have the patience, you can be a large-format specialist.

PANORAMIC FORMATS

Over the past ten years the panoramic format has grown substantially, especially for advertising, corporate brochures, and annual reports. I discovered this and basic data about panoramic cameras from Doug

Segal, who with his brother Mark owns Panoramic Stock Images, a unique agency located in Chicago, Illinois. There are three types of panoramic cameras: The wide-angle camera, such as the Fuji 617 or the Linhof 617, is a fixed-film camera. Also available are 4 × 5, 5 × 7, and 8 × 10 cameras that are custom-modified for wide-angle work.

In specially designed cameras, such as the Widelux, the camera is stationary and the lens swings in an arc that covers from 30 to 150 degrees. This is a traditional panoramic format. In the last group of panoramic cameras, the film rotates in the camera and the camera rotates in the opposite direction. The photograph is exposed through a moving slit that you can set for a 360-degree image.

The Segals suggest that one of the first two panoramic cameras is more practical for newcomers, but only in the 120mm and 70mm formats. They don't recommend 35mm panoramic cameras because the image quality doesn't measure up to the larger formats that buyers prefer. "We'd like our photographers to use a 6 × 17 or 6 × 18 wide-angle panoramic camera for time exposures," said Doug. "And we'd also like them to have a 120 Widelux 1500 or any type of swing-lens camera." The minimum (discount) cost for the popular Fuji 617 camera is about $2,600, and the higher-quality Linhhof 617 is about twice that price.

Many panoramic cameras use 105mm lenses that operate most efficiently at $f/16$ or smaller apertures. So panoramic stock photography is largely done in bright daylight; however, time exposures are feasible. According to Doug Segal, "There are a number of interior shots in our new catalog." And he added, "You need more training and experimentation with these cameras than you would with a conventional 35mm SLR. Composing pictures is much more critical."

COLOR-TRANSPARENCY FILMS

I estimate that 90 percent of stock photographers use 35mm slide film (color prints are rarely used for stock because reproducing from transparency film is still preferable). Photographers shooting specialized subjects, such as artwork copies, landscapes for huge blowups, still lifes, and architectural interiors, might elect to use larger-format films. In either case the choice is mainly between Kodachrome and other positive transparency rollfilms or sheet films made by Kodak and Fuji.

The color fidelity and sharpness of Kodachrome have long been the standards against which other color films are compared. In addition Kodachrome's dye structure gives it a longer lifespan than other transparency films before fading begins. I use both Kodachrome 64

(K64) and Kodachrome 200 (K200). The difference in color or contrast is negligible, although K64 is finer grained. When I'm shooting handheld or with a tripod in bright sun, the speed of K64 enables me to use comfortable shutter speeds and *f*-stops. On overcast days I choose K200 for subjects that require a shutter speed of 1/250 sec. or faster. And at dusk or at night, I usually load K64 in one camera body and K200 in another to be ready for different situations.

My experience has shown me that exposing K64 at ISO 80, which is 1/3 stop underexposed, produces better color saturation than shooting at ISO 64. If you haven't tried shooting K64 at ISO 80, experiment in a few picture situations and shoot the same subjects at ISO 64. Decide for yourself. I've also found that exposing K200 at its indicated speed works just fine. I don't recommend trying to underexpose this faster film even 1/3 stop.

If you aren't in a rush to see the stock pictures you shoot, or if you're traveling a lot, you can save money buying Kodachrome (or Ektachrome) with processing. Good prices are advertised at camera stores in New York City, as well as other cities listed in *Popular Photography* and *Petersen's Photographic*. During a trip, number your rolls on both the address label that is part of the processing envelope and the receipt tab you keep, and regularly mail them to a Kodalux lab. When you arrive home, many of your finished slides will be waiting. Knowing the order you shot your pictures in helps you coordinate caption and location data.

Kodak Ektachrome and Fuji transparency films are also excellent. Fuji Velvia is becoming a favorite with photographers because of its brilliant color. I tried shooting it at ISO 40 rather than its ISO 50 rating; the exposures were fine, but this film is too slow for me. You can develop transparency films (except Kodachrome) in your own darkroom or have it done by many independent labs, often in a few hours, a convenience you may value. Finally, remember that the faster the films, the more visible the grain is. Film in the ISO 100 to ISO 400 range offer practical speeds that will match your technical comfort as well as the subjects and the light you encounter.

LIGHTING EQUIPMENT

Contemporary photographic lighting in studios and on location is done mostly with electronic flash. Compared to flood and quartz lights, electronic flash stays cool, is more intense, makes smaller apertures feasible, and has a 1/1000 sec. duration that stops action easily. To

photograph one or two people, you may be able to use compact, camera-mounted flash units powered by AA, C, or D batteries. These units range from about 50 to perhaps 150 watt-seconds. For greater coverage you'll need AC-powered units that generate 200 watt-seconds or more. There are many relatively compact flash units on the market. You can attach two flash heads to some units in which the powerpack and heads are separate. Many of these more powerful electronic-flash units are now portable and often include modeling lights to show approximate effects before you shoot.

Quartz lights and photo floodlights give you the advantage of knowing better how a subject is lighted before you shoot, but they're hot and better suited to small areas. Sometimes you can use a quartz light to brighten shadows made by daylight coming indoors, knowing that the artificial light will produce warm tones on daylight-balanced transparency films. For some portraits and other interior shots, warmer light may be preferred.

If you're shooting ISO 400 black-and-white film, quartz lights might be all you need, especially to fill daylight shots. You can, however, shoot many subjects with floods or quartz lights, especially if you aren't comfortable using electronic flash, using a flash meter, or working with dim modeling lights.

Still, if you intend to shoot enough setup stock pictures, investing in powerful (600-1,200 watt-seconds) and portable AC-powered electronic-flash units is the professional approach. With a studio space large enough for the subjects you want to photograph or working on location, you can shoot quite a variety of pictures. Experiment with reflectors, such as umbrellas or flats, until you feel comfortable controlling reflected electronic flash. This is the preferred type of lighting for many types of stock setups.

Some photographers feel that having to carry and use a tripod is an annoyance. Others, including myself, find that a tripod is usually worth carrying because when used properly, it ensures sharpness and greater depth of field, or if desired, creatively blurred shots at night. In addition you often compose more carefully. Choose a tripod that you can carry comfortably, and if possible, get one that extends high enough so that you can position a 35mm camera at eye level. There are many good brands and models, but I think that the best tripods have a ballhead camera mount. The Gitzo is an outstanding tripod. A ballhead enables you to adjust your camera to a level position or any other direction without having to go through the tedious process of leveling the tripod legs. However, if you have a tripod or you buy one that doesn't have a ballhead, it is relatively easy to add an accessory ballhead. You can find these at camera shops and in mail-order catalogs.

5 ORGANIZING YOUR PICTURES

Once you have transparencies or prints, how you organize them is vital to selling your work. Unless you have supportive systems with which to number, index, file, and monitor the whereabouts of the images you made the effort to shoot, your work may be misplaced, lost, or stored in slide boxes in true dilettante fashion.

I'm reminded of an ad for ASMP's collection of legal essays with this heading: "What's 2×2 and worth real money?" The reference was to establishing the value of lost or damaged 2×2 slides (see Chapter 11). You should ask yourself the same question if you are lax about organizing your stock photographs. How much office work are those 2×2 slides worth to you? What needs to be done to traffic them successfully, either yourself or through a stock agency?

Stock photography is a potentially lucrative field, and I wonder how many readers fantasize about shooting all kinds of pictures and selling them for big money—when they get around to organizing their work. Some procrastinate and eventually curse the piles of unedited slides accumulating somewhere. You get the point: the pathway to success in stock may be complex, but you must take the necessary steps before you are ready to find markets for your creativity.

EDITING PHILOSOPHY: BE RUTHLESS

Editing your own work is difficult. The goal is to be as detached and objective as possible. You hate to throw away or store images that are almost just right yet not really quite good enough to market, such as a beautiful landscape with a distracting trash can off to the side or a seascape in which the waves are nice but not as good as in other shots

you took. Near-miss pictures may be sharp and properly exposed; however, in a minor way something is wrong with the composition, facial expressions, lighting, or action. If you were to submit these photographs to a client or agency, you would send excuses along to cover small flaws. Excuses are less than useless in the stock business. "Form follows function" is the basis for practical editing. Being ruthless is the form or approach; submitting only the best images is the function.

Each time you edit your own pictures, you're confronted with pictorial-quality decisions. Should you try to market pictures with busy backgrounds or those with slight subject movement that should be sharp? Not if the intent of the pictures is weakened even slightly. Your judgement will be suspect, as will your technical ability. In the competitive stock-picture market today, "almost right" isn't acceptable.

What do you do with rejects? Should you keep them and maybe try to market slightly under- or overexposed images? Should you send out slides that you know should be cropped tighter, hoping that the client will do so? Again, the answer is no in both situations—you'll undercut your reputation as a photographer. If you send obvious goofs, clients and stock-picture agencies will wonder why you didn't shoot alternate pictures that were more perfect, and if you did shoot some, they'll wonder why you bothered to waste their time sending flawed images together with the better shots. It is inevitable that pictures you don't ruthlessly eliminate may eventually mark you as a second-rate photographer.

SITTING DOWN AT THE LIGHTBOX

Since most photographers shoot and market color slides, this discussion concentrates on them, but techniques are similar for editing, numbering, and filing larger color transparencies and black-and-white negatives or prints. The principles of editing and making judgements about what's worth presenting to agencies or clients are the same for all mediums.

Lightboxes come in many sizes and types, from whole tables with fluorescent bulbs in them to portable boxes. The best lightboxes are metal with several 5000K fluorescent bulbs inside, spaced for overall even illumination. Spiratone sells lightboxes in several sizes, from $8\,1/2 \times 11$ inches to 15×23 inches. Vue-All offers two metal lightboxes that are $8\,1/2 \times 11$ inches and 11×17 inches with 5000°C lamps. I find that the smaller Vue-All lightbox fits perfectly on my desk, so I use it for editing and viewing slides when I'm typing shipping lists. Check local camera shops to see the variety available and to make comparisons.

You may also have seen several sizes of "slide sorters," which use 60-watt bulbs that aren't as well color-corrected as fluorescent bulbs.

The tilted front panel of a slide sorter consists of a series of molded plastic ridges that are likely to get hot, so this type of viewer isn't recommended for professional work. Whatever equipment and supplies you choose for your stock business, be comfortable with them. Excessive economy is frustrating, and ostentation is expensive.

It is feasible to make a lightbox using thin pieces of wood and small fluorescent tubes. Line the box with white posterboard for even illumination. Mount opal glass or translucent plastic on top. Although you might build a lightbox in a handy desk drawer, a freestanding design fits a convenient space and is portable. The top of a lightbox should tilt slightly for convenient viewing.

To start editing, I run through each box of new slides rather quickly, tossing out only those that are obvious failures resulting from accidents and carelessness, whether avoidable or not. When I come to a picture that I feel is a winner, I examine it more thoroughly over a lightbox through a magnifying glass called a *loupe*. The better loupes are large enough to cover an entire slide and cost more than smaller models. A less expensive loupe might be acceptable optically, but the more you pay, the better the optical quality should be. If you are nearsighted and don't need glasses for close work, try a loupe before buying it or ask if you need glasses to use it. As an eyeglass wearer, I prefer not having to use glasses when looking through a loupe. Check mail-order catalogs as well as local camera shops when shopping around for the best buy. (For purchasing information, see the "Resources" list on page 187).

Whether you're examining slides of a setup series that shows a process or symbolizes a relationship or working with scenics or people in motion, start by grouping images with similar subjects. Throw out the rejects right away. Next separate the best pictures, and make other piles of near misses. The best pictures include those with top-notch composition, expressions, color, and action. These are either sharp, and correctly exposed, or blurred in a painterly fashion (if that was your intention). As you edit, remember the best you can do will have to compete with other outstanding stock images of similar subjects.

Store near-miss pictures in separate files. I have boxes and boxes of them, and every few years I look at them quickly and throw 98 percent away. I can't bear to toss out near misses immediately, but I should. The "what if?" syndrome always hits, although experience shows that I have use for only one near-miss slide in a thousand. I put together slide shows for friends and family with my best near-miss shots, but I'm wasting space to keep very many of them.

All visual failures for various technical or pictorial reasons would be apparent to clients and stock agents. Stab reject slides with a letter

opener, and throw them away. I damage them so that someone else can't take a picture out of the trash and use it without permission. This is my ego at work; I enjoy the fantasy.

CAPTIONING SLIDES

Before I actually caption my work, I place the best selection of slides in separate stacks roll by roll in numerical order. It is also logical to stack them by subject if you wish. Next I stamp my name, a copyright symbol, and the year on each slide (see Chapter 7 for information on the importance of copyright). The copyright symbol helps to protect your valuable images from unauthorized use. Someone may get possession of and use a slide without permission or payment, but evidence of copyright on the mount or in the film itself should make people think twice. An important consequence of a copyright symbol is that a court can require payment of damages to you far in excess of just the fee you might collect from an unscrupulous user.

I print captions by hand on one edge of a slide with a fine-tipped pen. I include a few identifying words, such as "Jenny Lake, Grand Teton Nat'l Pk., Wyoming." On a slide of an outdoor fountain I might put "By Naguchi, Bank Lobby, Vincennes, IN." Use abbreviations, and be brief but informative. I add more detailed caption data on the shipping list, which the stock agency can incorporate if it wants to.

For my purposes handprinted captions are as fast or faster than a computer-captioning program because I seldom have more than six images that need *exactly the same caption*. For repetitive captions a computer program is preferable. However, captioning a variety of slides on a computer requires keeping the slides in order and then attaching the right caption to the right slide. Handprinting seems efficient enough to me. With only 50 or 60 slides to caption, I can do them faster by hand than I can type them, print them out, and attach them.

When I have 30 or 40 rolls of slides to organize at the same time (especially ones that show similar subjects) or when I have a lot of slides that require the same caption, using the computer makes sense. It is a pleasure to type a caption once and print it out any number of times on custom labels that I attach to the front of a slide or fold around from front to back.

A computer-captioning program provides four or five lines on each side of the slide, which is more information than you can fit into the space by hand. The file number and caption data may be written on the front with your name, address, and copyright on the back. Computer-

printed captions look neater and more professional, too. There are both computer-captioning and stock-file-management programs. Those designed for captioning only are reasonably priced and not hard to use. Custom labels to fit slides are available in quantity, usually from the software suppliers (see the "Resources" list on page 187).

INDEXING YOUR IMAGES: DEVISING A SYSTEM

If you already have a good system for numbering slides, negatives, and prints and you can find the pictures you want in a minute or two, you are fortunate. Skip to the next chapter. However, if you aren't entirely pleased with your system and want to improve it, keep reading. If "any day now" you plan to number and index a whole bunch of pictures that have accumulated for months or years on shelves or racks, be advised that you can't start selling stock photography until you have a reasonable numbering-and-filing system. Otherwise you risk losing track of your images, looking amateurish, and courting futility.

I feel it is essential that *every slide in your files have its own number or number/letter designation*. Indeed, every image in your files on any size film, in color or black and white, should have its own individual number. This is the only way you can adequately file your pictures or list them when sending a selection to a client or agency. And it is a sure way to know that all slides held or returned by a client are accounted for. You or an assistant will then be able to find pictures, as well as monitor shipments and returns accurately. No matter how many slides or black-and-white prints you have now, your collection is likely to grow, and you must have a comfortable and functional numbering system.

A full-time stock photographer I know uses generic headings to file slides in plastic sheets, but first he divides his work into geographic areas. There are files of pictures taken in the Northwestern United States, in the Rocky Mountain states, and other categories, such as Southern California, Texas and the Southwest, New England, and Florida and the South. There are also categories for Europe, Japan, Korea, Australia, and other foreign countries divided into consistent headings, such as scenics (several headings ranging from rivers to seascapes), heavy industry (including aircraft manufacturing, electronics, food packing), light industry (clothing, gummed-label manufacturing), business (offices, services), people not otherwise covered, transportation (including planes, trains, and boats), and other important groupings.

This photographer's files are typically categorized to fit the subjects he shoots, and it should be easy to use similar headings and devise

more to fit the kinds of pictures you shoot. Whether you wish to use geographical areas depends on how you choose to design clarity and access to pictures into your files. The key to, and the reason for, all picture-filing systems is access, which indicates how easily you can find specific pictures that you or a client may need. If you can locate shots of street scenes in Houston and street scenes in Rome equally quickly, your indexing and filing systems are a success.

Within the above system each slide has an individual letter/number designation for precise monitoring of deliveries, returns, and where to find images on file. Here is how he assigns the numbers and letters:

- 1 and up: geographic location
- A to Z, and AA, AB, AC, and so on: picture categories
- 1 to 9999: individual slide numbers.

A slide numbered 3BD-769, then, could indicate that it was taken in Southern California (3), was an aircraft factory (BD), and was slide number 769 in that category.

My friend keeps a record of all slide numbers and brief descriptions on his computer; the listings are chronological. So slide number 3BD-769 of an aircraft factory is filed with other 3BD pictures, while a slide numbered 3LA-769, also taken in Southern California, is labeled "LA" for a Los Angeles subject. Even with the same slide number in the same geographical area, these two pictures are distinguished by separate category designations. No two slides have the same numbers/letters, and while this photographer's computer is set up to find pictures by location and category, he has fine-tuned enough categories into the system to make searching relatively easy.

There are other ways to sensibly categorize and file stock pictures, and most are based on numbers and letters—and as few as possible so that the slide mount isn't overcrowded. Slides may be numbered with an adjustable rubber stamp or via a computer-captioning program. All filing systems include index listings that you can use to check for specific pictures on a hard copy or on a computer screen. Ask photographer friends about their numbering and filing systems. You may find one you like a lot. Remember to keep specific notes about the number/letter designations you use so others can access your files when you have help. You can do this with a wall poster showing numerical and alphabetical designations, lettered by hand in several colors to make it more legible.

MY SIMPLE NUMBERING SYSTEM

The system that I've used for decades has proven efficient. Either adapt it to your files or devise a variation that assigns individual category

numbers for each slide or print. Simplicity is an asset, but what is critical is to enable you and anyone who works with you to access pictures efficiently using your numbers and letters.

In my system I log each roll of film into 4 × 6 spiral notebooks because they tuck into drawers nicely, but any notebook that seems convenient will do. I date the top of each notebook page, and I date important entries that I need to remember. Each roll of film I shoot is listed chronologically by number, and each listing includes a thumbnail description, such as "Paris/Eiffel Tower" and "street scenes/Louvre exteriors." Because my files aren't huge, I can rely on memory of dates and places to find pictures I want that are filed in plastic sheets, usually in the order taken. I also have slides filed in special categories, such as "portfolio," "specific trips," "portraits," and "pictures from books" (that I've written). To find images I start looking for dates or descriptions in my index books to discover where to look numerically in my notebooks of slides in sheets. For example, to find images from my third trip to Europe in 1984, I turn to the notebook labeled with that date and trip.

Each roll of film has a number, and each slide frame is numbered by Kodak. So roll 257 includes Notre Dame, and frame #18 is a night shot of it; as such, 257-18 is the unique number for this slide. When a number of rolls cover the same subject, I group them in the index with one description, such as "1242-1246: Monument Valley and Arches National Park, UT." I began logging my slides by hand before there were computers, and I've indexed about 75,000 slides and 200,000 black-and-white and color negatives (for personal use) over many years. Mainly I must determine what year I shot something. Then I single out what I need. Together with a system of categories, which I use only for slides grouped in plastic pages, the average photographer would be able to adapt my numbering system comfortably.

NUMBERING YOUR SLIDES, NEGATIVES, AND PRINTS

After I look through a box of slides once, I stamp a roll number on each slide as soon as possible. I number and record each roll so that I can mix slides together and still match captions to them later. If only a few rolls come back from processing at a time, keeping up with numbering and indexing takes little time. However, when you're away on a job or trip for weeks, you're later faced with dozens of rolls of film. To facilitate the work as you shoot the film on location, number each film cartridge (or 120 roll) and/or the plastic canister, using a Sharpie or equivalent permanent marking pen. When you shoot with two or three camera

bodies, number the rolls according to the sequence in which you remove them from a camera. You'll be able to put the rolls in logical order later. For your caption notes, written or made with a miniature tape recorder, temporary, on-location roll numbers are also essential. You can also record additional specific picture data by frame numbers.

When you use film-processing envelopes, number each one to match the roll. If you develop your own film, number the rolls in order the same way. If you take your film to a lab, number the cartridges or canisters as described; a good professional lab can work out a way to deliver them to you in sequence. If this isn't possible, shoot identical pictures at the end and beginning of succeeding rolls to help keep them in order. When your color slides are returned and given file numbers, mark your in-the-field roll numbers on the slide boxes to correspond to your caption notes for specific rolls. Variations of these numbering and indexing systems also work well with print films.

For business or personal pictures, I number each roll, using a letter to indicate that this picture is from a negative, such as C247 for color and B247 for black and white. Each negative frame is numbered so that each print has a separate number. You should also use separate letters to designate medium-format negatives or color transparencies. Positive color from a roll of 120 film could be numbered M247 for medium-format and MB247 for medium-format black-and-white. This usually prevents confusion because roll M247, for example, may be taken long after color-slide roll 247, and black-and-white roll B247 may be from a different era. I number the back of black-and-white prints before I expose the paper.

With these techniques, you can devise your own numbering system. Use separate negative and transparency logbooks or index notebooks *for each type of film you shoot*. If you don't anticipate a lot of rolls of one size or type over the years, start at the front and back of one notebook for two different kinds of film. Make indexing easy for yourself.

STORING PHOTOGRAPHS IN FILES

In addition to numbering each picture, whether you sell your own stock or send it to agencies, you must meticulously file your pictures in groups in a prescribed order to fit your needs. A basic component of a filing system is being able to find and view specific subjects and images easily. To achieve this a majority of photographers store their 35mm *chromes* (a trade name for slides) in plastic pages that hold 20 slides in pockets. You can keep such pages in ringed notebooks or in filing

cabinets with plastic pages suspended on hangers for easy reference. Drawer dividers can be marked with categories or numbers to separate pictures in logical fashion. I recommend metal cabinets with full-suspension drawers because prints and slides by the hundreds are heavy, and wood cabinets may give off harmful vapors from the glue or paints they're finished with.

Plastic slide pages stored in looseleaf notebooks can be arranged chronologically by number or separated by subject according to your needs. Slide pages themselves should be of *archival quality*, which means that they won't damage slides chemically. There are two safe plastic materials, polyethylene and polypropylene. Check your local camera shops or request catalogs from Vue-All, Light Impressions, or 20th Century Plastics, and compare prices and descriptions (see the Resources" list on page 187).

Store both black-and-white and color negatives in envelopes made of materials that won't harm them chemically. Glassine envelopes are safer than those made of Kraft paper, which may eventually damage negatives. Check at camera shops or in the catalogs listed above. Properly filed negatives can then be kept in boxes or file drawers.

Contact sheets can be stored in numbered boxes or in file drawers in folders. I've always stored my negatives and contact prints separately because I didn't want to risk damaging negatives when I worked with the contact prints. If it is more convenient for you to keep them together, handle the negatives with care; they should be fine.

KEEPING TRACK OF PHOTOGRAPHS

Up to this point, I've discussed organizing photographs in your office in order to find them easily to send out or to return them efficiently to the files. But being organized also requires proper shipping lists, some of which are referred to as delivery memos. You may also photocopy slide sheets and duplicate many of your best pictures for multiple sales or protection if the originals are lost or damaged.

THE SHIPPING LIST

Since I market my stock photographs mainly through stock-picture agencies, when I send them pictures I don't include delivery memos meant for prospective buyers of photographs. (See Chapter 7 for complete information on creating delivery memos for listing photographs sent to a client and on the legal and business value of the

delivery memo). Instead, to have a record of every slide or black-and-white print I send to an agency, I type a shipping list on my computer using a word-processing program.

At the top of the shipping list I print my name, address, telephone number, and the date, or I print a short list on my letterhead. I prefer printing lists in fast dot-matrix mode so using fan-fold paper is easier than using my stationery. Each list has a heading, such as "Slides sent to XXX Agency." Slides are listed this way:

Roll 655:
2-7: Homeless man asleep in park in Los Angeles
11, 14, 18: Art show on lawn adjacent to La Brea Tar Pits, Los Angeles
22-27: 1906 antique Franklin car, Wilshire Blvd., Los Angeles
30-33: Crowd and police officer looking at antique car

Roll 656:
3-8: Pattern of sailboats, Catalina Harbor
11-19: Horsemen returning from campout, Catalina
23-28: Activity on beach at Isthmus, Catalina

I also included any information that will help an agency or client understand the essentials about a photograph. There is usually more caption material on the shipping list than I can cram onto the edge of a slide by hand. However, with a computer-labeling program you can include more than you can by hand, and with some programs the captions can also be printed out as part of a shipping list later.

Film rolls are listed in numerical order, as are slide-frame numbers, making them easy to check. A list may be as long as necessary, depending on how many slides you send at one time. At the end of the list I record the total number of slides being sent. A copy of the shipping list goes in my files, and another is sent with the photographs to the agency, which is happy to have the additional information. After the agency chooses the pictures they want for their files and returns the rest to me, I circle each returned picture on my shipping list. In this way I have an ongoing record by picture number of which slides (or prints) are on file at a specific stock agency and which are in my files.

With your shipping list on a computer disc, it is easy to delete the file numbers of pictures kept by one agency, add more slides if you wish, change the name and date, and print up a new shipping list for another agency. The work you do originally in tabulating all the numbers and descriptions pays off each time you make a revised list.

As I compile a slide shipping list, I either insert the slides in numerical order in plastic pages, or I stack the slides in returned Kodachrome boxes. Some agencies prefer to get slides in plastic sheets, others in

boxes. Both ways work, so just follow the agency's recommendations. The boxes are numbered and can be unpacked in the order they appear on the shipping list.

An agency returns some of the best slides for a variety of reasons, including: 1) there were too many of a subject, and the agency held the ones it liked best; 2) the subject wasn't needed for the agency files; 3) the agency wasn't excited by the way the photographer took the picture; 4) the lighting wasn't ideal or the photographer could've waited for more activity in a street scene; or 5) there was no model release, and probably no market without one.

After I've sent slides to the several agencies I deal with, I file similar shots of choice pictures along with returned slides in plastic pages in notebooks. For years I've been choosing illustrations for my books, articles, and competitions from my stock files of slides and prints.

PHOTOCOPYING SLIDES

Another thorough and satisfying way to keep track of slides sent to clients or agencies is to photocopy 20 at a time in a plastic page. Lay a page on the translucent glass of a copy machine. Then place a sheet of transparent plastic about 1/8-inch thick over the plastic page to hold it flat. Mount a 250-watt photoflood above the copier; this transmits light through the slides during the copying process. (Leave the top of the copier open, of course.) The copy you make includes a recognizable facsimile of 20 images and all the caption material appearing on the front of the slide mount, which is face down on the copier. Adjust the contrast setting on the copier to determine how far above the slides the photoflood should be placed. After you zero in the settings, making a series of copies is easy. I'm told that desktop copy machines that make satisfactory slide-page photocopies are the Canon PC3, PC4, PC10, and PC24 and the Ricoh Ripro, Jr. One last point: Black-and-white copies of slide pages are a good pictorial record for you, but you still need a shipping list with its slide numbers and additional caption data to send agencies or clients along with a delivery memo.

MAKING DUPE SLIDES

Duplicate 35mm transparencies were once frowned upon because their quality didn't compare well with originals. Now good *repro dupes*, or slides duplicated for reproduction in print, are hard to distinguish from originals, and stock agencies and photographers often dupe their best chromes for very practical reasons.

- After a dupe is made, the original slide can be filed and isn't readily subject to loss or damage.
- Dupes may be sent or shown to clients, on your own or through an agency, which also protects the originals. If a client insists on using an original, it can be leased if the fee warrants it and suitable insurance is assured. The insured value of a dupe is less than that of an original.
- An agency may submit dupe slides to branch and subsidiary agencies all over the world for lease to markets that don't compete with each other. This practice extends the income from individual images.
- Dupes are excellent for projection in audio-visual shows and as part of your personal portfolio. Prolonged projection, as you know, can fade a slide eventually.

You may have heard that "the best dupes are made in the camera." This means that when you have the opportunity, you should shoot numerous exposures of all picture situations you feel have top-notch pictorial quality. Wherever you are, whatever you photograph, it is a smart and profitable habit to take a lot of pictures from different angles, with different exposures and different lenses, in various types of light. I've always believed that *quality comes from quantity*. Within reason, the more variety you can shoot in a situation, the more your creativity will be engaged and the better the odds are you'll get salable images. By shooting plenty of originals, such as five or more of the best situations, you save time having dupes made later and satisfy clients who still prefer originals. Even if you sell stock entirely through agencies that regularly dupe your best pictures, they may want in-camera similar shots for their files. Remember, film is cheap compared to the time and effort you invest in taking pictures.

Some stock-picture agencies refuse to submit original slides to clients in order to protect the originals; the agencies often maintain that their dupes are of equal quality. Agencies either run their own duplicating department or arrange with a good professional lab to make repro dupes. A professional duping system uses a machine, such as the Repronar, with a camera mounted precisely over the slide that lies on translucent glass; under the glass is a properly diffused electronic-flash unit. Dupes are made on Kodak duplicating film that has reduced contrast or on Kodachrome that can be used with flash and may be slightly prefogged to reduce contrast. Because many clients prefer Kodachrome, individuals, labs, and agencies may work out their own techniques for making dupes on it.

Inquire about the duping services offered by labs you know, or ask about Kodak dupes at a local camera shop. Professionally made dupes

may not be cheap, and repro dupes are more expensive than nonrepro dupes. Ask for samples and rates from any lab you might use.

To make your own dupes without buying expensive equipment, you need a 35mm SLR camera with a macro lens or a reversed 50mm lens that focuses 1:1, a stand or tripod for the camera, a slide holder with translucent glass or plastic behind the slide to be copied, and a portable electronic-flash unit. You have to be able to reduce the output of the flash so that you can place the unit about 12 inches behind the slide. Exposure tests will give you good dupes, although it can be difficult to frame a slide perfectly and to achieve sharp focus when depth of field is so small. I use a homemade duping setup similar to the one described here to have a record of my best pictures and for projection. Moderately priced duping equipment is available from Spiratone, but I haven't tried any of it. I feel that a reversed camera lens or a macro lens provides better quality than duping equipment with its own lens. Note: Repeated handling may leave fingerprints on slides, and they can be removed with a professional slide-cleaning solution. I recommend PEC-12, an emulsion cleaner (see the "Resources" list on page 187).

Some picture agencies and photographers enlarge prime images to a 70mm format using 120 film. This larger format protects original slides and is impressive for presentations. I am familiar with the owners of a service called Superdupe and trust its craftsmanship. Inquire locally about 70mm duping service as well.

EDITING AND ORGANIZING YOUR PICTURES

Only the best images are good enough to compete in today's stock-photography market. Edit yours carefully, and eliminate the near misses. Sometimes near-miss slides can be given to models you promised pictures to. Be sure to give the models written permission to allow prints to be made of your copyrighted work. Ethical labs won't make personal prints without the photographer's okay.

The better your editing is and the better organized your filing and delivery systems are, the more professional an impression you'll make on everyone. So it is important to devise a numbering, logging, and filing system that fits your tastes, your type of pictures, and your business volume. Do some research and question other photographers as to how the organize their work. Be sure to caption slides succinctly; add more data on your shipping list if necessary. Too much data is preferable to too little. Finally, duping slides is an art. If you expect to do a lot of it and want to keep costs down, it is worth buying equipment and experimenting until you do it right. Otherwise have dupes made by professional labs.

6 MARKETING YOUR OWN STOCK PICTURES

"Should I sell my own stock photographs? Or should I connect with one or more stock-picture agencies to do it for me?" That question is asked by every photographer who contemplates shooting and selling a collection of stock images, as well as by those who have too few pictures yet to market. The answer depends on a number of things, such as your interest and aptitude in selling, how serious you are about shooting stock, and whether you'll enjoy shooting the kinds of pictures that agencies can sell in addition to the kind you like to take.

SHOULD YOU SELL IT YOURSELF?

Some photographers are really cut out to sell, and some can't face selling because they don't like rejection. Some are less interested in seeking markets than they are in shooting; that is my position, so I work with several agencies. But I know numerous photographers who enjoy the challenge of creating their own stock-picture assignments. They continually build their files, make client contacts, negotiate rights and fees, and welcome being in charge of their own stock business. They believe they'll learn better what to shoot if they're directly involved in selling. Some are reluctant to be tied down by an agency contract and also want to avoid having their images in competition with hundreds or thousands of other photographers' pictures in agency files.

Some photographers have found that their specialties will attract buyers directly without agency affiliation. John Shaw, noted for his wonderful closeups of nature, says, "Basically, all nature photographers today are running their own one-person stock businesses." Such individuals prefer to maintain personalized files and also do what is necessary to promote themselves in the marketplace.

There are also some negative aspects to selling stock photography directly to clients. According to photographer and agency co-owner Grant Heilman, "You can't expect to work profitably in the stock business without a huge existing file of pictures. For a while you won't earn enough to pay for film, but look ahead: the rainbow is there if you're dedicated to details and you can wait for the payoff. Keep in mind that stock photography is very competitive, so quality is vital and creativity is important." He indicates that while you're establishing your stock file, if you let an agency handle sales, you'll be able to shoot more, be less involved in time-consuming details, and have a better opportunity to work at another job while you build your business.

Walter Hodges, whose advice about shooting planned stock setups is quoted in Chapter 3, sells through two agencies, giving each separate images, and is certain he earns more this way. He says strongly, "Don't sell your own stock unless you have a staff to support the function. You need to shoot. You can't make money selling. If your wife or husband can sell, file, track, and all that, then you might give it a try. Personally, I'd rather go fishing."

KEEP THE WHOLE FEE OR SPLIT IT WITH AN AGENCY?

In theory it is refreshing to know if you lease a picture directly to a client that you'll earn the whole fee while a stock agency making the sale for you usually takes half of the money. But that isn't the whole story. Besides payment for shooting time, your income also pays you or an assistant for finding picture markets, sending work to clients for review, filing the images when all or some are returned, negotiating fees, and billing clients, perhaps more than once when they're late paying. Lost or damaged slides leads to additional work and headaches. The overhead of an assistant and the expense of promoting your pictures with mailing pieces or advertising are also expenses, so you aren't keeping the whole sales price of pictures.

While specialists in stock subjects probably net more by marketing their own pictures than by selling through an agency, they work harder handling all their business operations and have less time to shoot. As

such it is an illusion to believe that you'll do twice as well financially by not sharing fees with an agency. Choose to market your own work for the independence and control it offers and for the satisfaction of developing personal contacts in the marketplace.

THE KIND AND QUANTITY OF STOCK YOU SHOOT

The subjects you photograph should help you determine how you want to market your work. Those who specialize in photographing animals, babies, or flowers, for instance, can market their work *directly* to clients with more ease than those who shoot a large variety of subjects. Why? It is simpler to monitor the needs of markets for specific pictures than it is to sell all over the client spectrum. A friend who is noted for his pictures of professional football says buyers are more likely to contact him. He regularly sends lists of new material to clients, and with an assistant to fill requests he can spend more time planning and shooting. When the football season is over his pictures continue to sell for the next season, although he switches to shooting many species of snakes, toads, and lizards. Some of these creatures are kept in crates near his office, and pictures of this second specialty are starting to do well, too.

The number of pictures in your files may also help you decide whether or not to sell them directly. Photographers with a vast number of slides or prints may be more comfortable if an agency handled their work in order to spend more time taking pictures. Prolific shooters could choose to hire an office assistant to deal with marketing, which they can oversee while they stick to photography.

Photographers with a small file of pictures, such as 1,500 or 2,000 slides, might give their images more personal attention by self-marketing. Once they build their files further, they might turn some or all of the marketing over to an agency. However, full-time stock photographer Mark E. Gibson says, "We mostly sell our stock directly because I am very ambitious at marketing. We do have about 21,000 slides with two agencies, but income from them is only about 15 percent of our gross."

On the other hand, part-time shooters may be happier to make agency connections immediately, depending on their aptitude in finding markets, promoting themselves, and negotiating business arrangements. However, while a dependable agency can be comforting, a satisfactory agency alliance is usually more difficult for the part-timer to find. One agency owner told me recently, "An agency may only do a fair job of guiding some photographers about what to shoot, and it often doesn't give them much feedback about their images. Photographers will find that guidance and feedback depend on their importance to the agency. The more you shoot

and submit and the better your pictures sell, the greater the attention you get. As an alternative, being dependent on your own resources may be scary at first, but it will prepare you for a more independent future."

Selling your own stock photographs means having less time to take pictures and research markets in order to be aware of what's being published. Self-representation also means you need marketing guides, as well as negotiating and promoting techniques. Remember, whether you sell stock yourself or through an agency, you must be a self-starting individual to be successful. Consider your own needs and abilities objectively. Finally, you can sell stock yourself and also have an agency selling it for you, if you learn to avoid the inherent conflicts. (See Chapters 12 and 13 for different opinions on this issue.)

SALESMANSHIP AND BUSINESS APTITUDE

Marketing stock images means selling yourself at the same time. Selling directly to clients, you're knocking on unopened doors by telephone, mail, or in person; dealing with strangers; and representing yourself as well as your pictures. If having to do these things makes you uncomfortable, connecting with a stock-picture agency might be a better option. But if you like meeting and talking with people, researching your own pictures, sending requested pictures out, and can make decisions without anguish, selling your own stock should suit you well.

Selling directly, you may negotiate your own fees rather than accepting fees an agency negotiates for your pictures. That requires standing firm and sometimes risking the loss of a sale when dealing with a buyer who wants your work on a cut-rate basis. In such a case a stock agency should have more clout than an individual, but that isn't always true. Agencies are known to discount pictures to steady users "because they buy so many a year." On your own you might also choose to favor a frequent client price-wise, but the decision is yours.

Being in business for yourself gives you more control over the rights you license, which influences your fees. "I know what my work is worth," a well-known shooter told me, "and I hold out for fees that fit the rights I'm leasing. If I choose to compromise, I have good business reasons and I'm accountable only to myself. I used to sell through XYZ agency and while it had respect for my pictures, it also had a huge overhead. It licensed some of my best chromes for a lot less than I expected because it didn't try hard enough. The agency would say, 'We'll sell those same pictures more often than you will,' and that is true; volume makes a difference, but I still receive only half of the money it collects."

If you prefer to handle business details, negotiate sales rates and rights, and feel you can protect ownership of your work better than anyone else might, selling your own stock may be right for you. Success requires drive, an organizational talent, convictions about the quality of your work and what it is worth, and an ability to handle such details as filing and filling out delivery memos. Freelancing in any creative business takes determination and character that can withstand what I call living in "permanent insecurity."

EDUCATING CLIENTS

While selling your own stock, you'll need to constantly educate clients about the value of photographic rights and the differences in photographic usage. Education includes informing buyers about the meaning of copyright and explaining the reasons why you're asking a higher fee for a specific use of stock pictures. Clients are often on a company payroll with directions to get your pictures for as little as possible. Large or small, stock users will complain to you about having a "tight budget." Sometimes business discussions become confrontational, so the kind of tact and salesmanship you use, combined with your self confidence, experience, and aptitude at negotiation, can help determine your success. Your personality should be tuned to win friends and influence people without being exploited.

It is amazing how you can establish a rapport with an art buyer at an ad agency, book publisher, magazine, or any other user. And just when you're feeling a little smug about receiving stock requests regularly, that person is transferred or fired. Along comes a new art buyer who may like your work but may have other favorite stock suppliers already. Even if you continue to sell to the company, the new contact may have to be educated about the value of a photograph so what you've been charging won't be lessened. Diplomacy and skill are valuable ingredients in your approach, especially when you sell your own stock. The goodwill and relationship you develop with picture buyers will produce repeat sales and motivate them to remember you when *they* move to a new company and have stock-photography needs.

But be aware that someone may try to stretch your goodwill to undermine your rates or rights on the basis of friendship. A class in psychology or in negotiating can help you deal more effectively in the business world and give you more confidence. Even with training, trial and error will teach you a lot about how other people think and act in business deals. You don't want to be known as a hardhead or an easy discounter.

WHO DO YOU WANT TO SELL TO?

Answers to that question will depend on what subjects you like to shoot as well as your photographic style or approach. Analyze your photographs and the markets you've sold to previously or the ones you'd like to attract. Consider your visual and personal interests. What kind of pictures and subjects do you like to shoot most? What do you dislike shooting and want to avoid? Would you prefer to set up subjects and concentrate on markets for them?

If you think and shoot in a kind of journalistic style, selling to magazines, newspapers, books, and some industry annual reports should be your goals. There are all kinds of publications in the editorial field, and many unposed pictures don't require releases because they are newsworthy or educational. Become familiar with as many potential editorial markets as possible, study magazines at the library, look through textbooks, and note the variations of stock images. Setup shots showing, for example, babies, gardening, or couples in addition to nature and travel subjects are popular with these buyers.

If you enjoy studio shooting with lights, props, and models, advertisers would be ideal clients for your work. People in everyday photographic situations can also be set up on location, using portable fill lighting and reflectors. A typical picture may show a grandmother and a grandchild enjoying a leisurely afternoon in a park or backyard. Illustrative pictures that tell a minor story and are symbolic of everyday life situations are popular stock subjects. Stock prices for advertising are higher than editorial work, but competition in the ad field is greater. Releases are necessary for recognizable people, pets, and some types of homes and buildings (see Chapter 11).

If you are good with people and like technical subjects, targeting corporate markets would make sense. Annual reports, brochures, company newspapers, and sales-promotion shows using slides with music and a soundtrack are common stock uses. There may be hundreds of companies in your area and farther away that regularly want only stock pictures, and they may be easier to find than major advertisers or more distant editorial clients.

If still-life or architectural subjects are your favorites, advertising, editorial, and corporate could all be markets for your stock shots. When you look through books and magazines note the variety of these subjects, which may have come from stock files. If you prefer shooting nature, animals, landscapes, seascapes, and what may loosely be called travel photographs, markets for stock are magazines, books, some advertisers and corporations, as well as greeting-card, calendar, and

poster publishers. However, thousands of part-time stock shooters concentrate on outdoor subjects, and one buyer told me, "I won't even look at another shot of the Grand Tetons unless it is excitingly moody or dramatic or something I've never seen before. Mountains or national parks are in the public domain, they're sitting ducks, and stock files everywhere are full of them. Some travel subjects *are* hard to market, but if you are original and resourceful enough, your efforts might prevail."

Photographic flexibility is more than desirable, and it is often necessary to shoot numerous subjects that appeal to different markets. Capitalize on your own pictorial strengths and talents for profit.

SENDING OUT STOCK-PICTURE LISTS

Stock agencies often send catalogs of photographers' pictures to thousands of prospective and current buyers. An individual can't afford such an expensive sales practice, but there are several ways you can compete in the marketplace. It can be helpful to generate a picture list showing prospective buyers the kinds of images you have to offer. Printed out on your business stationery or on a letterhead created with your word processor, such lists can be updated regularly. Date the list, and give it a heading, such as "new stock pictures." Consider categorizing the list with such headings as "science," "city life," or whatever fits your needs.

After new pictures are listed, you may repeat older ones under a separate heading because the most popular images sell over and over. Grant Heilman told me that his black-and-white shot of Pemaquid Light on the coast of Maine amassed 103 sales over more than 20 years. It was still selling after he offered a similar picture in color. Other photographers also enjoy good sales records racked up by distributing lists of universally needed subjects over a long period.

This short sample of items on a picture list is from my files:
- Red barrel cactus flowers in bloom, Joshua Tree Nat'l Mon.
- Swarms of painted lady butterflies, Coachella Valley, CA
- San Gorgonio Mt. with snowy peaks, Riverside Co., CA
- Airport tower and airliners, Palm Springs, CA
- Pacific Design Center, Los Angeles
- Women in old-fashioned dresses, birthday party, park in Los Angeles
- Los Angeles downtown skyline just before sunset
- Construction equipment at road repair site, Redlands, CA.

You get the idea. If you send one or two pages with recent additions to your stock file, potential clients will welcome them. Sending a lot of pages to impress clients may overload them, but experiment and find

$1,950-per-page price. *Stock Direct* is distributed free to about 20,000 firms, such as ad agencies, publishers, public relations, and design companies. The publishers of *Stock Direct* seem to understand the needs of photographers and buyers as well. (For information on how to contact these two catalogs, see the "Resources" list on page 187.)

PROMOTIONAL MAILERS

These may be 8 1/2 × 11 individual sheets of quality paper printed on one or both sides with some of your choice stock images. Some mailers are folded in various configurations. Your name, address, and telephone number should be included along with a short sales pitch if you wish, such as, "The finest images of America's rivers and lakes." If hiring a designer is too costly at first, make your own layouts and rely on a good printer for advice and direction. When you get cost estimates on printing your mailer, remember that all printing quality isn't the same.

The expense of promotional mailers may seem high because you need only a limited number at one time, perhaps just a few hundred. But self-promotion helps you compete, and you may reduce the cost by arranging with the printer to use your mailer for his or her own promotional advertising, complete with imprint. If the printer is agreeable, the cost should be cut or eliminated in an even trade. If that isn't feasible, you may get more reasonable printing charges by promising to come back in four or six months with another order. Sending mailers at regular intervals is a good practice, even after you get yourself established, especially if your sales efforts are aimed at ad agencies. Plan a promotional campaign you can afford over a one- or two-year period. This could more than pay for itself in sales.

CASE HISTORY OF A SUCCESSFUL MAILER

Stock photographers Vince Streano and Carol Havens wanted to produce a mailer that had intrigue and staying power, not something that would be looked at once and thrown in the trash. Their campaign consisted of four 5 × 7 images mailed several days apart. Under each image was a question relating to it. The first photograph featured an Oriental woman with the question, "Where in the World Do You Find Quality Stock Photos of Foreign Locations?" To amplify the intrigue they sought, there was no indication of who sent the card. The answer was revealed with the fifth card, which contained all four images from the other cards. It arrived a week and a half after the first mailing.

Responses to the Streano/Havens promotional cards ranged from "very clever," to "different," to "uniquely creative." Following their long experience, this photographic team was careful that each image "accurately represented our files." The final card included a listing of the kinds of stock photographs they offer, and a week later they sent a letter that contained some of their background, a short client list, and more about the stock they had available. The initial mailing was a carefully selected 150 potential buyers in an industry-oriented, one-county business area. They received an excellent 18-percent response rate. And later when they sent the same promotional cards nationwide, the response rate was 26 percent. In all, the couple figures they increased their client base by 20 percent for an investment of about $6,000. "The results more than paid for the campaign," says Streano. "Some callers asked for images right off the cards."

SHOWING PHOTOGRAPHS TO BUYERS

Responses to your picture lists, promotional mailers, or personal letters will usually come by telephone or mail. Typically, requests will be fairly specific. Listen carefully and make written notes to clarify the order. Mention your rates and rights if the buyer doesn't ask, in order to avoid misunderstandings later. Choose pictures carefully. Send a few similar pictures when you have them in order to give buyers a choice.

Editors and art directors appreciate the opportunity to make selections. But they'll be annoyed to receive material that's unrelated to their needs. If you're asked for good shots of the Canadian Rockies, unless you query ahead of time and know that it is okay, don't send images of the Rockies in Colorado as well or instead. It is smart to find out how extensive the buyer's needs may be, so you may suggest photographs the buyer didn't think to ask for. For instance, if the request is for "children playing a game," find out if the client wants an indoor or outdoor setting, and how many children would be ideal. Does the client prefer an action game or a card game?

Remember, your talent as a photographer isn't everything. You have to be a communicator as well. Clients value tactful, friendly communications and they're usually rushed, so be systematic and friendly. Save chattiness until you know people better. These suggestions come under the heading of *enlightened self-interest*.

Be sure that your name and copyright symbol are on every slide or print (they can be on the back). When you type out a sending list, add more caption data where necessary. Carefully log each photograph by

file number. *Never* neglect these steps in haste. Being thorough is a form of business insurance. The good records you keep may save your business reputation and can add to your profits.

PACKING AND SENDING

There are various ways to fill out a delivery memo for pictures (see Chapter 7). Briefly, pack slides and prints well to avoid damage and then with a delivery memo, send them by insured or registered mail or an overnight-express service. If you use the United States postal service, buy a return receipt. Become familiar with insurance specifics for the carriers you use. Find out if the insurance you pay for covers replacement value of the pictures up to the limit you set, otherwise the carrier will try to re-evaluate your pictures. Some carriers offer a $100 insurance limit unless you pay for more. If you use a mailing service to send your work by UPS or another carrier, determine who is responsible in case of loss or damage. The mailing service deals with the carrier but may say that it is only your agent, while the carrier may ignore you and deal only with the mailing service. Try to avoid such Catch-22 situations.

The best evidence you can have in case of loss, damage, or unauthorized use of pictures is paperwork. This includes a delivery memo, shipping lists, and delivery receipts. I once sent several dozen slides to a large magazine at its request, and when it claimed that my package never arrived, I sent a copy of the United-States-mail return-receipt form that someone in the office had signed. The magazine didn't deny receiving the pictures, but said that they were mislaid during a move. The magazine finally found the package buried under other items, but if it hadn't, I had solid proof the delivery was made. An important warning: *Never send unsolicited pictures to any prospective stock user.* Anyone receiving unsolicited pictures isn't responsible for them. With your copyright symbol on each picture, the shots can't be legally reproduced, and if they *are* reproduced, you can collect damages. But unsolicited pictures may be thrown away, carelessly or on purpose. Paperwork is your protection. Your valuable stock photographs should never leave home without it.

Suppose that you've contacted a buyer with a list, letter, or promotional material, and you get a telephone call asking for specific pictures. The pictures *are* solicited but the company may be unknown to you, so ask for a faxed request in order to have something in writing. If you have no fax machine, try a fax service nearby. If time permits, ask for a letter request. You can say diplomatically that since you don't know the client, you've been advised to get something in writing.

7 THE BUSINESS SIDE OF SELLING STOCK

This chapter gets down to the nitty-gritty of stock-photography business practices: negotiating and setting fees, copyright, protecting rights, and making the most of paperwork. As one photographer told me, "There has to be a paper trail that tabulates what you're sending and substantiates your fees as well as the replacement value you put on the work. Everyone needs to keep good records to stay in business, and it is easier today because of computers."

Although I assume that average stock photographers who sell their own work or market through an agency, run a solo operation, most of the information in this book applies even if you have an assistant or a staff. As stock files multiply and your work is in more demand, you may need help in the office or while shooting, but wise business techniques stay the same. Success will make you more inclined to remain firm when negotiating fees and protecting your rights. Being part of a team can be a very satisfying arrangement. Talk to an accountant so business benefits are assured for you now and in the future.

HOW MUCH SHOULD YOU CHARGE?

You may be quite familiar with this fundamental, but I'll repeat the primary business principle of "selling" stock: *Ideally, you lease reproduction rights; you don't sell the actual images, which must be returned to you after use for further leasing.* Legal permission to print your pictures is governed by the rights you lease. Charging for usage and setting time limits have been long practiced by photographers as well as writers and composers. For example, Cole Porter licensed only

limited rights to his song "Anything Goes" to a record company. He also licensed rights for sheet music, for a motion picture, and for use in other media. He retained ownership of the copyright to the music. He leased usage rights, which is logical and financially sound.

The same reasoning applies to leasing or licensing the use of stock photographs. You own the copyrights, and you should benefit each time images are reproduced—no matter where. Cole Porter and many other creative people earned a lot of money licensing their original and often unique work. You are creative with your camera, as well as your visual talent. So when I talk about "selling," I mean leasing or licensing pictures that I continue to own. Only in rare cases does a photographer actually sell an original picture for exclusive usage, and then the fee is usually many times what it would be had the picture been leased.

Would it seem desirable if the reproduction fee for your photograph of a sailboat gliding full tilt through ocean waves, complete with a handsome background of blue sky and white clouds, was determined through continually updated data sheets supplied by The Union of Photographic Price Setters? Of course there is no such outfit for legal and practical reasons, but if there were, perhaps a visually superior image and a more ordinary one would have to be sold for the same price. Uniform pricing tends to ignore the special merits of pictures that aren't all equally appealing or exciting.

Deciding what to charge for stock photographs in a free market has its risks. When you're pricing for usage, keep these criteria in mind:

- Where and how the client intends to use the photograph
- Whether the picture is for advertising, editorial illustration or other usage
- The uniqueness of the picture
- The client's budget or prevailing rate of payment
- The publication's circulation
- The length of time the client needs the photograph
- The time and expense you've invested in getting the shot.

As you consider these basics individually, remember you are a businessperson as well as a photographer. Also keep in mind that it is normal to be overanxious in the beginning. You want to see your pictures in print, so when a buyer calls and asks how much you charge for that sailboat shot, you may undercut yourself by quoting too low a fee. Being overeager can result in charging too little, but you'll soon discover that it is all right to talk about money and to ask a fair fee based on the criteria listed above. Keep in mind, too, that the buyer isn't doing you a favor. Your photograph is needed for a specific place in a

publication, a poster, a greeting card, an ad campaign, or whatever. Photography may still be a serious avocation for you, but to the buyer it has commercial value.

HOW IS THE PHOTOGRAPH GOING TO BE USED?

On the surface this may appear to be a simple question, but it isn't. There are many facets of usage for you to investigate before you come up with a price. These include:

Type of medium. Whether you lease to a newspaper, magazine, brochure, or poster influences the charge for usage. Rates for advertising use are higher than for editorial because in advertising, stock pictures occupy space purchased by companies to influence people and make profits. The same is true for stock images in annual reports and business brochures. For editorial use in a magazine, however, the value of a photograph is determined by its size and uniqueness as part of an article or other spread.

Size of the final image. Another important consideration is the size the image is going to be used. The base for usage of photographs is considered a quarter page and one-time use, and other rates are established from those figures. A use smaller than a quarter page is usually billed at the quarter-page minimum.

Circulation. Fees charged for use of a photograph in advertising also depend on the circulation of the magazine or newspaper. Many national magazines print regional editions, so the advertising fee for use of a chrome nationally in *Newsweek* is higher than if it's used only regionally. For instance, because *Newsweek*'s circulation is more than 3 million, you might ask $2,500 to $3,000 to use a picture in a national-edition full-page ad. For the same picture in the same ad in a regional edition with a circulation of 1 million, the usage fee might be $1,500 to $2,000.

The circulation of local, regional, and trade magazines is usually less than national publications and fees are lower. For instance, in a full-page ad for a local magazine with a circulation of 300,000, the stock fee may be $850 to $1,000. Stock prices for newspapers, also based on circulation, are a little lower than for local magazines.

Frequency of use. An advertising photograph might be licensed for one year or six months, with an option to renew for an additional charge. Editorial pictures are usually sold for use in one issue of a publication, which ordinarily appears within six months. The number of times an ad is used also influences stock-picture fees. In *Negotiating Stock Photo*

Prices Jim Pickerell recommends that 20 percent of the asking price should be tacked on each additional use, though this is negotiable.

Editorial usage. There are consumer magazines, the ones you buy on the newsstand or subscribe to, as well as internal and external house organs that may resemble consumer magazines and are published for employee and customer communications. The larger its circulation, the more a magazine should pay; however, some with large circulations pay almost the same as smaller magazines because market conditions are competitive and payment policies are inconsistent. Inquire about a magazine's page rate as a basis for quoting a usage fee and refer to *Negotiating Stock Photo Prices.*

Some photographers feel that being seen in a well-known publication is partial compensation for accepting lower fees that might be offered. Editors may try to reinforce that theory. In *Negotiating Stock Photo Prices* Pickerell says a stock agent told him that "with magazine fees failing to keep up with inflation . . . a photographer should be prepared to accept lower fees and use the magazine as a shop window in order to get other work." He says he "totally disagrees with this position," and my experience indicates he is absolutely correct. Pickerell states that publication in a news magazine, for example, may get you calls from other news magazines paying equally low rates, but it probably won't get you corporate work or advertising inquiries.

Unless your work is published consistently in various magazines and/or you are a specialist in such subjects as hard-to-get wildlife or high-tech shots, occasional photographs even in the best magazines will rarely result in calls to see more of your work. Only when editors see one of your pictures published and need the same or a similar subject immediately are they likely to contact you. Otherwise, they may admire the work and forget it simply because it is part of the vast amount of imagery they see weekly. The next time they need stock they'll call someone they know or a favorite stock agency. Of course "favorite" photographers and agencies are subject to change, which means when you're established you can expect more unsolicited requests for stock pictures.

So accepting lower fees in return for exposure in print as a means of self-promotion is an illusion. Remember, too, that advertising photography is rarely credited. You can't deposit credit lines in your checking account or use them in the grocery line. However, if you're just starting in the stock business and credit lines will help build your self-confidence, decide how much the boost is worth to your ego. Set a limit on discounts for picture credits. Whenever possible hold out for what you feel is a fair fee, and don't be seduced by promises of prestige instead of enough money.

Uniqueness of the picture. You should charge more for hard-to-get photographs than for more common ones. For instance, if you have unique or unusual photographs of an event, person, or place, add a premium to the fee. Rarity is always worth more money.

Time and money you've invested. This can be tricky because you may shoot hundreds of pictures on a trip or location, and they could be valued equally in terms of your investment. However, should you make a trip to a distant place you can add a surcharge to stock pictures to help pay for time and expenses especially when the images are unusual and more difficult to get.

UNDERSTANDING REPRODUCTION RIGHTS

The rights you lease help determine the fees you charge. Those fees are stated on your delivery memo, which also requires that all photographs be returned to your files after use. That stipulation includes prints, which a client may say aren't one of a kind as slides are, but you want them back to avoid someone using a shot found in a company file without bothering to inquire about rights. The definitions of reproduction rights that follow were developed over the years by ASMP and through my own experience.

Exclusive rights. The photographer leases the right to reproduce pictures for a specific time period, for a geographic area, or for a type of use, such as billboards. During the proscribed time you agree not to grant rights to the same or similar pictures to any other client. For example, you might lease exclusive rights for a shot of a man running in a brand-name shirt for a year or more to the shirt manufacturer, or you might also allow a greeting-card publisher exclusive use of a specific image of flowers for a certain time period. Other variations include licensing pictures for posters only, or for use in other countries. There are lots of possibilities in advertising especially where clients want product protection.

Fees for exclusive use are higher than for one-time rights. But when a client wants a shot exclusively, Jim Pickerell suggests, "The price is very open to negotiation." He says that a one-year exclusive fee justifies a 300-percent increase over the normal rate. For example, if the standard one-time fee is $1,000 for a picture, exclusive use for a year would be $3,000. This percentage increase is a guideline. During negotiation the price would be based on the image, the client, and other factors. You also could arrange exclusive rights sale to a farm scene, for instance, for an ad only. This would allow you to lease the same picture to an encyclopedia which isn't competitive and isn't published at the same time.

One-time rights. This is the most common arrangement between clients and stock photographers. Pictures are leased for one reproduction in one language in one edition of one publication in a specific distribution area. You might sell the same scenic shot to a postcard publisher for one-time use, and lease it soon after to a noncompetitive market, such as a bank-check manufacturer.

Electronic-reproduction rights. Leasing pictures for use on television can be limited in the same way as they are in print. Find out the areas of distribution (national and local), how long the client wants to use the images and make your agreement accordingly.

A more recent application of electronic reproduction is the inclusion of still photographs on a CD-ROM disc used mainly as a catalog by stock-picture agencies (see Chapters 8 and 10). The *ASMP Stock Photography Handbook* has an excellent section on the new technology, which points out the potentials of new markets and the perils of keeping track of images once they are in a computer's memory.

Buyouts. This means full transfer of all rights from the photographer to the client, including copyright. Buyouts can also mean sale of specific rights, rather than all rights, or of all rights for a limited time or area. Buyouts are most often associated with advertising usage, and the fees are much higher than for one-time rights.

All rights. This means leasing rights with certain limits such as time or distribution areas, but doesn't mean transfer of copyright. If you make such an agreement and are paid three or four times the normal rate, be sure there is a stipulation that copyright remains in your name.

PRICING PRACTICES

In the past ASMP has surveyed its members to find out how much they charged for various uses of stock pictures. The first edition of the *ASMP Stock Photography Handbook* (1984) included pricing tables summarizing survey findings that are now somewhat outdated. In the second edition (1990) there are no pricing tables because an up-to-date survey hadn't been made. A note explains that stock prices don't appear because "it became apparent that many new categories of stock usage had come into the marketplace since the publication of the first edition of this book." If that seems disappointing to you keep in mind that the market changes, and prices reflect the market. ASMP's 1990 edition encourages you to make your own pricing chart, and for this purpose includes an appendix entitled "Self-Determined Price Lists." Here, you can fill out your own

data in many categories. "The well-prepared stock photographer or agency makes use of similar charts as a guide to pricing," the appendix explains. These price-list forms are also available on computer discs for IBM-compatibles or Macintoshes, making them easy to fill out and revise (see the "Resources" list on page 187).

Negotiating Stock Photo Prices was first published in 1989, and author Jim Pickerell recently updated it with a valuable 24-page supplement. I strongly recommend this slim book for the sensible pricing guidance it offers. Pickerell is a veteran in the field who sells some of his stock pictures directly, and also sells through a number of stock-photography agencies in the United States and abroad. He says his booklet is aimed at established professionals and developing professionals to give them a "starting point" for pricing, "as well as many techniques for carrying out successful negotiations." He adds, "I've provided a *framework* to help you develop your own numbers."

In a section entitled "Hazards of the Business," he points out, "there are a great number of potential stock pictures users who place a value on photographs that is less than the true cost of production and distribution. If the photographer consistently allows these people to set the price than setting it himself, he will soon be out of business." He adds, *"You need to learn when to say no to some clients, and seek those who will pay enough to enable you to make a profit and stay in business"* (the italics are his).

After notes about negotiating, a telephone price form, several helpful checklists, and data about Pickerell's base-number principle, the book reviews rights and gives some guideline pricing tables. Several professional stock shooters have told me they use his book as a basis for pricing, and it should be helpful to you. Since Pickerell distributes his book by mail, he can keep you apprised of new editions.

RESEARCH AND HOLDING FEES

A research fee may be charged by a photographer or stock agency to cover the time spent searching for and selecting images to fill a request. Many established photographers, says the *ASMP Stock Photography Handbook*, send a bill for research along with the photographs and the delivery memo (see page 85). The *ASMP Stock Photography Handbook* suggests photographers may charge $75 per submission, which helps cover administrative costs and discourages buyers who aren't serious. This fee is sometimes deducted if a sale above a minimum amount (often $200 to $250) results.

Charging a research fee should be based on the complexity of filling a request and your experience in the field. Beginning professionals may

wish to wait until they're better established, unless a request doesn't seem serious or entails a lot of extra work. If you make it clear that the research fee will be deducted from the sale price of pictures, clients will see that you're seriously in business.

Usually, a client holds pictures sent for review for two weeks without being charged a holding fee; however, photographers and stock agencies can't afford to have potentially profitable images remain out of circulation in the marketplace for unlimited time periods. Holding fees can pressure clients to make more timely decisions, and their use varies among stock agencies and photographers. After a stipulated time, a fee of $5 per week per transparency, or $1 per business day, may be charged. This charge should be stated in your delivery memo. In *Negotiating Stock Photo Prices* Pickerell says that most textbook publishers hold photographs "unusually long, and some companies encourage photographers to send dupe transparencies." Costs of duping could be unusually high; he adds, "greater than the total income you might receive from the sale of usage rights to textbooks."

How you handle holding fees depends on various circumstances, such as how a client may respond to reminders that you want a decision and the conviction you have about operating in a business-like way. Holding fees or research fees are optional but may serve you well to expedite inefficient buyers.

UNDERSTANDING COPYRIGHT

The copyright law is the primary legal device by which a creator proves and maintains ownership of published photographs. The copyright sign — © — on a slide or print warns others that they may not reproduce or exhibit the work without first getting permission and, usually, by paying for the rights. If a photograph has no copyright notice on it, it's still protected by the copyright law and by the Berne Convention, which doesn't require a notice to be placed on the work. Occasionally when no copyright notice is there, someone may not bother to contact you about rights or fees and may ignorantly assume that the picture is available simply because it is on hand. This can lead to headaches even if payment is offered later. It is good business practice to stamp a © on your work with a year date; if you ever have to sue, this is a distinct advantage.

The copyright law places ownership of pictures in the hands of the person who made the exposures unless there is an agreement in writing to the contrary. The main exception to automatic ownership by the creator is a category in the copyright law called *work-for-hire*, which

primarily covers *salaried* photographers. The law says employers own the copyrights to pictures taken by employees unless other arrangements are made in writing. This affects company photographers and isn't related to working with a stock agency. However, if a prospective buyer asks you to sign a work-for-hire agreement, you should know that you're handing over ownership and copyright to your work—and you should have a very good reason to give up future sales of a stock image. A huge sum of money is often a primary reason.

There is also *joint copyright*, which means that two or more individuals hold the copyright on a photograph. This would cover a team who shoots stock together. Only in special circumstances is a photograph part of a "joint work" even though it may be combined with other pictures in an ad or editorial piece.

Always label your slides and prints with a ©, the year, and your name. If you shot a picture several years ago and it has never been published, you may date it the year you first submit it for publication. The © notice may be handwritten, but using a rubber stamp is more efficient. The law says that the copyright notice must appear in a "conspicuous area" of the photograph to be valid. Either the front or back of a print or slide mount is suitable.

With or without a copyright notice, when you submit pictures you've taken and you own to a client or agency, the images are copyright-protected. If a publication fails to use a copyright notice with your credit when your pictures are printed, your ownership of the material isn't affected. Copyright of the publication itself also protects your pictures.

REGISTERING COPYRIGHTS

Although it isn't required, there are several good reasons to register your photographs with the Register of Copyrights (see the "Resources" list on page 187). Request Form VA from the Information and Publications Section and ask for Circular 1, called "Copyright Basics," which explains all the ramifications in clear detail. In addition to individual pictures or a collection (see below), Form VA can be used to register books, brochures, posters, postcards, advertising materials, and individual ads.

If your published photograph has no copyright notice on it and hasn't been previously registered, you have up to five years to register it. However, you must copyright your pictures within three months after publication if you want to collect full damages in case of infringement. "Copyright Basics" explains it all.

The fee to register a photograph is about $20, and you must send one copy of the work. Since you would go broke registering one picture at a

time, for convenience and economy unpublished slides or prints may be bulk-registered. (Published work is ready to send in a magazine or book, when you haven't previously registered the pictures in your own name.) For bulk registry, you can assemble a lot of slides in plastic sheets in a looseleaf notebook. Keep a concise list of all pictures by number for your own records, or make a duplicate notebook. Send the collection with one Form VA and one registration fee. Give the collection of pictures a title, such as "Collected Work of J. P. Photographer, January-October, 1992." In this way the Copyright Office can easily distinguish each of your image collections from the others. Call or write the Copyright Office if you have questions.

There are several other ways to register groups of pictures. You can photograph a group of slides on a light table and send enlarged prints, or using a copy machine, make sharp color copies of 20 slides inserted into a plastic sheet. Send contact sheets of black-and-white or color negatives for bulk registration. Dupe slides shouldn't be too far over- or under-exposed so the images can be readily identified. Sending a very similar slide instead of a dupe you want to copyright isn't acceptable; the "almost-like" picture could lead to complications the Copyright Office wants to avoid.

COPYRIGHT INFRINGEMENT

The most frequent problem photographers encounter is unauthorized use of pictures by prospective clients who happen to have your slides or prints on hand. Whether or not your copyright notice is on the images, you can claim infringement. When legal action is necessary because of infringement, the picture must be registered previously. (As mentioned earlier, you have three months after first publication to do this.) If the user is obstinate, point out that your copyright has been registered and that the user may be liable for $10,000 in damages and more for "willful" infringement, which means the user knew what it was doing. You'll need an attorney at some point if the user isn't willing to pay a fair fee, and you may also sue to collect legal fees.

However, in case of copyright infringement it is good practice to discuss the problem with the user and determine a fee. You may now negotiate for more money than you would've asked had the two of you discussed payment before the shots were used. According to photographer Mark E. Gibson, "A procedural infraction we encounter is clients that select a photo, go to press with it quickly, and then try to negotiate a low fee after it's in print. We explain this 'shopping' procedure is backwards, and we charge accordingly."

To help discourage unauthorized use of pictures you may use slide enclosures that when broken open can't be resealed. There is also a transparent "anti-ripoff" seal to tape over the edges of a slide mount. It says, "Copyrighted image—No unauthorized use—$250 minimum fee if any seal is broken." (See the "Resources" list on page 187).

THE ART OF NEGOTIATING

Part of stock photography is the pleasure of shooting pictures and seeing them published. Smart business practice includes understanding leasing rights and using business forms (see pages 128–130). You wear two hats: you are a creative person and a businessperson. Even if stock is a part-time enterprise for you, operating at a loss is discouraging and eventually will cause the IRS to deny some or all of your expense deductions. Therefore, to support your creativity and advance your business, you must become a reasonably good negotiator.

As you know, business is partly a social process. Working with local clients, you may have a chance to know them better, and they you. When clients are out of town, get acquainted over the telephone when it seems appropriate. I recently read about a successful investment banker who hosted lunch in his private dining room for visiting celebrities and local friends. "No real business gets done at these luncheons," said one guest. "But what is business, really? Doesn't it start with the assembling of goodwill?" That's the basis of successful negotiating.

Dick Weisgrau, old friend, former photographer, and currently the executive director of ASMP, holds another view. He says, "Negotiating is the process of resolving disagreements. It's a logical extension of the selling process; it's a technique you can learn. Even if there is no disagreement between you and a client about rights or other conditions of a stock deal, fees may have to be negotiated to arrive at an agreeable figure between what they want to pay and what you want to charge."

There is a wealth of information available about negotiating for the sale or lease of photographs in the *ASMP Stock Photography Handbook*. In Jim Pickerell's *Negotiating Stock Photo Prices*, he explains his beliefs about negotiating the minimum pricing goals photographers might maintain. "My definition of being professional means being paid at a level that would enable a person to support himself in this profession. However, don't feel that if you aren't making a full-time living as a photographer, you aren't qualified to charge 'professional' prices for your photographs," he says.

Keep that in mind as you study the art of negotiating. When clients find your stock images worth paying for, the fees you charge should be

based on that fact. Don't put yourself down and be tempted to charge less than basic fees because you are a part-timer or because you don't have much of a track record yet.

Maria Piscopo, author of *The Photographer's Guide to Marketing and Self-Promotion*, sees negotiation in a different light: "Photographers weak on business practices and pricing tend to attract clients who know how to take advantage of that weakness. Protect yourself with strong pricing policies and standards for pricing."

NEGOTIATING TECHNIQUES

Your business success depends in large part on your ability to make agreements that satisfy yourself and clients you would like to hear from again for future stock sales. When making deals, you must strive to be clear in what you ask or state, so that confusion and misunderstandings can be avoided. Your manner on the telephone, in person, and/or in writing should be friendly. And you should make your interest in the client's picture needs clear even if this seem evident. Strive for a calm, cordial approach. You want to be relaxed, so the client's mood will be friendly, too, even if he or she sounds frantic. Establishing a rapport is important, and the way you do it will differ according to the personality and business position of each client.

Psychologically, your awareness of how clients think pays off handsomely. Learn as much as you can about what they want, the type of pictures, the usage planned, and any special conditions, such as space needed for type. If a client isn't clearly informed, explain that you can't quote a price until you know these things, and that not all your stock images are priced the same way. Some may have cost more to produce because of, for example, model fees or high travel expenses. Perhaps you have a specialty that few others can offer, or you have access to remote countries or industries. You may work well with children or animals, you may have an unusual panoramic or high-speed camera, and in particular, your years of photographic experience count. These are all abilities the client may not be familiar with. You'll hear it over and over: client education is a consistent part of doing business.

But negotiating shouldn't be a contest. You aren't in a personal confrontation that one person wins and one person loses. If there is a clear winner and a clear loser, the negotiations have failed you or the client in some way. Find out what's negotiable. Once you have the facts and a price is offered, look at the deal and decide if you can accept it.

When you're asked to discuss photographic fees, it is important to know as much as possible about clients and their requirements, and to

take your time. Never rush or be hurried through a negotiation. Explain that you're shooting or involved in another deal, and offer to call back soon. It can be risky to start answering questions without adequate preparation. Then you may refer to your own pricing list or perhaps call another photographer for advice.

Many professionals will be helpful when you ask about pricing because if you aren't sure of a fee and you underprice your pictures, you're really hurting the market for other photographers who are experienced. By checking with a veteran and getting a recommended range of fees, you're helping maintain standards in the stock field in general. You may charge at the lower end of the range if you're just starting out, but try not to diminish your own value because you don't have a lot of years in the stock business.

When you discover the client's idea about a fee for pictures, ask yourself, "At what point will the client compromise and still feel that it came away satisfied?" One way to accomplish this is to imagine trading places. As the other party, how badly do you want this deal? How important do you seem to the client? What kind of fee limits can you imagine the client envisions? Does the client seem to be under pressure to make a deal with you? Asking yourself how the other person sees his or her goals and bargaining position can help stimulate your negotiations.

During negotiation, you should also show empathy. When appropriate, acknowledge the client's point of view. For instance, if a buyer says the budget allows only X dollars for a wanted stock shot, you might respond, "I understand you have pressures and I'd like to accommodate you. But I've researched the market with some colleagues, and the fee I've quoted is slightly less than average for the usage you want. Perhaps if you told this to your people, they'd be more satisfied." Suggest the buyer check and call you back. If the client wants to continue negotiating, suggest a fair fee. That may be what the client wanted all along.

Let clients know that you really want to make a deal, and you feel they do, too. Speak candidly. You aren't saying you'll accept their offer, but you're showing that the sale is important to you, as is their business. This can pave the way for a compromise on the fee if that is your goal.

Listen carefully. Perhaps the buyer will offer a fee for pictures that you find acceptable, and this is fine. But maybe you wait for a question about fees, and none comes. Listen and analyze the client's tone and the words used. If they are upbeat, you may be inclined to quote a higher fee to start than you would otherwise.

Consider options. If clients hedge when you ask what the budget allows, find an opening and ask again what they're prepared to pay. If the response is still vague and they ask how much you would charge, offer a

range, such as $250 to $500, "depending on how the picture will be used." Good negotiation means you keep your options open and are ready to propose alternatives until both sides can settle on satisfactory figures. If the buyer immediately accepts the $250 figure, ask more about usage. Then say something like, "Based on what you've said about circulation and the size, a more realistic price would be $375." You may get a lower counter offer or a "yes." In either case, you've tried to be flexible.

DELIVERY AND INVOICE FORMS

The essence of good business, and an excellent way to avoid conflicts and confusion with clients, is thorough record-keeping; this is also referred to as paperwork. No matter how friendly a picture buyer may seem, an oral agreement is too easily misunderstood and can be a problem when solid evidence of your viewpoint is a necessity. Written agreements are helpful to photographers and clients alike because their respective obligations are clearly visible to all. If there is a disagreement paperwork is far more reliable than memories, which may fade and become subjective.

STOCK-PHOTOGRAPHY DELIVERY MEMO

Be sure to send a delivery form in either the standard ASMP format or your version of it, with all stock submissions. It should have your name, address, and telephone and fax numbers on top, or the form may be printed on your letterhead. List the pictures being sent with their file numbers plus other data and an evaluation of each in case of loss or damage (see page 133). List picture titles only, if you choose to send more detailed captions separately. If you need more room, use another page to list additional slides. It should also have your name, address, and other pertinent information on it and be marked Page 2 of 2 (or whatever). Note that "Terms, Conditions" should be printed on the reverse of page 1 in case the two (or more) pages get separated.

Make a photocopy of the delivery memo (except for the standard terms and conditions, which you should already have on file). File copies of the delivery memo along with client correspondence, a photocopy of the slides if you make one, and/or the slide list with expanded captions.

The delivery memo serves as an agreement that gives the client 14 days to make a selection and stipulates a holding fee along with other conditions. Paragraph 3 of the terms and conditions makes it clear that the user may only examine the photographs and make a selection. The

delivery memo doesn't grant any reproduction rights, which are licensed by the stock-photography invoice. Paragraphs 4 and 5 obligate the user to take care of your pictures and return them safely, and makes the user liable in case of loss or damage.

Paragraph 5 of the terms and conditions stipulates $1,500 each (*or another amount of your choice*) for loss or damage to each original slide. You should also indicate a specific dollar amount for loss or damage of dupe transparencies (less than originals), black-and-white negatives and prints, and contact sheets. Court decisions, in New York especially, have recognized the $1,500 figure for loss of an original slide, but there are other circumstances to consider when evaluating your work. While $1,500 has been asked for and collected by some photographers for loss or damage of their slides, prints, and negatives, the amount should bear a reasonable relationship to the provable value of the work in these terms: your experience, fees collected or usage prices charged for other similar pictures, individual style and reputation, the ease or difficulty of shooting the slide(s) in question, unusual expenses involved, and the volume of your stock sales.

You can see why stock photographers find delivery memos important: all that small print gives you a useful framework for business transactions. Courts find delivery memos helpful in making a decisions about lost or damaged photographs, and using the memo form indicates that you are a professional.

Practically speaking, if you are an aspiring or new professional, using a delivery memo is a good business technique. However, value your work according to your experience and ask advice from other photographers. If a user lost or damaged some of your slides during a negotiation about their value, your stipulated price may have to be lowered. So be sure to set it high enough at first. Consider a figure somewhat less than $1,500 to express reality. (Read Chapter 7 of the *ASMP Stock Photography Handbook* for more details.)

STOCK-PHOTOGRAPHY INVOICE

You may have your own invoice form, but the ASMP format has terms and conditions on the back that, as discussed earlier, can be very helpful in case of disagreements. Again, use your letterhead or be sure to include basic identification on the invoice. Not only does the invoice indicate what you're charging for the pictures involved, but it also serves as a license of rights. This, then is your written permission for the client, preferably after payment is made, to use the pictures within the limits you've discussed and indicated on the invoice. Be specific in

the terms you record on the invoice to help avoid confusion, ill will, and possibly even litigation later.

Look especially at Paragraph 11 of the terms and conditions. The *ASMP Stock Photography Handbook* explains that if you want arbitration to occur in your home state, and in some areas if you want to assure the possibility of arbitrating, you must fill in that blank and have the invoicing memo signed by the client. The *Stock Handbook* also states that the arbitrating provision is included because that means of settling disputes is generally faster and less costly than going to court. In some areas litigation may be preferable, so ask an attorney about using the arbitration clause.

Notice that the terms and conditions of the stock-photography invoice also request safe return of all materials, editorial credit line and copyright notice, liability in case of misuse of photographs or model release, timely payment, and free copies of printed materials.

When you know in advance what pictures will be used, a delivery memo and stock photography invoice can be sent together along with the images. This is likely to happen when your picture is known from a catalog or other reproduction. Remember that rights granted have to be filled out on the invoice in any case. Another important business form is a model release, which is particularly necessary for advertising stock photographs (see Chapter 11).

To ensure success in all facets of finding and servicing stock markets, you should find both shooting and business activities to be a challenge. If you don't enjoy contacting people, keeping track of submissions, and negotiating fees, you'll be better off spending your time shooting and selling your work through a reputable stock-picture agency, which is the subject of the next two chapters.

It is impractical to discuss whether you're making a profit from stock, or how long it will take. Each person's situation is different. When you've been in business a while, assess your expenses and income along with your satisfaction. If you're happy and feel success coming on, you've made the right choices. It is very likely that success means you've also made some wise business decisions.

Clearly, negotiating rates and rights for any sort of stock photographs requires knowledge of the market and how to compromise. Gracious compromises can satisfy clients and achieve the points you find acceptable. Flexibility, conviction, and awareness are also essential to successful negotiation.

8 HOW STOCK AGENCIES OPERATE

This chapter focuses on how stock-photography agencies operate, how they select photographers and promote and sell stock, and whether or not they are worth the average 50 percent commission they charge. The pros and cons of choosing a stock agency are covered in Chapter 9; here you'll learn how agencies differ and whether you can be certain of finding representation.

Craig Aurness, an old friend and owner of the Westlight agency (no conflict of interest here—he doesn't represent me), which opened in 1978, describes many agency operations in a report entitled, *International Stock Photography*. Subtitled, "Research report on picking and managing stock photo agencies and on stock markets worldwide," the fifth edition was published in 1990. In this chapter I've digested some of the Westlight report's main points about how stock agencies operate. Aurness says Westlight has had to turn down numerous photographers in order to give full attention to 60 exclusive members whose work is distributed around the world. Since he didn't feel comfortable about suggesting other agencies, he wrote the report to provide photographers with information about agency operations to help them make their own decisions. Much material that follows is excerpted from the Westlight report.

The number of photographers represented by each of the 100 United States agencies described in the *ASMP Stock Photography Handbook* ranges from 5 to 800. The average may be 100 to 150 photographers per agency, although larger agencies represent well over 300. The Westlight report claims there may be fewer than 20 "major general stock agencies in the United States, and perhaps only 50 in the world." Obviously, a lot of medium and smaller agencies are quite capable of competing in a marketplace they carve for themselves.

Since the mid-1980s more agencies and photographers are selling stock, and competition has greatly increased. According to the Westlight report, "Stock agencies welcome creative photographers, but the real success stories are the businesslike photographers who listen to their agencies and produce, produce, produce. In many ways, the best stock photographers are small business entrepreneurs who are driven to succeed. These same successful stock photographers are often their own creative directors, designers, stylists, editors, and assistants who caption each image. Photographers who can't listen, learn, and edit don't have a chance in the future stock market. Artistic egos and superstars are not a major part of the future in stock."

MANY TYPES OF AGENCIES EXIST

The Westlight report says the 10 largest agencies in the United States have a total of about 700 employees and represent about 3,000 photographers. Every year each of these large successful agencies produces a catalog with 100 or more pages and a circulation up to 100,000 clients. In the United States, surveys indicate that most clients call an average of only four stock agencies for each project they want to illustrate. Because of aggressive marketing by the largest agencies, many clients tend to think of them first.

In the small-to-midsize category, there are more than 300 agencies. Together their combined staffs total about 1,500 people, and the agencies represent an estimated 30,000 photographers.

I am familiar with many midsize agencies that have sufficient financial resources to do competitive marketing, although Craig Aurness believes that the gap between large and small general agencies is growing, making it harder for the smaller, nonspecialized agencies to compete effectively.

The Westlight report identifies three kinds of agencies that sell commercial stock: the editorial and story agency, small specialized agencies, and major networking agencies. The first type is slowly venturing into advertising stock. Editorial agencies include those that have no subagency distribution (in foreign countries) and those that have affiliate agencies abroad. Some editorial agencies may also focus on making duplicate sets of pictures for stories, primarily for magazines.

The second type of agency rarely distributes photographers' images through other agencies, and they may concentrate on a regional or specialized market. Their catalogs are small and infrequent, or they may send promotional mailers. The last type of agency focuses on the

commercial market, but sometimes sells to editorial buyers. Major agencies often exchange photographs and catalogs with their affiliates abroad. They generally produce one catalog a year for world distribution.

AGENCY SIZE AND STAFF

According to the Westlight report, what makes a great stock-photography agency is service to clients and to photographers. Excellent service requires good people, good files, good information, good management systems, and productive photographers. A number of agencies have achieved winning combinations and enjoy increasing success.

When evaluating whether or not an agency is right for you, keep the following rules of thumb in mind. First, a lot of photographers in an agency means a good variety of images in the files, which attracts clients. However, each photographer and each photograph add to agency overhead. There is a fine balance between the number of photographers at an agency, its overhead, its volume of sales, and its management. If any one of these gets out of hand, agency success may be jeopardized. Specialists within an agency may not compete for sales with others whose specialty is different, but almost all photographers travel, shoot scenics, and contribute to what Aurness calls the timeless files where some competition does exist. "Timeless" refers to photographs of sunsets, cute children, state buildings, and prominent city street scenes that are consistent sellers year in and year out. These are the clichés that many stock photographers are prone to shoot.

About agency staffs Aurness says, "Today's best stock photography comes from shooting stock as a self-assignment, current in style, under the close guidance of the agency." This means that the agency should have management systems not only for filing and sales, but also for helping their photographers. When you question photographers about their specific agencies, ask about the kind of guidance they're given. Find out how much time the photographer spends on stock so you'll be able to compare this with your own efforts.

Agency staff members who work daily with clients should have strong sales training. A well-managed agency has the following departments: sales, front-office reception, a library that can also handle returns, photo research, computer services, shipping, photographer relations, international distribution, marketing, management, and accounting. To some degree this pertains more to large agencies than to midsize and small ones.

The greatest asset of an agency is the enthusiasm of its photographers. They should be committed, creative, and productive professionals

who've made shooting stock a priority in their lives, and who listen to the agency's needs. The fewer superstars and big egos the better.

QUALITY CONTROL AND AGENCY BUSINESS PRACTICES

As you'll find in the stock-agency interviews in Chapter 13, all agencies are greatly concerned with presenting images of only the highest quality, aesthetically and technically. Stock-agency editors have to be very particular to ensure top-notch images, which means that they reject a lot of pictures by even the best photographers for whom the acceptance rate is also high. Agency editors have so much experience seeing the kinds of pictures clients choose and the quality of images made throughout the industry, that they must edit with great care. My experience shows that stock agencies aren't consistent in what they accept. I may spend a few weeks traveling and offer 400 slides to a large agency, which might keep 7 or 8 percent for their files. I check over the slides, make a new shipping list, and send the remainder to another agency abroad. In turn this agency may keep 15 to 20 percent of the images because its files aren't as filled with those subjects. Finally, I send the returns to a third agency that is just beginning to build its stock files, and the acceptance rate may be between 20 and 25 percent. Each agency insists on pictorial quality, but each has its own subject needs—which benefits me.

The Westlight report puts a high sense of ethics on top of the list of good business practices, followed by systems for monitoring shipments, returns, and sales that a photographer can easily understand and inspect. To stay ahead of trends, an agency should have sophisticated, computerized market-research programs and should make surveys of client needs. Agency personnel should have a thorough knowledge of stock subjects and their value, and should negotiate prices with fairness and integrity. There should be an agreement with photographers on a minimum price for rights leased, below which the agency shouldn't go. Well-run stock agencies also place a high value on communications with their buyers as well as their photographers. Many agencies publish desktop newsletters for clients and photographers to keep both informed of operations that will enhance the agency's image.

Stock agencies must keep close track of how much income their files generate in relation to how many pictures are in the file. The world average of stock sales, according to the Westlight report, is only $1 to $2 per photograph per year. That means that if an agency has 500,000 images on file, it should gross between $500,000 and $1 million per year

on those photographs leased during the year. Thus agencies must control the number of new slides in their collections not to increase faster than sales increase. The best approach for an agency is to invest in picture categories that need images, and not in files that are already filled and tend to age slowly. If you shoot sunsets or national parks, you face minimum acceptance because the files may be full. What an agency needs and the pictures photographers want to market can be considerably out of sync. The Westlight report includes a list of more than 100 subjects that age slowly and that tend to fill agency files most quickly. Examples are babies, fireworks, holidays, mining, rainbows, storms and waterfalls.

Most agencies ship catalogs and dupe slides, plus some extra originals, to their affiliates; however, the higher number of originals being sent is having an impact on the market. Submitting extra originals to subagents allows them to make duplicates to balance their files in relation to their own markets. For example, a photograph of a crowd may have only limited value to a British agency, but an agency in Spain may need many crowd shots. With extra originals, which you may provide to your agency in the United States, a subagent has the opportunity to make dupes for wider sales.

The Westlight report also points out that the percentage of images accepted, filed, and distributed is directly related to the number of trained editors at the agency, the agency's editing philosophy, the quality of the work, and the need for the photographs. I found this especially interesting in light of my own experience. Once an agency I work with took several months to edit and return reject slides to me, and when I complained, I was told that its best editor had left and a new one was in training. Agency personnel can certainly affect your peace of mind and income.

DO STOCK CATALOGS REALLY BENEFIT PHOTOGRAPHERS?

In the June 1991 issue of *PDN*, an informative monthly published for professional photographers but of interest to advanced amateurs, English photographer Rick Strange expressed his dissatisfaction about the studio catalog situation. Stock agencies, he said, like the sell-by-catalog approach because it is successful on a global basis. He quoted an agency director who said that 80 percent of the company's global sales come from fewer than 12,000 images. So Strange asked some questions. Does anyone ever see the other millions of pictures in the agency's files? Have picture buyers become so lazy or unimaginative that they no longer request a selection of chromes on a given subject?

Catalogs, said Strange, have come to look alike. Subjects included are virtually the same: children, businesspersons, offices with computers on

desks, landscapes, clouds, agricultural closeups, and "a couple of token animals." He claimed that other creative efforts of innumerable photographers are filed away, "like time capsules, waiting for future generations to discover them." He said his own studio income from two agencies (he sells through seven) was cut in half the year after their first catalogs appeared. This demonstrated how agency marketing efforts are concentrated on catalog images "at the expense of other stock in their files," said Strange.

At some point in the future, Strange believes, picture buyers will begin to realize they've seen all the catalog images before, and they may be motivated to visit stock agencies again or ask for stock selections to see what else is available. And what will they find? Exaggerating somewhat, he predicted that agency files will be full of chromes that duplicate catalog images. "All the rich variety that existed B.C. (before catalogs) will no longer be available." He admitted being pessimistic and said "catalog mania" may die a natural death, especially if photographers have to pay an unfair share of their cost. (Perhaps catalogs will be replaced by CD-ROMs; see Chapter 10).

All of this suggests that if you become affiliated with a stock-picture agency, it would be worthwhile for you to be included in an agency catalog at present, but find out how that may affect all your other images in its files.

WHAT KINDS OF PICTURES DO AGENCIES WANT?

To understand what kind of images sell best, look at catalogs and stock images you see in print. If you see the same subjects in agency catalogs year after year, then you can be reasonably sure of what sells. Photographers should ask themselves if they are capable of producing *better* images than the ones already on the market, which may be several years old by the time they're published. Compare what you see in print with your own work and honestly rate yourself. Most photographers, says the Westlight report, don't have an objective outlook about their work. A few good frames aren't enough. To be successful, you must have the skill to produce excellent stock regularly. Stock photography shouldn't be regarded as a hobby you can take lightly.

If you're accustomed to shooting assignments, it may seem easier to shoot stock at first. Eventually you may find it a drawback having to generate your own ideas and motivate yourself to photograph; the images may not sell for perhaps several years. Success takes patience and means not only studying the markets, but also keeping your mind

open and being objective about your skills and goals. Early on you may decide that an alliance with a stock agency would be a real advantage to you. Since you may have to invest a lot of time, money, and creativity to get a good start, it can be comforting to have someone marketing your work while you continue shooting. Income from stock may come sooner because an agency guides you as it sells your work. Of course, your personality and drive affect success greatly.

Don't copy other photographers' work. As I've said before, copying someone else's work is illegal, unethical, and wrong. Yet according to the Westlight report, copying is a problem in the stock business. It is easy for photographers to discover what kinds of images sell over and over, and because they want fast sales and aren't experienced at generating stock ideas themselves, they may produce the same images seen so often in agency catalogs. Both agents and photographers should be familiar with pictures seen in print but then work hard to come up with *new* visual solutions.

Large agencies will usually take a new photographer to fill a specialty the photographer excels in. Many stock agencies today need photographic specialists in specific areas, such as sports, medicine, wildlife, scenics, and certain types of people pictures with releases. "Even so," notes the Westlight report, "in today's market a focus on wildlife may still be too broad. There are many good animal photographers," so you may not be seen as special by an agency. But if you concentrate on birds of prey, whales, golf, or tennis, your pictures may open the door of a good agency. If you bring a collection of "exceptional" specific images to an agency and commit yourself to producing more consistently, you'll get the attention of even the best agencies—which may be all but closed to new photographers.

Scenic and travel photographers will have trouble gaining acceptance in most agencies today. However, specializing in an important city, such as London or Paris, could make a difference. And someone who concentrates on a location, for example, the American Midwest, might also be valuable to many American agencies. On the other hand, generalists, photographers who shoot a smorgasbord of subjects, "are valuable to a new, small agency, but seldom to the established larger agencies."

AGENCY PRICING STANDARDS

Because competition between stock agencies for clients' dollars has become so fierce, agencies often ignore even their own pricing guidelines to make a sale. Agencies (or photographers) may need to

remind clients that they get what they pay for in stock photography. Great photographers, says the report, are attracted to agencies that uphold pricing standards. Agencies that are involved with discount pricing on a regular basis run the risk of losing their best photographers.

Agencies with unique or specialized files have developed their own higher pricing standards because they have images (or photographers) unavailable elsewhere. But generally speaking, competition undermines consistency in pricing. In the heat of the moment, many agents may forget that photographers need a fair return on their efforts so they can afford to shoot new stock, and agencies need a fair income to cover their overhead. However, the Westlight report maintains that distorted values result in more agency sales with discounts for clients, but less money for photographers. In the end, then, large agencies with many photographers, who choose to discount more because of higher volume, may do fine but photographers lose income and are discouraged to produce more and better images .

Some agencies may decline smaller sales, leasing only to publishers for higher-paying projects. This may be effective for business, but it cuts income for some photographers. Another pricing game, as described in the Westlight report, is to make an annual contract with a client for volume buys. This practice results in a fixed fee. When this happens, sales are seldom evenly distributed among the agency's photographers.

In terms of pricing, the report asserts, "An agency that needs to drop its prices is likely short on service or weak on product." This may be the case when supply is higher than demand, but "there are many sensible alternatives to dropping prices." These include improved training of sales personnel, better editing, more guidance for photographers to help them produce better images, and more catalogs, which are increasing in importance.

To estimate an agency's standard pricing, go by the average, not its extreme, sales figures. As the Westlight report says, it is wonderful to hear about sales of images over $1,000 but they aren't very common. It is more sensible to base your future success on repeat sales from many types of images. "In the United States," says the 1990 report, "image sales average $150-250 for editorial and $250-$600 for commercial [advertising], depending on the agency. Repeat $350 sales [from various subject categories], usually for brochures, are the real golden stock nuggets. Many repeat sales allow photographers to plan financially with some consistency." Agencies shouldn't stress their $1,000 sales to you, Aurness says. He adds, "The overall average in a mixed-sales agency is estimated to be around $300 for each sold usage. Asking your agency what its average is might prove interesting."

9 CHOOSING A STOCK AGENCY

More than half of the professional shooters I've talked to are affiliated with an agency. Some deal with only one, some with several, and many sell through agencies as well as on their own. Each individual has valid reasons for marketing his or her own work, doing it through an agency, or both, and there are pros and cons associated with each choice.

The primary motivation for marketing through a stock agency is being able to spend your time planning stock shoots and taking pictures while other professionals promote and market your work. While you are on a trip, an agency is available to take calls, negotiate fees, and find clients for you. An agency's contacts among publications, ad agencies, and corporate clients can be far more extensive than yours, and its specialized experience and knowledge of selling stock can make sharing your income worthwhile. An agency's branches or affiliates can also make your pictures more salable abroad where it isn't always easy for individuals to monitor sales agents and to collect their share of stock income.

Other reasons to favor stock-agency representation are that an agency organizes and files your pictures, makes dupes, and assumes responsibility for the safety of your valuable chromes. This saves you office space and time. Many agency staffers are specialists in these matters, and have the experience and judgement to edit your work and present your strongest images to buyers. They also handle negotiations with buyers in a less emotional way than you might. As a result an agency may arrange suitable prices for your work more consistently than you can, and it has established systems for keeping track of unpaid bills.

An agency may also suggest that you shoot photo subjects that buyers ask for, which you wouldn't otherwise know about. Its constructive comments about your technique or style can help you improve your work to satisfy a diverse marketplace. Finally, having your

pictures in an agency catalog is very likely to be beneficial to your income and reputation.

However, if you like editing and handling your own work, enjoy having contact with clients, and are stimulated by the opportunities to promote and sell directly, you may prefer to shoot, edit, caption, and market your own photographs. You should like the feeling of being in control of the licensing of your images, as well as handling other stock-business operations. And if you specialize in certain subjects, you might feel that having personal knowledge of clients' needs is an advantage when it comes to both shooting and selling. You should find it challenging to negotiate with buyers, and you may believe that you can maintain higher stock rates than an agency can. Since so many sales originate from pictures printed in agency catalogs and you aren't in control over whose work is selected, you may not want to compete for catalog space and be frustrated when your needs don't seem to be met.

Another reason to market your own stock, even though it takes more work than having an agency do it, is that you're convinced the 50 percent commission you save will be worth the effort you make. You also might not be eager to sign an agency contract that ties you down for a number of years, after which more time will pass before all of your work's returned to you. Furthermore, you might worry that if a stock agency fails, your pictures could be tied up in litigation or be difficult to get back from floundering agency owners. So you could decide that you prefer to do the work and take the risks of selling your own stock; you think you can do it well and maintain your own business accountability at the same time.

TAKING A MULTI-AGENCY AND/OR PERSONAL APPROACH

The monthly *PDN*, which can help you make business decisions, published the results of a survey of stock photographers in a May 1990 article by Nancy Madlin. The figures excerpted here shed light on the actual selling practices of professional stock shooters. The newspaper received 166 responses from what it felt was an experienced group, 73 of whom had been involved in stock between 11 and 20 years.

Eighty-two percent of respondents were affiliated with stock agencies, and 80 percent of that group was satisfied with the relationship. Seventy-seven percent of those represented by agencies also sold stock on their own. Only 30 percent had exclusive relationships with one agency. Of that group, 63 percent sold stock on their own. The median price per licensed image was between $201 and $400 as reported by 93 percent of

the respondents. And the median response the photographers gave for the highest price for single images was between $1,501 and $2,000.

Both photographers who sold through stock agencies and those who didn't reported similar average prices-per-image over a given time period. However, higher one-time sales prices were reported by more photographers represented by agencies. The median amount of yearly income from stock reported was relatively low, between $10,001 and $20,000. Of the group making more than the median, 53 percent made more than $50,000. Photographers selling only through agencies had higher incomes than those who sold through agents *and* on their own, or those who sold their own stock entirely. The *PDN* report suggested that agency-only photographers more often had advertising as their primary market, those who sold both ways reported they sold most to corporate clients, and those who sold on their own only did so mainly to magazines.

Selling some of your work through one or more stock photography agencies and selling some of it yourself directly to clients are both feasible and widespread, as demonstrated in the *PDN* survey. Several photographers explain specifically how they do this (see Chapter 12). All try to avoid sending the same or very similar pictures to more than one agency and/or directly to clients. For instance, pictures may be divided so that a specialized agency gets all the animals and wildlife, while still-life and architectural photographs go to another agency and more general subjects go to yet another.

Veteran stock shooter Vince Streano says he doesn't find it difficult to avoid conflicts. He explains, "I think multi-agency conflicts are a figment of the imagination of most agencies. Our agency contracts give each of them exclusivity in a certain geographical area, which means that Carol Havens and I won't sign with one agency in another agency's area. When it comes to distributing pictures, we shoot a lot of film and divide chromes according to what is appropriate for each agency. We keep 10 to 15 percent of the best images for our own files, but I make 6 × 9 cm dupes of many choice shots that I send to the agencies."

Streano adds, "There was an instance when a client asked us for some general California pictures for a magazine story, and called each of our three stock agencies as well. All four of us sold pictures to this client, because we probably all chose different images, which is typical of individual tastes. So there was no conflict. However, I do give agents exclusives on my images that appear in their catalogs. It is only fair and sensible to restrict distribution of catalog photographs to that particular agency, and being discreet has paid off."

While I don't sell stock directly to clients, I do work with several agencies, and I'm careful not to send the same pictures or definite look-

alikes to potential competitors. I have a routine: I edit each group of pictures carefully and set aside images of agriculture, science, and special nature subjects for one specialized agency. I send the remaining chromes to a large agency in the United States or to one abroad first, depending on the material. When rejects come back, I re-edit, revise the shipping list, and send the pictures to the other well-established agency. When it returns my images, I pull any that may cause conflict since I know what has been selected by two agencies, and I submit to a third agency with somewhat different needs because its files are newer. There is little or no overlap among these agencies, and in many years I've had no problems.

Jim Pickerell markets his stock through a wide-ranging network of 19 separate stock agencies, five of which publish catalogs. He says there is often a long time lag between the time you submit your work and when the agency chooses pictures for a catalog. Even so, the photographer needs to keep each agency informed of which pictures are in which catalogs, and must have those or similar shots returned from the other agencies. Many agencies want exclusive control over pictures similar to those in the catalog. When an agency asks me for an exclusive on catalog pictures I ask for return of the same pictures from agencies in the United States, but not from a foreign agency, which has its own distinct marketplace.

SEARCHING FOR A STOCK AGENCY

In the 1970s and into the 1980s it wasn't too difficult for working professional photographers with a midsize file of general stock subjects to find an agency to represent them. There was less pressure for photographers to produce stock on a regular and frequent basis than there is now. Part-time stock producers were welcome then, but less so now; stock photography has become bigger business. Many agencies have turned to more dynamic sales and promotion techniques, and unless a photographer is a successful specialist or has a large selection of stock images ready to sell, many agencies aren't interested.

STOCK-AGENCY SOURCEBOOKS

For information about stock agencies, how they operate, what their specialties are, and many other facets that can help you make choices, ask for recommendations from your colleagues, and then turn to one of the sourcebooks discussed in this chapter. Agencies tend to have their

own personalities, which are usually based on the business and artistic values of the owners and employees, so there are many agency viewpoints. While differences among agencies exist, similarities are common, such as the basic desire for technically excellent, well-composed, widely applicable images.

The most thorough of agency sourcebooks is the *ASMP Stock Photography Handbook*. As you leaf through its 50 pages of listings that describe American agencies, you must carefully interpret what you read. For example, here are some quotes from various agencies about submitting photographs:

- "Initial submission of 100 photographs" (Many agencies ask for what I call an "audition selection" of 200 to 400 photographs, and one wants 1,000 slides. The Image Bank, one of the largest and most prestigious stock agencies, asks for 500 photographs in all subjects as an initial submission.)
- "Prefer a large body of work, with a strong editorial background"
- "No minimum for initial submission"
- "Need model-released people"
- "Need college sports"
- "Need lifestyles"
- "Need fashionable travel" (Dozens of other subjects are mentioned.)
- "No submissions without written approval."

INTERPRETING AGENCY LISTINGS

The following categories are used to collect information from the 100 stock agencies described in the *ASMP Stock Photography Handbook*. This data was painstakingly gathered through questionnaires, telephone calls, and personal visits to most of the agencies by ASMP members in various sections of the country. They are grouped in five regions: New York City, Northeast/Mid-Atlantic, South/Southwest, Midwest, and West/Northwest. There are also foreign agencies in Europe and the Far East.

Date established. An agency in business since 1970, for instance, indicates a certain stability, although those established in the 1980s may also be thriving operations. This gives you an idea of the agency's lifespan.

Number of photographers' work it has on file. An agency representing only 50 photographers may give their work more attention than one representing 300 photographers. But this could be misleading depending on the number of employees who are editing, filing, selling, and keeping track of billings.

Gross billings when available. Again this is hard to judge but you know that higher gross billings indicate more business volume, not necessarily more income per photographer. Divide the number of photographers into the gross billings and compare for a rough indication. In actuality some full-time successful stock shooters may gross $100,000 or more from an agency's sales while others may be happy to make $10,000 or less a year. The number of pictures each individual has on file is a factor, too.

Number of employees. There seems to be a fairly constant ratio between this number, the number of photographers, and gross billings.

Names of agency owners. These names will usually mean nothing to you unless they are also well-known photographers. Later when the agency contact is listed, it is interesting to note if you'll be dealing with an owner.

Photo files. The approximate number of photographs in various sizes, color and black and white, is another indication of the agency's size, diversity and business volume. Subjects the agency concentrates on and whether the files include pictures by agency personnel are also revealing. The latter information tells you whether or not you're competing with someone whose work may be favored.

Three other sourcebooks list stock agencies. One is the *PACA Directory.* (PACA stands for Picture Agency Council of America, which promotes communication between photo agencies and other professional groups.) This book includes the PACA code of ethics, as well as verbal self-portraits inserted by about 85 member agencies. The material is sketchy compared to what is in the *ASMP Stock Photography Handbook,* and some of the names to contact are different. Lists of stock subjects the agency carries are under "referral information."

Another book is *The Photographer's Market,* which is published yearly by Writer's Digest Books. The 50 or so pages of listings cover the kind of subjects wanted, payment terms, who to contact, and miscellaneous tips from the agencies. This sourcebook is available both in bookstores and by mail order.

The *Stock Workbook* is a catalog for stock buyers in which about 200 agencies buy ad listings. Published by Scott and Daughters Publishing, Inc., it is expensive; you may find it in the library. (For more information on these sourcebooks, see the "Resources" list on page 187.)

CONTACTING AGENCIES

Photographers have individual personalities and styles, as do stock agencies. Whether you now shoot stock part-time or devote a major part

of your professional effort to it, you have a reputation to uphold—and so does each stock agency. Not every agency will be interested in you, and there certainly are agencies that won't fit your needs. So how do you start your research? By all means ask pros you know about stock agencies that they are familiar with. Keep in mind what kind of pictures they shoot and how important stock is to their total activity, and make an objective comparison to your work and volume.

If there are one or more stock agencies in your vicinity that are close enough to visit conveniently and the data about them in the *ASMP Stock Photography Handbook* is appealing and appropriate, assemble the kind and number of slides they ask for and call for appointments. If you're welcomed and favorably impressed with the agency and its people, you could be in luck. It is unnecessary to be associated with an agency in your geographic area to have a successful relationship, but personal contact at the beginning and as you work together can be very helpful. Some picture buyers like to work with agencies in their vicinity as well.

Los Angeles photographer Glen Allison says, "Because I happen to live in a city where my agency [Tony Stone Worldwide] has an office, I go in maybe once or twice a week. I make it known that I want them to return any of my images they feel are mediocre. I get pointed critiques on my work, which they know I won't take personally. I must make my images better and better so I need to understand why some of them don't make the mark. I work hard at becoming a shining example of what in their opinion is a great photographer to work with."

Photographers who infrequently visit their stock agencies usually devote less time to shooting than those who make the effort to have in-person contact. It is also possible to have a friendly relationship via the telephone, mail, and fax machine, but these don't supplant agency visits, which can help generate photography ideas and additional sales.

If you can't call on the agency at first, write and describe the kind and number of pictures you have on file, and ask for a note from the agency agreeing to review your work. Ask also for any printed guidelines the agency may have about making submissions. Writing is usually preferable to calling the agency to make initial contact. Agencies are busy. Besides, you want something in writing that says the agency welcomes your submission. An "okay" over the telephone doesn't make me comfortable enough but once you have a letter or fax, calling may be helpful for clarifications and for a personal touch.

Do some research to discover which agencies have the kind of operations and file potential to fit your type of photography and business methods. Be realistic about expectations. A large established agency is unlikely to be interested in selling for photographers who have only a

few hundred pictures on file and don't expect to shoot new stock more than three or four times a year. Such individuals may be excellent photographers busy on assignments most of the time, or hobbyists. You can't even expect an agency in your own city to take you on unless it believes your work will help augment its files and that you'll be adding pictures on a fairly regular basis.

If you have a specialty, the odds are in your favor. But once again the amount of time you expect to spend shooting is a big factor. My stock volume is less than that of many shooters who devote more time to it but I've proven myself able to take scenic and people pictures that sell, and I have a cooperative attitude toward the agencies. A pleasant, outgoing, and flexible personality is of special value in business, and may be as important as a file of excellent pictures to some agents.

When you choose work to show, your versatility is also important. The universal or special appeal of the subjects you shoot and the way you see photographically influences agencies. For instance, when selecting slides to introduce your work, try to show how thoroughly you've shot some subjects: using various lenses, from a diversity of viewpoints, horizontal and vertical, and with different lighting effects. At the same time, be selective. Opt for quality, not just quantity. Don't show near-miss pictures. The agency expects to select your best pictures to offer clients, but it doesn't expect to be your basic teacher as well.

Don't send or take news and personality pictures to an agency that advises it doesn't stock them. Watch photo credits in magazines or newspapers for a while to better determine what sort of images certain agencies offer publications. When you write for permission to submit a portfolio of slides, ask questions about the agency's pictorial emphasis if you aren't sure.

STOCK-AGENCY CONSIDERATIONS

When you visit a stock agency, according to my own research and the *ASMP Stock Photography Handbook*, you should consider the following points. First, is the agency located conveniently for buyers to visit? Does the place look neat and well organized? Does the staff convey a sense of professionalism? Are buyers permitted to go through the files? Are there separate viewing areas? Are the photo-file areas well lighted? Can you tell if color transparencies are stored in archival plastic sheets? Are photographs being packed for return to photographers or shipments to clients well protected? Are they shipped insured via the postal service or the UPS?

Do the people working at the agency seem competent? If possible, observe someone editing slides to get a feeling about the judgement shown and to see how the images are handled. Do clients seem to be getting personal attention? Are buyers charged a research fee? If so, is it deducted from the licensing fee in case of a sale? Are holding fees charged? Is the photographer's percentage calculated on the total amount a buyer pays?

Does the agency have a catalog? (If so, ask to see it.) How often is it published? How much do photographers have to pay to have work included in the catalog? Does the photographer have to share the cost of making dupes of important transparencies? What happens to the dupes at the agency or in the hands of subagents if you leave the agency? (They should be returned to you along with originals.) Are buyers charged for lost or damaged original transparencies and dupes? What percentage goes to the photographer? (There is usually a 50-50 split, just like a sale.)

You should be familiar with other business practices as well. Does the agency ask a photographer's permission before agreeing to a *buyout*, which means "all rights"? Most shooters want to be consulted to be sure the terms are fair. How does the agency keep track of its associate agencies that sell pictures abroad? What kind of paperwork do these agencies get, and how often are they visited? Do the foreign agencies maintain careful copyright protection for the photographer? What percentage of foreign sales does the photographer eventually get? Are funds from sales abroad kept in a separate escrow account? (Probably not: agencies tend to resist separating photographers' money from operating funds. Until commissions are paid to photographers, the agency has free use of the money. ASMP is trying to encourage the use of escrow accounts.)

Also, can you see the want lists the agency sends to photographers? How often are they compiled? What happens to your photographs if there is a change of agency ownership, the agency goes out of business, or the owner dies? (The agency contract should arrange for orderly transition or for return of all your pictures, and you should feel protected.) Can you see a copy of the agency contract? How many years does it run? Is it automatically renewed unless you notify the agency to the contrary within a certain time period? (Renewal shouldn't be automatic, and should be restricted until agency/photographer negotiations are complete.) If you sign an exclusive agreement, which isn't necessary at many agencies, would the agency share a percentage of your expenses on specific projects?

How often are photo files edited to remove outdated material that's returned to photographers? How many images do the agency's most

successful photographers have on file? How much are they likely to earn per year? (This information is available without revealing photographers' names.) Can you see a typical sales statement sent to photographers? Does it specify rights granted along with fees? Are clients identified? (Sometimes they aren't when the agency wants to prevent direct—and unethical—competition from photographers.)

Finally, obtain a copy of the agency's delivery/invoice form, and examine the terms. These should be similar to those on the sample forms in the *ASMP Stock Photography Handbook* for your protection. In your research all of these are important factors to discover: the overall sales efforts a stock agency makes, the kind of attitude it shows toward clients and toward you, the help it may give you in choosing salable material to shoot, the consistent care it takes with your images, its detailed sales reports, and how timely its payments to you will be.

The Westlight *International Stock Photography Report* suggests that you ask some other questions to help make choices and define a relationship with an agency. What subjects does the agency need most from you? Do you have a style or existing pictures that are especially marketable? If you make a major commitment to produce stock, how much guidance can you expect from the agency? Who supplies the agency with pictures similar to yours? Knowing your in-file competition is enlightening. What are the major types of clients the agency serves? Marketing is important, so it could be helpful to ask some graphic designers, editors, and art directors which stock agencies they like to deal with best.

Do all the photographers the agency represents receive the same commission and the same catalog opportunities? Some agencies give top producers a larger percentage of gross sales as a concession to the extra volume they produce. This isn't fair to those with fewer sales. Neither is restricting their images in a catalog because they need equality to encourage continuous shooting and reasonable income. Ask the agency for the names of some photographers they work with and try to talk to half a dozen who aren't major catalog photographers. You should know how the work of others in the files is selling.

Does the agency have pricing guidelines you can review? What is the basis of pricing for various usage rights? Does the agency offer volume discounts? If an agency has regional sales offices, will you be paid for their sales the same way? Are regional-sales commissions lower, as they are for foreign sales through subagencies? Regional-sales commissions should be the normal 50 percent; if not the agency may be taking an unfair profit. Where does the agency have subagents abroad? What percentage do they take? Can you see a subagent sales report? Are pictures listed by photographer's name, by image number, or both? This

is important because number-only sales are hard to monitor. Does the agency use an easy-to-understand system for auditing your records of both international and domestic sales? Become familiar with the business forms the agency uses, and learn how the terms protect your rights. Find out how photo credits will read for images sold by the agency.

Does the agency accept duplicates? If so, does it prefer 35mm or 70mm? If the agency makes dupes, who pays for them? If you leave the agency, would there by any cost to you for dupes or other services? Are their dupes captioned and mounted like originals? Usually they should be labeled as dupes to be fair to clients.

How quickly does the agency edit and return images you send? What is the usual percentage of pictures they hold from submissions in your specialty? It may have computer records to show this. How much detail does the agency want in captions? How do they want captions and credit placed on a slide? Is the agency careful about cleaning and remounting images returned after a sale? There should be a standard check-in routine to assure this. Does the agency support ASMP's effort to value lost color slides at $1,500 each, depending on individual circumstances? If you were to leave the agency, how long would it take for it to return all your photographs? Is this guaranteed in writing? It can be very frustrating to switch agencies and have the return of all your pictures delayed more than a year.

Will the agency contract make it clear that your images are your property and not the assets of the agency in the event of bankruptcy? In the event the agency is closed, are all of the images returned? It may not be possible to get all the above questions answered, depending on your importance to the agency, but at least you know what to ask. Inquire in depth when possible.

All of these factors are important: the overall sales efforts a stock agency makes for photographers, the kind of attitude it shows toward clients, the research it does to help photographers shoot saleable material, the consistent care the agency takes with images, its detailed sales reports, and its on-time payments.

FIND OUT ABOUT AN AGENCY'S CATALOGS

Agency sales from catalogs represent an important part of their business. Agencies are spending a lot more time and money to produce and distribute catalogs because buyers find them so convenient to order from.

Choice images are selected for catalogs, and the categories and types of pictures are usually repeated from year to year. For example, shots of sunsets and children playing in this year's catalog may be replaced by more of the same subjects next year, by the same or different photographers. Some catalogs show only a number under a picture; some include the photographer's name as well as a file number. In any case this kind of promotion can improve your income and is to be desired according to a number of experienced photographers I've talked to. Craig Aurness feels that catalogs have become the dominant method of communication between a stock agency and its buyers. He says, "Only the best work is going to be represented, and if a photographer doesn't get into a catalog, he won't get much visibility in the market."

Since many agency catalogs represent as much as 50 percent of sales, the Westlight report suggests you get the following information before signing with an agency:

- The size of the catalog in pages, how often it is published, and its print run and circulation (In the United States the average low circulation is 25,000 and high circulation may be 50,000).
- How are catalogs delivered to clients?
- Are there secondary uses of the same pages? (For example, are they used in such publications as the *Stock Workbook* or for direct mailings?)
- What is the quality of the printing reproduction, paper, and cover style? (Catalogs I've seen recently are handsomely produced.)
- Would catalog design or layout help impress clients?
- What, if anything, would it cost you per image to be in the catalog?

Try to get some stock-agency catalogs and study the kinds of images you see in them. Note the categories covered. Decide which of these categories your work would fill best. If you do little work that would fit a catalog now, think about what you might enjoy shooting that would have catalog potential. Once you're situated with a stock agency, talk to those in charge about getting into its catalog, if it hasn't approached you first. The subject of catalogs may seem commercialized and unemotional, but it is integral to the stock business.

STOCK-AGENCY CONTRACTS

This can be a complex subject. Variations in contracts reflect different relationships between photographers and stock agencies. Some agencies have no contracts; others offer a letter outlining basic terms of

agreement, copies of which both parties may sign. Reprinted on pages
110–115 is ASMP's sample contract "designed to serve as a model for
the photographer in evaluating contracts offered by the agencies." It
covers essential elements of many contracts and if used, "it should be
modified to fit the particular circumstances." In other words, don't
expect any agency to use or accept ASMP's model contract as is.

The ASMP sample contract was designed primarily as a model for
comparison with agency contracts. The following is an explanation of
the contract terms with additional notes. For more detail I urge you to
read the full explanations in the *ASMP Stock Photography Handbook*.

Grant of authority. If you aren't certain the agency will make a serious
effort to tap markets around the world, don't give it "sole and exclusive
world rights" to your work. Most photographers believe that exclusive
representation is unnecessary. If you're attracted by exclusivity, in
return Craig Aurness suggests, "There should be a solid limitation on
the number of photographers the agency represents and a reasonable
management of competition among photographers in the files." He adds
that the financial instability of some agencies in the early 1990s has
made photographers fearful of "putting all their eggs into one basket."

Usually when you're getting started in stock you need the option to sell
in markets agencies don't touch, sometimes because rates aren't high
enough. However, if you already have a high-volume stock-photography
business, you need to take the special precautions discussed in the
ASMP Stock Photography Handbook. Also, consider the word "sell" and
ask if the agency takes it literally. Ask that "sell" be defined as "licensing."

One photographer I read about said his contracts include a
nonexclusivity clause because he had an experience with an agency that
almost went bankrupt, and he could've lost all his images. He asked for
a stipulated $300 minimum on any stock sales, and the elimination of
any clause that requires the photographer to indemnify the agency in
case of a lawsuit. He says he scrupulously marks his slides "R"
(released) or "NR" (no release), and it is the obligation of the agency to
stay aware of same. "If they don't," he asks, "why should I be liable?"

Terms of contract. The sample form provides for three years as a
reasonable balance between the interests of the photographer and the
agency. Provisions for automatic renewal are "inappropriate" and aren't
included. There is also a suggestion that after the initial period, the
contract should stay in effect "until either party notifies the other of its
intention to withdraw. A 60-to-90-day period is reasonable."

Delivery of images. Stipulation of a 30-day period for the agency to edit
and return unwanted images seems reasonable.

Obligations of photographer/warranties of photographer. This clause is there to impress on photographers their obligations, especially in caption accuracy and properly maintaining model and property releases.

Obligations of agency. Among these obligations are careful preservation, handling, and storage of stock photographs; protection of copyrights; use of photographer's name on the work; notification of infringements; and ethical dealing with clients.

Compensation. This clause covers commission percentages, payment time, and the listing of items that should be included on statements. It gives the photographer the right to examine the agency's records.

Retrieval of images. Since the agency may "drag its feet" in returning a photographer's images when a contract's terminated, this clause specifies three months for return of pictures in the agency files, and one year for return of images in the hands of clients. If the agency asks for extra time to retrieve work in files abroad, this should be negotiated.

Dupes. These need to be restricted in number and use and must remain the photographer's property. The whole issue of dupes "has to be measured against the potential revenue" they may produce. The contract provides choices.

Defaults. In an effort to avoid having the photographer's work tied up in courts or negotiations, the material should be returned immediately in case of bankruptcy, closing of the business, or other threatening problems. Transfer of physical control of the files, after bankruptcy or other closing of the business, without the photographer's permission, would be "deemed null and void."

Foreign subagents. Since a three-way split results from subagents, this subject should be considered carefully so the photographer feels the split is fair.

Death or disability of photographer. This clause gives photographers or their estates the right to terminate the contract with 60 days notice. The *ASMP Stock Photography Handbook* suggests that you read Chapter 13 on the photographer's estate, which includes a discussion of the care and handling of stock files.

Taxes/inability to locate photographer. This is self-explanatory.

Indemnity. The photographer and agency will protect and hold the other harmless in case agreements or warranties by either party are breached.

Independent contractor/miscellaneous. These items are self-explanatory.

Contract Between
Photographer and Stock Picture Agency

AGREEMENT made this................day of................., 199................, by
and between [name and address of Photographer]...
...
(hereinafter referred to as "Photographer") and [name and address of agency]..................
...
(hereinafter referred to as "Agency").

RECITALS

Photographer is engaged in the business of creating photographic images (hereinafter referred to as "Images"). Agency is in the business of arranging for the license of such Images to interested clients (hereinafter referred to as "Clients"). Photographer and Agency have determined that it is in their mutual best interest to enter into this Agreement whereby Agency shall represent certain Images of Photographer for license to Clients upon the terms and conditions which are set forth herein.

1. Grant of Authority

(a) Photographer hereby appoints Agency and Agency hereby accepts such appointment as Photographer's agent in respect of the license of Photographer's Images. As used herein, the term "Images" shall be limited to those Images created by the Photographer as shall be delivered by Photographer to Agency and accepted by Agency pursuant to Paragraph 3, below.

(b) Agency is granted limited exclusivity hereunder as follows [check approriate limitations]:
 (i) Regional U.S. as follows...
 United States, its territories and possessions..
 Foreign countries as follows:..
 (ii) B&W................ Color................ Both B&W and Color...............
 (iii) Stock............. Assignment............. Both Stock & Assignment.............
 (iv) May Agency employ Subagents? Yes...................... No......................
 If "yes," list permissible Subagents...
 ...
 ...

(c) The obligation of exclusivity set forth in subparagraph (b) shall consist solely of Photographer's covenant not to place the Images with any other stock picture agency, picture library, or other similar selling medium of Images as limited by subparagraph (b). Unless otherwise provided, nothing contained herein shall in any way be deemed to prevent Photographer from engaging in assignment photography for Photographer's own account or from engaging in the sale or license of Images directly to Clients. The accounts listed on Exhibit A, attached hereto, shall be deemed "House Accounts" and serviced exclusively by Photographer for all purposes, and all fees attributable to "House Accounts" shall be Photographer's sole and exclusive property.

(d) Except as may otherwise be provided herein, Agency shall have discretion regarding the terms and conditions of any license of the Images delivered to it by Photographer. Notwithstanding the foregoing, any license of rights in and to the Images, on a "buy-out" (i.e., a transfer of all or substantially all rights in and to an Image) or "exclusive" basis, shall require Photographer's prior written approval, not to be unreasonably withheld. Agency shall have no authority to transfer to any client any underlying rights in the Images.

(e) Agency acknowledges that it will not license the use of any of the Images for less than........
Dollars ($..............) without Photographer's prior written approval.

2. Term

(a) This Agreement shall commence as of the date first set forth above and shall continue for a period of three (3) years thereafter (the "Initial Period"). Agency shall have the right, at least thirty (30) days prior to the expiration of the Initial Period, to notify Photographer of its desire to renew the Agreement for an additional period of one (1) year commencing upon the expiration of the Initial Period. Agency shall thereafter have a continuing right, upon thirty (30) days' written notice prior to the expiration of each successive renewal period, to elect to extend the term of the Agreement for a one (1) year period. Notwithstanding the foregoing, Photographer may, upon receipt of any such thirty (30) days' notice, notify Agency of its desire to terminate this Agreement, and the Agreement shall thereafter terminate at the expiration of the then current Term. The Initial Period and each renewal period are collectively referred to herein as the "Term."

(b) In the event Agency has failed to derive gross billings from Photographer's Images for a period of one (1) year, Photographer shall have the right to terminate this Agreement on thirty (30) days' prior written notice to Agency.

3. Delivery of Images

(a) Promptly after the execution of this Agreement, Photographer shall deliver to Agency such Images as Photographer deems will further the purposes of this Agreement. Promptly upon receipt of such material, Agency shall review same and within thirty (30) days thereafter return to Photographer all Images, designating those Images which Agency deems appropriate for license pursuant to its Agency obligations hereunder. Images so designated shall be redelivered to Agency and the use of same shall be governed by this Agreement. Images not selected and not representing so-called "dupes" or "similars" to Images designated by Agency may be sold, licensed, or used by Photographer in Photographer's sole discretion.

(b) Images redelivered to Agency for use pursuant to the terms of this Agreement shall at all times be and remain the exclusive property of Photographer, to be held in trust by Agency solely for the limited licensing purposes described herein.

(c) All references herein to "Images" shall be deemed to refer to those Images accepted by Agency.

4. Obligations of Photographer

Photographer shall use all reasonable efforts to accurately caption all Images, and affix proper copyright notice in Photographer's name to such Images. Photographer shall indicate those Images for which a "model release" has been obtained. Upon Agency's request, Photographer will deliver a copy of any release to Agency. In the event an Image does not contain a notation concerning the existence of a model release, Agency acknowledges that no such release shall be deemed to exist and Agency assumes full responsibility for the subsequent use of such Images, and releases and indemnifies Photographer from any and all damages incurred by Agency, Photographer, or third parties in connection with such uses.

5. Warranties of Photographer

Photographer represents and warrants to Agency as follows:

(a) Photographer is the sole and exclusive owner of the Images and of the right to license such Images.

(b) The Images do not knowingly infringe copyright, trademark, right of privacy or publicity, and do not knowingly defame any third party.

(c) Photographer has the right to enter into this Agreement and perform Photographer's obligations hereunder.

6. Obligations of Agency

(a) Agency shall supply a suitable environment for long-term storage, care, and retrieval of Images, including protection from dust, heat, damp, and overexposure to light.

(b) Agency shall use its best efforts to license the Images and to maximize the prices received by Agency for same.

(c) Agency shall diligently and carefully process all Images so as to avoid loss or damages thereto, and index the Images with reference in each case to Photographer's name. The method of indexing the Images shall be in the Agency's sole discretion, provided such method must permit location of any Image within two (2) weeks and return to Photographer within one (1) month after request for same by Photographer, subject to Paragraph 8, below. Upon the return of any Image to Agency from a Client, Agency shall promptly cause such Image to be refiled so as to insure ready access for subsequent licensing and/or retrieval.

(d) All Images licensed by Agency shall contain copyright notice in Photographer's name as such notice has been indicated by Photographer on the face of the Images. In the event no notice is so affixed, Agency agrees to affix notice in Photographer's name before license of any Images to the Clients as follows: ©199_____ [Photographer's name], and Agency in each such case shall determine from Photographer and shall utilize the correct year to be included in said notice. Agency shall require, in all agreements with Clients, that the Images shall be protected by copyright in all uses, pursuant to applicable law or regulation.

(e) Agency shall promptly notify Photographer in the event it discovers unauthorized or infringing use of or the loss of or damage to any of the Images. Upon receipt of such notice, Photographer shall control any legal action and shall notify Agency as to the manner in which Photographer wishes to proceed in respect of such infringement, loss, or damage. Photographer shall have the right to cause Agency to be joined as a party in any litigation concerning the Images. Any recovery from such action shall, after payment of all costs (including reasonable attorney's fees), be divided between Photographer and Agency on the same basis as revenue is to be divided, as set forth in Paragraph 7, below.

(f) Agency agrees to conduct itself in all its dealing with Clients in an ethical and reputable fashion.

(g) Agency acknowledges that the Images are of a unique, fragile, and extraordinary artistic nature which cannot be easily duplicated and the loss or damage to any such material will result in irreparable harm to Photographer, not readily compensable by monetary reimbursement. Accordingly, Agent will use its best efforts to protect and preserve the Images, and exercise all due care in the handling of the Images.

(h) To the extent information supplied to Clients by Agency in respect of an Image differs from the information supplied to Agency by Photographer, the accuracy of such information shall be Agency's sole responsibility.

(i) All obligations of Agency under this Agreement apply as well to all permissible subagents.

7. Compensation

(a) In consideration of the services furnished by Agency hereunder and the performance of its obligations hereunder, Agency shall be permitted to retain:percent (.....%) of gross billings in connection with the license of the Images. "Gross billings" shall be defined as all revenue, of whatever nature and from whatever source, derived from license of the Images, and shall include, without limitation, holding fees and interest assessed, but shall not be deemed to include so-called "service fees." The only permissible deductions from gross billings are the following:

 (i) bad debts and other uncollectible sums actually incurred;
 (ii) reasonable currency conversion costs.

Agency acknowledges that all sums received as gross billings from the license of the Images are held in trust for Photographer, subject only to the retention by Agency of its commission as set forth above.

(b) Agency shall remit payment and provide Photographer with a detailed statement setting forth the licensing by Agency of the Images on the following basis [select one]:

☐ (i) Every thirty (30) days on or before the 25th day of each month.
☐(ii) Every sixty (60) days on or before the last day of each odd ☐/even ☐ numbered calendar month.
☐(iii) Every ninety (90) days on or before fifteen (15) days after the close of each calendar quarter.

(c) Such statement shall include the following information:
 (i) Identity of image
 (ii) Identity of Client
 (iii) Rights granted
 (iv) Date payment received
 (v) Gross billings
 (vi) Deductions from gross billings.

(d) If, during any reporting period, gross billings derived from Photographer's Images do not exceed One Hundred Dollars ($100), payment of such sums to Photographer may be deferred until the next reporting period. In no event, however, shall royalties be paid any less frequently than annually, and notwithstanding any deferral of payment, regular statements shall continue to be sent to Photographer.

(e) Photographer or a designated representative shall have the right, upon reasonable notice and during regular business hours, to inspect Agency's books and records and to make extracts thereof as same relate to Photographer's Images. In the event, as a result of such an audit, it is determined that Agency has underpaid Photographer by an amount equal to or in excess of five percent (5%) of all monies due to Photographer, then Agency shall bear all costs and expenses of such audit as well as remitting to Photographer all past due sums with interest to date. The foregoing shall not be deemed to be a waiver of or limitation upon Photographer's other rights or remedies in the event of such underpayment.

8. Retrieval of Images

(a) Upon the expiration or termination of this Agreement, Agency shall use all reasonable efforts to promptly retrieve and turn over to Photographer all the Images then in Agency's possession, no matter where such Images may be located. In no event shall such retrieval and delivery to Photographer require more than a period of (i) three (3) months after termination, in respect of Images in Agency's files; or (ii) one (1) year after expiration or termination in respect of Images in the possession of Clients at the time of such expiration or termination.

(b) Photographer shall have direct access to Agency's files, upon reasonable prior notice, for purposes of furtherance of Photographer's professional interests (e.g., exhibitions), or in the event Agency does not comply with its retrieval and return obligations pursuant to this paragraph.

(c) During the retrieval period after termination or expiration, Agency shall diligently return to Photographer all Images returned by Clients. If Images are still outstanding one (1) year after termination or expiration, Agency shall provide Photographer with written notification specifically setting forth: (i) identification of Image; (ii) name of Client in whose possession Image is being held; and (iii) address of Client.

9. Dupes

(a) For purposes of this paragraph, "Dupes" shall be defined as duplicates, facsimiles, or other reproductions of Images, whether created by Photographer, Agency, permissible subagents, or clients.

(b) Agency [select one]
 shall ☐ shall not ☐
be authorized to license the use of "Dupes" to clients.

(c) In the event licensing of "Dupes" has been authorized, Agency shall not permit clients to create "Dupes" without Photographer's prior written approval.

(d) All "Dupes," regardless of which party has caused such "Dupes" to be created, shall be and remain, from the moment of creation, the sole and exclusive property of Photographer, subject only to permissible licenses.

(e) Agency shall account to Photographer for "Dupes" in all respects as if they were Images licensed under this Agreement and all provisions of this Agreement shall apply to such "Dupes."

10. Default

(a) Agency shall be deemed to be in default of its obligations upon any of the following occurrences:

(i) Breach of any of its representations or warranties contained herein or any other undertaking on its part to be performed hereunder and failure by Agency to cure such breach within ten (10) days after receipt of notice from Photographer specifying same.

(ii) Any activity by Agency outside the limited scope of the authorization issued to Agency hereunder.

(iii) If a petition in bankruptcy or for reorganization is filed by or against Agency; or if Agency makes an assignment for the benefit of its creditors; or if Agency fails to timely pay its general creditors; or if a receiver, trustee, liquidator, or custodian is appointed for all or a substantial part of Agency's property, and the order of appointment is not vacated within thirty (30) days; or if Agency assigns or encumbers this Agreement contrary to the terms hereof.

(iv) If agency ceases to conduct its business or sells or merges substantially all of its assets.

(b) In the event of any act of default as set forth above, in addition to any other remedy Photographer may have, Photographer shall be entitled to immediately terminate Agency's authorization under this Agreement and shall thereupon be relieved of any continuing obligation it may have to Agency. Upon such termination, all business activity in respect of the Images shall immediately cease, and Agency will promptly retrieve and deliver to Photographer all Images as required pursuant to Paragraph 8, above.

11. Foreign Subagents

In the event Photographer permits Agency to employ the services of any foreign subagents in connection with the license of the Images, Agency may do so, subject to the prior written approval of the Photographer first having been obtained after notification to Photographer of the name and address of the proposed subagent. In no event shall Agency commission or fees, including the fees of Agency and all permissible subagents, exceed that percentage of gross billings specifically stated as Agency's compensation in Paragraph 7, above.

12. Death or Disability of Photographer

In the event Photographer shall die during the Term hereof or shall become disabled or incompetent, Photographer or, in the case of death or incompetency, Photographer's personal representative, shall have the right, exercisable by sixty (60) days' prior written notice to Agency, to cause this agreement and Agency's authorization hereunder to terminate.

13. Taxes

As between Photographer and Agency, Agency shall be solely responsible for the collection and payment of any and all taxes whether in the nature of a sales, personal property, remittance, excise, or other tax which is or may become due and payable in connection with any license of the Images pursuant to the terms of this Agreement.

14. Inability to Locate Photographer

(a) Agency shall use all reasonable efforts (including inquiries with appropriate trade associations) to locate Photographer in the event statements are returned unclaimed. To assist Agency in this endeavor, Photographer shall provide Agency with an alternate address for notice purposes on the signature page of this Agreement.

(b) In the event that, notwithstanding Agency's efforts, Photographer cannot be located, Agency shall deposit any portion of gross billings due to Photographer in a separate interest-bearing account (into which account Agency may deposit sums due to other Photographers whom Agency is unable to locate). Such sums shall remain on deposit for a period of five (5) years or such longer period of time as may be permissible by law. Six (6) months prior to the expiration of such time period, Agency shall provide the American Society of Magazine Photographers, 419 Park Avenue South, New York, New York 10016, or its successor organization, with written notice of the name and last known address of Photographer. Such notice shall be sent to the Executive Director by certified mail.

(c) If Agency is not contacted by Photographer or his/or personal representative before the expiration of such time period, the sums on deposit with Agency shall be treated according to the laws of the State of . concerning abandoned property.

15. Indemnity

(a) Each of the parties hereto agrees to indemnify and hold the other party harmless from and against all final judgments and settlements with consent (hereafter collectively referred to as "claims") which may arise as a result of a breach or alleged breach of the party granting the indemnity (hereinafter the "Indemnitor") of any representation, warranty, or undertaking to be performed by such Indemnitor. The party being indemnified (hereinafter the "Indemnitee") shall promptly notify the Indemnitor of any such claim, and the Indemnitor shall thereupon have the right to undertake the defense of such claim. The Indemnitee shall have the right, but not the obligation, to be represented by counsel of its choice and participate in such defense at its sole cost and expense. The Indemnitee shall not settle any such claim without the prior written approval of the Indemnitor.

(b) Anything to the contrary containing herein notwithstanding, in the event Photographer is called upon to indemnify Agency pursuant to the foregoing indemnity, Photographer shall not be liable for any monetary sums in excess of the share of gross billings heretofore received by Photographer from Agency pursuant to this Agreement.

16. Independent Contractor

The parties hereto acknowledge that this Agreement is one of agency only and does not constitute an employment agreement and that Agency is acting in the limited capacity of an independently retained agent on Photographer's behalf. Agency may not set itself out or bind Photographer contrary to the terms hereof.

17. Miscellaneous

(a) Agency may not assign this Agreement without the prior written consent of Photographer. Any assignment in contravention of the foregoing prohibition shall be deemed null and void. Photographer shall have the right to assign this Agreement to any corporation in which Photographer is a principal stockholder, and to assign Photographer's share of gross billings earned hereunder.

(b) Except as may otherwise be provided herein, this Agreement shall be binding upon and shall inure to the benefit of the respective heirs, executors, administrators, successors and assigns of the parties hereto.

(c) This Agreement incorporates the entire understanding of the parties concerning the subject matter contained herein and may not be modified, amended or otherwise changed in any respect except by a separate writing signed by the party to be charged therewith.

(d) This Agreement and all matters collateral thereto shall be construed according to the laws of the State of . and any jurisdiction of such state.

IN WITNESS WHEREOF, the parties have excecuted this Agreement on the day and date first set forth above.

. .

 (Agency) (Photographer)

 .

 (Address)

 .

 (Business Telephone)

ASMP's sample stock-agency contract is a good one for study and comparison, and may also help educate an attorney on items to check in an agency contract under consideration by a photographer.

CONTRACT NEGOTIATION

Contracts may look like they're cast in stone, but the terms in an agency contract are negotiable according to the needs and desires of the parties involved. Read the contract thoroughly or have an attorney do it for you. Make notes and be sure you understand every item involved. If you aren't sure of what a clause or term means, ask for an explanation. Never assume.

Compare an agency contract with the "ideal" ASMP sample contract, which was written to protect the photographer's best interests. Mark the places you want to change or inquire about and make a list of the topics. "Ask yourself what you are willing to give up and what you expect they might give up," says the *ASMP Stock Photography Handbook* essay on contracts. Try to assess the agency's needs objectively. "The key to successful negotiating is in finding some meeting point where the line between the wants and needs of the agency and photographer meet."

When an agency contract includes stipulations you find difficult to accept, remember that it is a changeable document. Keep in mind that your work is appealing enough to the agency to offer you a contract, so you have some clout, too. As you discuss contract differences, try to think of alternate ways of meeting the agency's needs. Maybe you can propose compromise terms it'll find agreeable. Write those alternatives down for discussion, and try to be reasonable.

Here are some negotiating tips. Express your concerns, and explain how you understand the agency's point of view. Empathize with the agency if it says it has problems in "making exceptions," but point out that the contract must meet your minimum needs at least. Frankly explain that you want to sign with the agency, but you have to protect your own best interests. If you're willing to compromise, why isn't it? You're merely asking for a fair deal. Be prepared to hold out on something, and then offer to trade it for a concession on the agency's part. As the *ASMP Stock Photography Handbook* says, *"Don't be intimidated.* They wouldn't be talking to you if they didn't want your work Be specific, reasonable, persistent. Be a negotiator."

Photographers have compared finding the right stock agency with finding a good doctor or even a compatible spouse. The key to the arrangement is trust. Don't rush to make an affiliation until you're satisfied with your research, and you have a good feeling about whatever agency (or agencies) you like best.

10 NEW TECHNOLOGIES IN STOCK

It is unlikely that photographers are going to install new, expensive high-tech equipment in their offices or homes to transmit digitized images to clients, but that is what's happening at stock agencies and other would-be picture suppliers. Photographs can also be manipulated and combined electronically. So clients might receive original images with no credit lines that they could alter or combine. These new technologies may affect your business. Combining images or digital transmission from a collection may rob a photographer of credit and/or payment, but computerized distribution of images is a convenience to the advertising and publishing worlds. Because sophisticated computers, programs, and other electronic marvels are stretching the boundaries of stock photography, the highlights and pitfalls of these new processes are reviewed here.

PICTURES ON A DISC

Today computers are able to track, analyze, record, and, most recently, *digitize* everything from illegal transactions by drug dealers to superior stock images offered by agencies to buyers. Digitizing converts photographs, still or in motion, into millions of bits called *pixels*. A computer screen is composed of these tiny dots, which may be thought of as miniature light bulbs in an electric sign. Each microscopically small pixel can be switched on and off like the bulb in a sign, but this happens dozens of times a second. Another analogy compares digitizing

to screening a photograph to make a halftone but with far more gradations. The more pixels there are per square inch, the sharper the resolution of an image. *Low-resolution* (low-res) digitized images don't reproduce well in printed form, but *high-resolution* (high-res) images reproduce similar to the way original color slides do.

When an image is digitized, its component bits may be recorded on magnetic tape or on a compact disc, or they can be stored in a computer's memory to be read immediately. Bits are reassembled electronically for playback of an image on a screen, or pixels of an image can be reconstituted as a color print or color separation. When you shoot with a digital-still camera, the conversion to pixels takes place as the image is created, so there is no film. With other equipment a slide or print may be scanned and digitized by a computer and the resulting assemblage of pixels stored internally. Fax machines use a similar scanning process to transmit printed words and pictures over a telephone line.

In a digital camera, images carried through the lens are electronically translated to a magnetic disc. A disc drive then operates as a coding device that converts images from a still-video camera to be viewed on a monitor. Creating a print, according to the *ASMP Stock Photography Handbook*, "requires a separate device, which may ultimately be marketed as an accessory to the drive The day when we'll be processing digitized images from disc to print, much as we process film now, is clearly on the horizon." That process is now used regularly.

Picture resolution isn't as good from a magnetic disc as from conventional film—yet. In late 1991 the maximum number of pixels produced on a computer compact disc (CCD) for a 35mm slide was between 500,000 and 1.1 million. In comparison, a Kodachrome 25 slide has a resolution equivalent to about 5.2 million pixels. However, high-res video monitors used for special effects have at least 2,000 lines running in each direction for a total of 4 million pixels. (A standard television screen has 525 lines and 275,626 pixels.) Various companies are working to improve the resolution of digitized photographs via software and hardware innovations, which are announced regularly.

DIGITAL IMAGES AS STOCK

Today photographers present their *original* images to clients. Between now and the twenty-first century, film and paper may well be supplanted by invisible pixels manipulated by tiny computer chips to be viewed on a monitor or transformed into film or paper pictures—without conventional cameras. Original chromes can already be transmitted digitally from a

stock agency, for instance, to clients or to branch agencies that have compatible equipment. Slides, negatives, and prints can be scanned and converted into pixels for transmission over telephone lines. At the receiving end an image can be converted to color separations or color film, positive or negative, by special printing equipment.

Technical problems involving retaining high-res image quality are still formidable enough to limit the uses of this method of imaging. However, some stock agencies are transmitting low-res digital images so clients can preview and select slides or prints. Low-res images can be transmitted more quickly and are more efficient to work with but they don't reproduce well because of their lack of sharpness.

Some magazine and book publishers now receive digitized pictures that are reconstituted as transparencies or prints and reproduced in conventional ways. National Digital Corporation (NDC) equipment is capable of creating low-res images that may be transmitted for previewing in less than a minute, as well as high-res pictures that require about 12 minutes to scan and transmit. *Photo District News (PDN)* reported that three news magazines used cover shots that were transmitted via digitizing equipment during the Persian Gulf war.

THE DIGITIZING PROCESS

At a stock agency, *PDN* explained, when an image request is received, a slide or print is pulled from the files and scanned over a lightbox by a video camera attached to a computer. An image is then compressed for transmission over telephone lines using a high-speed modem. The NDC system is also capable of digitizing and translating images into a form that can be transmitted via a fax machine. Every agency and design firm has a fax machine, which means all of them can preview images without needing the more elaborate and costly NDC equipment. According to the *PDN* report, a stock-agency executive said that "the fax option is used about five times more often than the transmission to computer because customers find it easy to use."

The transmission of photographs via the NDC system saves time and speeds up business decisions. An agency in New York City can preview a news picture sent from a European city via computer and telephone lines, and a deal can be made the same day. Then, as reported in the same *PDN* story, the New York agency's European office can take the slide to the magazine's local office for computer transmission to New York, or a selection of images can be flown over on the Concorde the next day.

Larger stock agencies are equipping themselves with NDC systems for fast service to such buyers as publishers and advertising agencies

and for transmission of pictures to branch offices in the United States or abroad. Today medium-size and smaller agencies may not need such equipment until competition and volume warrant the investment. Agencies that do use electronic transmission of images also send delivery memos similar to those used for original slides or dupes to protect the rights of both the agency and the photographer. When the reconstituted digitized image has been used by a buyer, I assume that it is returned to the agency by mail or an overnight-express service.

CD-ROM PICTURE DISTRIBUTION

The term *CD-ROM* stands for compact disc, read-only memory. This condenses millions of digitized photographs video-copied for this form of storage. This is similar to sending digitized images over telephone lines. But in CD-ROM form they're recorded and viewed via special CD players attached to computer monitors using special software. A CD produces good quality, but the images can't be manipulated because you can't "write" more on a CD. It is for reading only.

In the early 1980s when CD-ROM image collections were introduced, one outfit purporting to be a stock agency in formation contacted numerous photographers to arrange to include hundreds of their pictures on its forthcoming CD. The agency planned to sell copies to stock users along with CD players and said that it was arranging with a special lab to make dupe slides for buyers who ordered from the CD-ROM collection being assembled.

Because a CD can hold hundreds of images in small format, this so-called stock outfit was hungry for product but negligent about photographers' rights. I heard that the company did manage to fill a CD and distribute some to buyers, but later it collapsed from the weight of its own scheme, which wasn't well thought out. Photographers were left holding paper agreements that didn't safeguard their interests well. I believe that the photographers had problems getting their work back from this now defunct company. I mention this unfortunate event as a warning about similar arrangements you may hear of. Investigate thoroughly. Ask colleagues about their experiences and for their opinions. New technologies breed new dubious techniques in order to acquire product.

CLIP COLLECTIONS

More recently in mid-1991 *PDN* reported that several companies now publish "clip collections," with which artists are supposed to make layouts

only of photographs on CD-ROMs. Pictures are made available for instant use inexpensively. While the resolution of the images on these discs isn't high enough for magazine-quality color separations, one company sells dupe slides of images on the disc for ridiculously low prices. But the most unbelievable part of this specific arrangement is that in some cases, *all rights* to pictures reconstituted from some discs are available with no further charge beyond the few hundred dollars for the disc itself.

In the September 1991 issue of *PDN* a story about variations on the CD-storage-and-distribution theme includes a contract offered by Microsoft. *PDN* calls this "a blueprint for giving away the store." Marty Loken, president of All-Stock and of the Picture Agency Council of America (PACA), says, "This is a nonexclusive buyout by an entity that has the ability to put images into the public domain. It is incomprehensible that any photographer or agency would sign this."

Some photographers who've sold their work for these clip collections say that they are "experimental" and hope for volume sale of discs on which they receive a royalty. It is too early to tell if that philosophy is financially valid but super-cut-rate stock photographs won't appeal to quality markets because they are simultaneously available to anyone who buys an identical CD. As such the validity of signing an all-rights agreement with a CD publisher seems not only unwise but self-defeating. Clip-picture discs may cut into conventional stock sales and won't do the professional photography industry any good. If you're approached keep in mind that once your name and work are included in a low-priced photographic collection, your reputation may be undermined.

MANIPULATION BY COMPUTER

Using high-tech methods similar to those responsible for special effects seen in some movies, sophisticated computers are capable of photographic manipulation. This includes combining several images to create a new picture. Elaborate and expensive equipment from Scitex, Crossfield, or Hell, or hardware and software systems designed by other individuals and companies are becoming more commonplace. With complex software it is possible for a skilled operator to eliminate the background in a photograph of a home on the edge of the sea and reposition the home among green hills, beside a pond, or perhaps with children playing nearby with other homes visible. If there are clouds in the home-by-the-sea picture and you want a blue sky, you can achieve this as well. If the stock buyer needs a woman in the foreground instead of a man, the substitution can be made via a computer program.

A *Los Angeles Times* article about movie special effects discussed a
chase sequence in *Terminator* in which director James Cameron had a
large street sign transposed by digitally reversing the lettering and
correcting the perspective for the altered point of view. The possibilities
of digital-image manipulation of still images on a computer screen are
also endless, and they can be produced later as prints, transparencies,
or color separations ready for the printer.

DIGITAL RETOUCHING

Computer technology is also used to retouch photographs or to correct
colors in transparencies before or after separations are made. For
example, if you shoot a sunset and leave the location before the sun is a
deep orange, you can enhance the color by computer. Manipulation can
also help to refine an image, tone down bright spots, eliminate shadows,
or get rid of blemishes. These are electronic manifestations of
retouching limited only by creative talent. Such innovative processes are
being used to improve advertising photographs, often from stock files.

Potential computer manipulation can also tempt editors of
newspapers and magazines, large and small. A television magazine once
ran a cover showing a talk-show host's head combined with a model's
body, supposedly to show how the celebrity had slimmed down. The
seamless result was effective, if inaccurate. Even the respected *National
Geographic* once altered the position of the pyramids at Giza to orient
them better into its cover format.

MANIPULATION AND COPYRIGHT PROBLEMS

Several serious problems accompany image manipulation. A client using
a new image made by combining several originals may not try to sort
out the credits to apply for a joint copyright in the names of those whose
work is involved. A client may not even admit having a composite image
made using one of your originals. So if the user is unscrupulous, it may
be difficult for you to discover how your work was used and to get paid.
Some stock-agency owners are concerned that the industry isn't ready
to cope with the dangers of loss of copyright control.

In the May 1990 issue of *PDN* editor Nancy Madlin wrote a cogent
article, "High-Tech and Copyright," which she believes mix as well as oil
and water do. Fears about controlling the usage of digitized photographs
are very real, she reported. This isn't an issue that producers of CD-
ROM collections, for instance, are very eager to discuss. "They're afraid

we'll start worrying about the copyright implications . . . and they don't have any solutions. This leaves users' honesty and the copyright law the only things standing between your images and their repeated re-use all over the globe," she said. Some nearsighted picture buyers feel that photographers are standing in the way of progress by demanding payments for their work. One person at a conference on the effects of new technology on photography actually argued that perhaps we shouldn't continue to think that copying is "morally wrong."

A suggested partial solution is a *copyright collective,* a group formed to license usage of many people's photographs and collect fees that are distributed to the copyright owners. This system has long been used in the music business to collect fees from radio stations and orchestras, but it is uncertain whether it can be adapted to published photography in a broad way. One organization called the Copyright Clearance Center in Salem, Massachusetts, has operated since 1978 to grant rights to industry to make photocopies and collect for the rights holders. But the group's effectiveness is reduced because it has no internal legal enforcement capability.

In Madlin's article about high-tech and copyrights, she also quoted Marty Loken, head of the Allstock agency in Seattle, Washington, who feels that ways of doing business will have to change. In regard to stock collections on discs, Loken said that "clients don't *want* to do the research. They want us to find the pictures for them within hours or overnight. They also need someone to help them find solutions to creative problems, and the human mind is still way ahead of the computer in terms of imagining and understanding concepts We'll all get to live a while longer with our antiquated ways of doing business."

I hope that PACA, to which the best agencies belong, together with photographers' organizations, such as ASMP, will devise ways to monitor the problems and ambiguities of manipulated, combined, or retouched photographs to help cope with the smokescreen that some wish to blow over ownership and compensation.

Try to keep track of the expanding digital computerized photographic world. Find out as much as you can about the proposed uses of your pictures. Keep in mind that it isn't "re-use" but a new use when your pictures from a book are digitized for a disc by the same publisher. You might inquire at the stock agency that licenses your work about how it handles sales for videodiscs and collections. Reputable agencies will give you a straight story. If you sell your own stock, check with colleagues about rates and the customs of publishers in what is sometimes called "interactive media" or "desktop media." Both indicate collections or combinations of pictures, often with words.

11 LEGAL ASPECTS OF THE STOCK-PHOTOGRAPHY BUSINESS

You can avoid or minimize legal problems in selling stock photography by remembering a few principles. First, never assume. Be specific, and include complete paperwork with your submissions. Get receipts for all deliveries; clients must be accountable. Be sure to use the copyright symbol on your work. Always keep your eyes open for your own photographs in print, and ask friends and relatives to do the same. Try not to accept excuses in place of proper fees and credits. Finally, don't be intimidated when you know your rights have been abrogated. If these practices become second nature to you, you should have little if any legal trouble with your stock photography.

A few years ago a photographer left some stock slides of models with an art director for review. He had a receipt signed for them, but he didn't include a delivery memo that contained more complete terms. Shortly afterward the art director was asked by a department of his company for a "pretty-girl" picture and quickly arranged with the photographer to use one of his chromes. Within a few weeks the image appeared on the cover of a brochure for some plumbing equipment. The photographer was paid, and all the slides were returned to him.

When the model discovered her picture in the brochure, quite by accident, she sued the photographer who had no release. He had taken

the picture while testing the model, and he intended to pay her and get a release when one was needed. (This, of course, wasn't a good plan.) He forgot. She asked for $3,500 including damages. Fortunately, the photographer had liability insurance covering such circumstances, and the insurance company settled on a compromise with the model. However, the art director had also been negligent in not asking for a model release before using the picture in the brochure, and his company's insurance shared in the settlement.

PHOTOGRAPHIC MODEL RELEASES

Model releases amplify the usefulness of all stock pictures that include recognizable people. Releases can make the difference between leasing a shot for $250 to a travel magazine (for which a release isn't necessary) and leasing the same picture for $2,500 to an advertiser (in this situation, no release means no sale). A signed model release gives you and your client permission to use pictures when someone otherwise could bring a *right-of-privacy* lawsuit against you and the picture buyer. This could be far more expensive than paying a model for signing a release in the first place.

Model releases are absolutely essential for recognizable people used in advertising. A release gives you permission to use specific photographs of individuals, adults or minors, and the release informs models what they're agreeing to. The usual signed release allows the photographer to lease pictures for purposes of trade and advertising. It also helps protect the photographer against an *invasion-of-privacy* lawsuit, and it may protect against a libel suit if a model claims that he or she has been ridiculed and has lost status and/or income.

Model releases are also required for most pictures used in corporate publications, for illustration of fiction, and in some states for use of a photograph on a magazine cover. Remember, setup stock photographs are good sellers not only because the photographer has control of people, places, and things, but also because models routinely sign releases covering advertising and trade.

Released pictures are a cornerstone of stock photography. They aren't generally necessary for stock shots used in magazines, books, and other editorial or informational purposes. The First Amendment to the Constitution protects, without releases, nonadvertising or noncommercial photographs in any medium on any subject of public interest, about any person. In most states a magazine or book cover is considered noncommercial, and no release is needed when the cover of a book is

used in a paid ad. However, if the book cover is used to advertise any other product, a model release will be necessary.

In some cases courts say there must be a reasonably close relationship between the person(s) shown and the topic illustrated. However in a recent case a photograph of a large family was used to illustrate a magazine article on birth control. Although they weren't mentioned in the article, they sued for invasion of privacy and lost. Even so, when you shoot stock where requesting releases is feasible, do it.

In some cases magazine editors like to have releases for children seen in pictures, mainly for the assurance that parents won't declare later their children were "exploited." Often such pictures are assigned and releases obtained. In a case when someone complains to an editorial or educational publication that his or her picture was used without permission and the photographer has no release, the publication usually explains why no release was necessary. The publication's goal is to avoid a nuisance suit by unscrupulous people who hope to be "bought off" with small sums.

In news or featured stories used by a company publication for internal or external distribution, editorial matter *may* be considered commercial. I've worked for magazines and newsletters, such as those published by Chevrolet, Ford, IBM, and an independent grocers association, and their policies differed. Some required releases; some didn't. Ask about releases when you have picture requests. Many company publications are flexible.

Timeliness isn't strictly defined by the First Amendment, so photographs taken months or years ago may usually be used editorially without releases. Pictures showing social conditions are also protected. For example, shots of homeless people leased to newspapers and magazines don't need releases in proper context. Pictures of public figures, such as politicians, movie stars, and other celebrities, can also be published without releases, except for advertising. Prominent names and faces are considered news and "fair game" for photographers, even if something potentially embarrassing's happening. However, captions must be substantially factual. When people die, their right to privacy ceases in nonadvertising media, but in some states pictures of deceased people may not be used for advertising or trade without permission from their estates.

All this means that legally you may shoot and offer for publication any subjects that aren't specifically restricted without permission, and not worry about releases. Restrictions and permissions are required at most military installations, in courtrooms, inside museums, at concerts or theaters, in private homes, in or at other places that request no pictures be taken, and anywhere you or a tripod might interfere with traffic. Remember, you may *shoot* in many locations without permission or need

for model releases, but you may not *sell* or *lease* pictures for advertising or commercial use without signed releases if you want to avoid trouble.

When you photograph someone this week and get a signed release, keep in mind that if you photograph the same person again next month for a different reason, you'll need a new release. Each release pertains to a separate set of images that should be described, complete with roll numbers and date, on the release forms. If you hire models, there should be no problem about getting new releases each time you work together; if you photograph a friend at different times and the pictures have advertising potential, get separate releases for each session.

You don't have to pay a model to make a release legal. Amateur models would usually prefer prints or slides to being paid $1.00. If a shot has advertising potential, I promise amateur models 10 percent of the net fee for ad sales made.

In some states a minor is someone under 18; in others, the legal age is 21. Know the law in the state where you're shooting. If in doubt about a person's age, ask for a driver's license or some other form of identification. Some people may claim they are old enough to sign a release and then ask for money or threaten a suit if a shot is used commercially.

When your fine-art photographs are exhibited or published, you're usually protected without releases. Many such pictures are taken in public places where the right of privacy doesn't apply to photography. Get releases from portrait subjects when you feel you need protection. Pictures of nudes or scantily clad models require releases no matter where they're published. The release establishes that you had the models' permission to offer such pictures for publication. If you want to avoid releases for nudes, don't include the model's face, although I ask for a release as insurance even then.

Release customs fluctuate. Confer with your advertising, editorial, and book clients regarding their need for releases and ask advice from picture agencies. Remember that *you* as well as your subjects and clients have legal rights.

WORDING A MODEL RELEASE

A release states that the person photographed gives his or her permission to the photographer not only to take the picture, but also to use it in specific ways. A release should protect the photographer against invasion-of-privacy lawsuits, which may arise when a photograph is used for purposes of "trade or advertising." Releases can also protect you against libel suits. "The risks in these areas are extremely serious," says the *ASMP Stock Photography Handbook*.

A release must be dated; this is also true for storage envelopes for slides and negatives as well as your picture index. Individual slides and prints don't have to be dated. Your records should make it clear which release applies to which pictures. You need a new release covering each picture set that isn't part of a specific series.

Release forms from the *ASMP Stock Photography Handbook* are below and on pages 129–130. The longer adult release covers all the bases, but it may intimidate some people. Many professional photographers use a simplified release, but "it does not afford the overall protection of the longer release," advises the *ASMP Stock Photography Handbook*. The short form is also called a "pocket" release, which is easy to store in a

ADULT RELEASE

In consideration of my engagement as a model, and for other good and valuable consideration herein acknowledged as received, I hereby grant to _____ ("Photographer"), his/her heirs, legal representatives and assigns, those for whom Photographer is acting, and those acting with his/her authority and permission, the irrevocable and unrestricted right and permission to copyright, in his/her own name or otherwise, and use, re-use, publish, and re-publish photographic portraits or pictures of me or in which I may be included, in whole or in part, or composite or distorted in character or form, without restriction as to changes or alterations, in conjunction with my own or a fictitious name, or reproductions thereof in color or otherwise, made through any medium at his/her studios or elsewhere, and in any and all media now or hereafter known for illustration, promotion, art, editorial, advertising, trade, or any other purpose whatsoever. I also consent to the use of any printed matter in conjunction therewith.

I hereby waive any right that I may have to inspect or approve the finished product or products and the advertising copy or other matter that may be used in connection therewith or the use to which it may be applied.

I hereby release, discharge and agree to save harmless Photographer, his/her heirs, legal representatives and assigns, and all persons acting under his/her permission or authority or those for whom he/she is acting, from any liability by virtue of any blurring, distortion, alteration, optical illusion, or use in composite form, whether intentional or otherwise, that may occur or be produced in the taking of said picture or in any subsequent processing thereof, as well as any publication thereof, including without any limitation any claims for libel or invasion of privacy.

I hereby warrant that I am of full age and have the right to contract in my own name. I have read the above authorization, release, and agreement, prior to its execution, and I am fully familiar with the contents thereof. This release shall be binding upon me and my heirs, legal representatives, and assigns.

Date: _____ _____
 (Name)

_____ _____
 (Witness) (Address)

SIMPLIFIED ADULT RELEASE

For valuable consideration received, I hereby grant to _____ ("Photographer") the absolute and irrevocable right and unrestricted permission, in respect of photographic portraits or pictures that he/she had taken of me or in which I may be included with others, to copyright the same, in his/her own name or otherwise; to use, re-use, publish, and re-publish the same in whole or in part, individually or in conjunction with other photographs, and in conjunction with any printed matter, in any and all media now or hereafter known, and for any purpose whatsoever, for illustration, promotion, art, editorial, advertising and trade, or any other purpose whatsoever without restriction as to alteration; and to use my name in connection therewith if he/she so chooses.

I hereby release and discharge Photographer from any and all claims and demands arising out of or in connection with the use of the photographs, including without limitation any and all claims for libel or invasion of privacy.

This authorization and release shall also inure to the benefit of the heirs, legal representatives, licensees, and assigns of Photographer, as well as the person(s) for whom he/she took the photographs.

I am of full age and have the right to contract in my own name. I have read the foregoing and fully understand the contents thereof. This release shall be binding upon me and my heirs, legal representatives, and assigns.

Date: _____ _____

 (Name)

_____ _____

 (Witness) (Address)

camera bag. Use it with caution, warns the *ASMP Stock Photography Handbook*, because "every time you remove some language from a release, you are inevitably removing some degree of protection as well."

Note the phrase on the adult release, "for any purpose whatsoever," which covers a stock image for advertising or any other type of publication. In many cases you don't know what a picture may be used for, so get a signed release whenever possible. If you have no release for a salable shot, try to get one. If that is impossible for a picture that could be used for trade or advertising, talk to the client about retouching someone's features. Consult an attorney who is knowledgeable about publication law. You may also look into liability insurance to cover you in case of an unexpected suit, with or without a release.

With the help of an attorney, you might combine portions of one or two release forms into a single one for yourself, or you may write your

PROPERTY RELEASE

For good and valuable consideration herein acknowledged as received, the undersigned, being the legal owner of, or having the right to permit the taking and use of photographs of, certain property designated as _____, does grant to _____ ("Photographer"), his/her heirs, legal representatives, agents, and assigns the full rights to use such photographs and copyright same, in advertising, trade, or for any purpose.

The undersigned also consents to the use of any printed matter in conjunction therewith.

The undersigned hereby waives any right that he/she/it may have to inspect or approve the finished product or products, or the advertising copy or printed matter that may be used in connection therewith, or the use to which it may be applied.

The undersigned hereby releases, discharges, and agrees to save harmless Photographer, his/her heirs, legal representatives, and assigns, and all persons acting under his/her permission or authority, or those for whom he/she is acting, from any liability by virtue of any blurring, distortion, alteration, optical illusion, or use in composite form, whether intentional or otherwise, that may occur or be produced in the taking of said picture or in any subsequent processing thereof, as well as any publication thereof, even though it may subject me to ridicule, scandal, reproach, scorn, and indignity.

The undersigned hereby warrants that he/she is of full age and has every right to contract in his/her own name in the above regard. The undersigned states further that he/she has read the above authorization, release, and agreement, prior to its execution, and that he/she is fully familiar with the contents thereof. If the undersigned is signing as an agent or employee of a firm or corporation, the undersigned warrants that he/she is fully authorized to do so. This release shall be binding upon the undersigned and his/her/its heirs, legal representatives, successors, and assigns.

Date: _____

(Name)

(Witness)

(Address)

own full release plus a simplified form to suit your needs. The same advice applies to the releases for minors and property.

Ask the owners of featured homes or other real estate to sign property releases, so they don't feel they're being exploited for advertising and trade. However, if a building is incidentally part of a background in a picture, a property release isn't required. Photographers take all kinds of pictures that include homes, theaters, and office buildings, but when they aren't the dominant subjects, they're

considered incidental. When buildings and other property are included in advertising pictures, you need a release signed by the owners or their agents. This doesn't apply to a city street full of buildings, but you need releases for featured homes and other structures. There have been successful claims regarding identifiable buildings in advertising photographs for which no release was obtained, and the same is true for buildings in places where admission is charged.

The property release on page 130 can be adapted to cover animals by referring to the animal in the blank space calling for a description of the property. Again, this pertains only to commercial use of such pictures.

PUTTING YOUR RELEASES TO GOOD USE

File releases carefully. Place specific roll numbers on each release to match negatives or slides. When possible I also record frame numbers to make it easier to find shots later. Remember to date releases, and keep them with contact prints, negatives, or slides or file them separately in chronological order. I do the latter to make them more accessible. Each separate set of pictures of the same people requires its own release. Mark your stock photographs with the letters "R" or "NR" to indicate model-release availability. An agency or client will know if a picture can be considered for advertising. Never use "R" on a picture if you don't have the release in hand. You may, however, tell an agency or client that a release is available—then be sure to get it.

Ask to see other photographers' release forms and compare theirs to the ASMP forms, which may be the same. Include your name and address on release forms. It is easy to design your release on a computer and print it out or have photocopies made.

If you don't choose to ask people for releases while traveling, get their names and addresses so you can send pictures and request releases later. People are usually flattered to be photographed and will often cooperate.

Some model-release forms allow the use of a person's likeness in a composite or otherwise altered image, which covers retouching or computerized manipulation. If in doubt about coverage for these processes, get legal advice.

UNAUTHORIZED USE OF YOUR PHOTOGRAPHS

It might happen that a client leases a picture for a brochure and later reuses it in a newspaper ad without informing you or negotiating additional payment. This may occur because the slide was on hand and

someone was ignorant of proper business practice or claimed to be in too much of a rush to negotiate fees and rights. Occasionally it could happen in good faith when there is a misunderstanding. More often it is unethical, and it is always illegal.

First, you have to discover that a picture was reused, and some clients, or even stock agencies that might not report all sales to you, are counting on you remaining blithely uninformed. When you do find out, complain to your agency or contact the user if it was a direct sale. Either send a bill or discuss the fee, which should be doubled or tripled to cover unauthorized use. You'll probably have to negotiate a final fee, and you may have to hire an attorney, especially when the amount of money involved warrants it.

In another case, you or an agency may send a client a photograph as part of a portfolio, marked "not for reproduction," and later you find that it has been reproduced somewhere anyway. Again, this could be accidental or the guilty party may hope you don't discover your picture in print. Negotiate a fee and a penalty bonus for such unauthorized use, and get the picture back as soon as possible. You may have to take legal action against difficult parties.

Some clients think photographers can be exploited because "they make too much for picture sales anyhow," and because clients are bigger and have more clout. They might promise to buy your pictures in the future or make excuses and suggest you let this one pass. Try not to be manipulated. In most cases taking a firm stand will make clients realize that negotiating suitable payment is smart. Although people do make honest mistakes, you should assume at the start that you're being deliberately exploited to avoid payment. Accidental use of a picture is possible but needs to be rectified quickly. When clients seem sluggish in dealing with unauthorized use, they're often stalling to see if you'll just forget about the whole thing.

TAKING LEGAL ACTION

Before starting legal action because of unauthorized use, you may begin with a telephone call, and follow up with a written protest if action isn't immediate. Tactfully and firmly suggest a solution in terms of payment, including a penalty for ignoring your copyright.

Be prepared for promises of payment or settlement that are later ignored. Some offenders will give you a runaround as part of their way of "doing business." Consult an attorney immediately. A legal-sounding letter may be all that is necessary. If that doesn't work, arrange to sue for the reproduction fee plus damages and legal fees. A copyright-

infringement judgement including damages can cost a client much more than your doubled or tripled fee. Many threatened suits are settled before they get to court, with payment to your attorney included. Some dishonest people will test the limits you'll go to and hope that the amount of trouble involved will encourage you to eventually accept an inadequate settlement.

Approach the problem of unauthorized use with conviction. Keep in mind that if you collect a larger fee than usual, the client will perhaps decide not to exploit other photographers. If you're threatened with loss of the client's business, ask yourself if you want to deal with such individuals anyway. Don't hesitate to get legal advice. Ask a colleague for an attorney recommendation, or inquire at a local ASMP chapter office for an approved list of attorneys. Be tactful but resolute. Moderate your indignation but make your expectations clear.

LOST OR DAMAGED PICTURES

Your stock files are an investment on which you may collect dividends for decades, so loss or damage of pictures can reduce your income. This can be very serious depending on the popularity of images. A lost or damaged print can be replaced and may be compensated for accordingly, but negatives and lost or damaged original transparencies are usually irreplaceable. To avoid such losses, some photographers send only dupe transparencies to clients; originals continue to be protected in files. Since the quality of dupes has improved considerably and more clients are willing to reproduce from them, problems of loss and damage of originals are decreasing. Nevertheless, how to deal with them remains the same.

PROTECTING PICTURES IN TRANSIT

Slides and prints in transit to or from a buyer should be insured. But it is expensive to insure groups of slides for thousands of dollars when you use such private carriers as Federal Express. Most carriers insure packages for $100 as part of their basic charge, and some have a $25,000 limit. Compare insurance rates. If you're sending a few original transparencies, you may want to insure them for nominal sums, such as $500 each, on the basis that loss or damage of pictures in transit is minimal. Also consider United States postal registration, where limits are higher and fees are lower than private carriers.

It may be difficult to collect on lost or damaged transparencies from the post office and other carriers unless you have substantial evidence

that your work has previously sold for the amounts you're claiming (proving the value of your work is discussed on page 135).

Many stock agencies have learned to pack pictures securely, as you should do. But they insure packages for nominal sums, such as $250 or $500, even when the total value of the contents is much more. They do this to save money based on their experience that few packages are lost by the post office or private carriers. Even minimal insurance creates enough attention that parcels are cared for and losses are few. One agency owner told me, "Insuring for the potential value of several hundred transparencies in a shipment would be prohibitive on a regular basis. Fortunately, experience shows full value insurance is very rarely necessary."

When you insure or register packages at the post office, pay for a return-receipt form, which becomes a signed proof of delivery. Private carriers usually have packages signed for. As further protection, ask clients to sign and return your delivery memo. If a picture buyer is careless or has dubious ethics and claims that pictures never arrived, you need evidence on paper to the contrary. An attorney told me, "Once you can show proof that the other party has received your pictures, the burden of proof regarding negligence shifts to them."

WHEN THE CLIENT IS RESPONSIBLE

Pictures are lost or damaged most often through accidents or carelessness of editors, art directors, color separators, secretaries, or other office personnel. Picture agencies establish a routine for contacting clients about lost or damaged pictures, and so should you if you sell your own work. Start by inquiring about the pictures by telephone and follow up by making a claim for loss or damage by letter. Proper paperwork that accompanies transparencies is your best ally. Delivery memos make clients responsible for work they solicit; you need these documents to make a case, either directly to the client or later in court.

If you can't routinely collect proper payments for lost or damaged color transparencies and you must file a suit, you need a lawyer who is familiar with such matters. Besides asking colleagues for referrals, if you are an ASMP member you can use the society's Legal Referral System, which you can access through ASMP headquarters or chapters.

VALUING YOUR PHOTOGRAPHS

When you make a claim for lost or damaged original transparencies, either directly to a client or in court, you need to value your images by

precedent. You can do this by using previous sales prices of your own work or by referring to awards for work similar to yours made in previous court cases. Photographers are often handicapped by lack of understanding from juries or judges about the value of original color slides. A few years ago an art director lost his briefcase that contained 63 transparencies submitted by a stock agency. When he reported the loss to the police, they asked why he was making such a fuss about a few lost snapshots. Someone remarked, "How much could they cost? A couple dollars each? They're just little pieces of film in cardboard mounts." That response is typical of people who shoot snapshots for fun and have no understanding of the stock business.

The lost-briefcase dispute was settled by arbitration as agreed to by the agency and the client according to stipulations on the back of the delivery memo. The ad agency the art director worked for felt that the award of $94,500 ($1,500 for each of the 63 lost slides) was totally unreasonable because there were substitutes for a number of them in the agency's files. To the photographers involved, however, the award represented the potential lifetime value of the lost images.

"In determining value," says the *ASMP Stock Photography Handbook*, "recent New York cases have taken into account a broad spectrum of factors." These include technical excellence; the photographer's selective eye, prestige, and earning level; the uniqueness of the subject matter; the established sales prices; and the frequency of acceptance by users. The book notes that this approach "has resulted in recoveries for photographers in the range of $1,000 to $1,500 per transparency."

Whatever you stipulate as the value of an individual slide, it is necessary during litigation to establish that the amount's reasonably related to the provable value of the picture. However, the outcome of arbitration and court cases isn't predictable. In a case of lost slides, a magazine had signed a receipt stating each image was worth $2,000. A judge decided this figure to be an "unreasonable penalty," and awarded the photographer $1,000 for each slide, plus $12,000 interest because the case had taken so long to settle. (For further details, refer to the "Settling Disputes" chapter of the *ASMP Stock Photography Handbook*.)

COPYRIGHT INFRINGEMENT

Keep track of legal cases and precedents by reading *PDN*, where you'll find accounts of such interesting cases as *Rogers v. Koons*. Jeff Koons made a large sculpture and had many copies produced, all based on a photograph of a couple holding a group of puppies taken by Art Rogers.

Koons said he just used the picture as a reference, but the judge said the sculpture was an "exact copy" of Rogers's photograph. His copyright was infringed, and he was awarded damages equaling the considerable profit Koons made from selling the sculptures.

In an article in the October 1990 *PDN*, David Weintraub and Nancy Madlin reported on copyrighted photographs that end up being painted, included in collages, used as backdrops, or even "rephotographed." Since Andy Warhol began using popular images in his art, Madlin and Weintraub say, "the line between harmless borrowing and downright plagiarism became blurred." Artists may call this "appropriating" images and consider it harmless, but photographer Arnold Newman says, "Anybody that takes it (the copied work) seriously and pays money for it needs to have his head examined."

Interestingly the Weintraub/Madlin article goes on to say that Warhol, who "popularized the notion that source material can include images already existing in society . . . went to great lengths to obtain usage rights for the photographs used in" his works.

PRINTING COPYRIGHTED SLIDES

Ethical photography labs refuse to make prints or dupes from negatives or slides marked with a copyright symbol and the photographer's name. This protects you when you submit pictures to a client or give a picture to someone for personal use. A friend showed me a letter from a K-mart processing lab informing him that it couldn't make prints from his family slides without a letter of permission because they were copyrighted.

Friends at photography labs can be helpful in other ways to photographers. A colleague received a call from a lab to inform him that slide copies of his pictures in a stock-agency catalog had just been processed. My friend contacted the company that copied his work for an audiovisual show without asking permission, and it agreed to pay double the fee it would've been charged had it merely come to him for original or dupe slides. "It would've been ridiculous not to double the fee," my friend said, "because it would only encourage the company to try the same stunt again."

JOINT AUTHORSHIP

With the advent of computer manipulation and combining of images, keep in mind the copyright-law definition of a *joint work*. This is "a work prepared by two or more authors with their intention that their contributions be merged into inseparable or interdependent parts of a

unitary whole." The key to a joint work, according to Bill Vann writing in the Dallas *ASMP Newsletter*, is that the intention exists at the time that the work's created.

I've heard that some advertising art directors have tried to claim joint copyright with a photographer because the art director made the original layout. This isn't valid. Photographers do the technical and creative work to make the actual photograph, and joint authorship isn't an acceptable way to strip them of their ownership rights. As more photographs are combined by digital means, the whole concept of joint authorship will be explored and defined more clearly.

COLLECTING FEES

When you sell your own stock photographs, you have to be patient about the often extended length of time it takes for clients to pay you. Ad agencies stretch payment schedules to 45 or 60 days and longer. Magazines may take 30 to 60 days. Corporations and other clients have their own individual payment arrangements. Ask delinquent clients how long you might wait for payment. In time if your bill seems to have been ignored, you should write, send a fax, or call, tactfully reminding someone of your unpaid bill, and include a copy of it.

When a client seems unresponsive too long, ask an attorney to send a letter or take the party to small-claims court, depending on where the client is and how much is involved. Friendly persuasion may be enough to do the trick, and it is less expensive and time-consuming than a lawsuit or hiring an attorney.

Clearly it is in your own best interests to be aware of and to stay on top of the latest legal considerations that will inevitably have an impact on your ability to sell your photographs as stock. You need to place an appropriate value on your images, effectively utilize the services of lawyers and expert witnesses, be able to go to arbitration, and know what to expect in the courts in order to succeed.

12 ADVICE FROM STOCK PHOTOGRAPHERS

For this chapter I interviewed eight photographers whose experience in selling stock qualifies them as experts. Their advice and observations differ in some ways and are remarkably similar in others. Whether or not I agreed completely with all of their opinions, the full interviews are here to give you a variety of ideas and backgrounds; you'll find that this material often augments other material in the book. The photographers I chose shoot a wide spectrum of subjects in various styles and geographic areas. Watch for their credit lines in magazines and books. Sort out their views, and adapt those that will help you most in your own stock work.

The interviews varied in length. In some cases the photographers didn't answer the entire question, but what they did say was helpful. In other places they added useful information. I think that you'll appreciate the diversity of their approaches to shooting and selling stock pictures.

THE QUESTIONNAIRE

- How did you get started shooting and selling stock photographs? About how much of your work time is now spent at it
- What kind of stock subjects do you generally shoot? Do you feel specialization is necessary?
- Do you sell your own stock? Do you also sell through one or more stock agencies? Do you have contracts with them? How do you divide your pictures or subjects to avoid multi-agency conflicts?

- Do you plan stock setups, hire models, and find locations? Are these usually separate shoots or tied into assignments?
- When do you usually shoot stock? During your travels? In connection with assignments? When your files need refilling?
- When you photograph people, is compensation to them sometimes tied into sales? If so, on what basis?
- What are the most important things you would tell an earnest newcomer about selecting and shooting stock subjects?
- Do you prefer 35mm cameras or larger formats or both? Do you choose the camera size to match the subject?
- Do you shoot all color or black and white or both? Do you make and lease dupes, or do you have dupes made by a lab?
- Please give readers some tips about choosing and working with a stock agency. Should you visit the agency first? Have you had unfortunate experiences with stock agencies? (No names needed.)
- What are some important points about selling your own stock photographs?
- What is your basic advice about negotiating prices with clients? What sort of pricing guide(s) do you use?
- Have you had disputes with clients or agencies about lost or damaged transparencies or unauthorized usage? What have you learned to do or to avoid?
- Please tell me about your filing system. Are your files computerized or otherwise accessed? Do you use a computer-captioning program?
- Do your stock agencies communicate suitably? What do you do about late payments from them, if any? How do you deal with your own stock clients who don't pay on time?
- How different will be the stock business in 5 or 10 years?
- Would you like to add other guidance for photographers who may or may not be shooting stock?

VINCE STREANO, ANACORTES, WASHINGTON

Streano and his wife, Carol Havens, shoot stock on a regular basis in the United States and abroad. He is currently president of ASMP.

"Getting started in stock wasn't a conscious decision initially. I always kept a separate group of images that grew into a stock file. After leasing some of these I realized stock could become another good source of income. Then I made a round-the-world trip photographing children in 12 countries, and those shots along with foreign location material comprised the bulk of my files for quite a while. After I left the

Los Angeles Times in 1975, I did assignments as well as stock from, which we now get 80 to 90 percent of our income.

I feel specialization is especially necessary for people getting started in stock because they need to be known for a few subjects. I'm known for hot-air balloons—even though I haven't shot any since 1980, I still get calls for them—and for gray whales and transportation subjects. I shoot a wide range of subjects that interest me. We spent a summer in Alaska, and we've been to China and recently to France. The longer you are at it, the more you realize which subjects are most marketable.

We sell our own stock and also sell through several agencies. We have some contracts, but I think that multi-agency conflicts are a figment of the imagination at most agencies. We contract to give agencies exclusivity in certain geographical areas, which means we won't sign with another agency in their area. I shoot a lot of film and divide the pictures to fit the needs of appropriate agencies. We keep 10 to 15 percent of the best images in our own files, and I make 6 × 9cm dupes of them and may send some dupes to the agents. When an agency uses a shot in its catalog, I restrict it from all other agencies.

We rarely plan setups. However, there are times when I find people in good stock situations and will approach them and ask if they mind if I shoot. I may work with them for half an hour, and I get model releases and pay small fees or give them pictures in return for their time. I like the authenticity of using people who aren't models.

I do shoot on my travels, and I stay in the East a few extra days to shoot after attending an ASMP board meeting in New York. Sometimes the pictures I shoot on assignment are generic, without trademarks, and they work for stock. In my assignment-confirmation form there is a clause that stipulates that any seconds or similars of pictures I submit will be kept in my files, and after six months I'll be able to use them as stock. So far no one has objected to that.

I tell classes we teach to shoot the area you live in at first. Cover these subjects well: industry, tourist attractions, recreation, housing, and other aspects of your general location. When you're starting, prospective clients are going to assume you have pictures of your own area, so start there. Then photograph people, industry, couples with babies, or whatever you have access to. Get comfortable with a couple, and visit them often to take generic-type pictures. If you can get into an industrial situation, shoot it.

Then shoot things you're interested in. Don't try to tackle subjects you know nothing about just because you think they'll sell well. Someone else out there who knows the subject better will likely do a better job on it.

I enjoy shooting 35mm and stick to it. However, agencies and photographers are learning that images have more impact in larger format, which may make them more salable. I agree. A client looking at a sheet of 35mm slides and a selection of shots in a larger format will automatically gravitate to the latter. So I'm duping 35mm slides as 6 × 9cm transparencies, which gives me the versatility of continuing to use my many 35mm lenses as well as the sales appeal of a larger format. The 6 × 9 format is the same proportion as 35mm, so no cropping is involved.

I shoot only color for stock. The dupes I make are definitely good enough for reproduction, and I've found there is a lot less prejudice against them than you'd get toward a 35mm dupe. Because 50 to 70 percent of all stock is sold directly from catalogs, each time clients order from a catalog, they're getting a dupe. So reproduction from 35mm and larger dupes has become accepted in the marketplace. I've had double-page spreads printed from some of my 6 × 9cm dupes, and they hold together very well. I'm not saying they'll exactly match a 35mm original, but so far no one has sent me back a dupe and asked for an original.

The agency situation is changing dramatically and rapidly. Not long ago you could arrange agency representation easily because their files weren't that full. Today there is an oversupply of photographers and pictures so if you have 'more of the same stuff,' you'll find it difficult to get in with an agency. I definitely feel that when possible you should visit the agency you're thinking of if for no other reasons than to see that they're handling slides properly and dealing with clients in a professional manner. There are many considerations in choosing an agency: How you get along with it, how well it likes your work, and whether you have a specialty it needs in its files.

Negotiating prices is probably the most difficult part of selling your own stock. You should realize that every time you sell a stock shot, there is going to be price negotiation. The larger the usage, the higher the price and the more negotiating there's going to be. If you're intimidated or not comfortable with negotiation, you'd better get someone else to do it, or learn the art and skill yourself. I tell students the most important skill they can learn other than photography is negotiation.

It is very important to stay firm with as high a price as you possibly can. The downward spiral of stock prices now is very disturbing, and it is more difficult to make a living. There are good guidelines out there, including Jim Pickerell's *Negotiating Stock Photo Prices* and the *ASMP Stock Photography Handbook*. But you need to develop your own price list, based on some of the others, for certain popular usages, such as brochures, magazines, small advertising applications, and textbooks. Have these as a starting point.

Also keep in mind how much it costs you to do business. To cover expenses and make a decent living, you need 100 sales a year at a minimum of $500 each, and that means a lot of sales and money at first. That is why it is vital to keep your prices up.

Another important point: When someone asks for a price over the telephone, never give it off the top of your head. Get as much information as you can about the usage, thank the individual, and say that you'll get back to him or her soon. Sit down, research the market, and make sure you have a proper price in your mind and that you are in a good mood to discuss it. Then call back and quote the price. If it is a big usage, such as a national ad, and you aren't sure, try to find out what price the client is thinking of first. Occasionally the client may surprise you. If you ask, 'What's in your budget?' or 'What did you pay for this particular usage before?,' you don't have to agree with the figure, but it gives you an idea of what is in the client's mind.

We don't use a computer for filing. Carol has devised a very good filing system based on geographic location and subject. We also have good cross-referencing on 3×5 cards. With more than 100,000 images in our files, to assign each a number and put it in a computer would have been a six-month undertaking. The way we're set up, we can easily find images in one of 18 major categories that are divided into minor categories. We have a printout of the subcategories for reference. But we've used the Cradoc Captionwriter for many years. Anyone serious about stock must have a computer-captioning program.

Some agencies communicate better than others. We work with several agencies, and some do better jobs than others in different areas. As the stock business gets more complex, agencies had better make more of an attempt to stay in touch with their photographers and keep them apprised of what's going on. Most agencies send us want lists about three times a year. A few big ones have sporadic newsletters.

I'd suggest that photographers pay attention to agency statements, and if one comes with sales fees lower than they should be, the photographers should ask about them. If the agency is selling rights way under market prices, photographers need to say, 'I can't make a living when you sell pictures that low.' If enough photographers do that, I'm hoping agencies will keep prices up or raise them.

While I've said it is harder to get into a stock agency today, I think there is a place for photographers who don't shoot full-time but have a specialty that may be unusual. If you sell your own work, let everyone know what you have and try to be the best in that field. If you do well, be prepared for other people to move into the same specialty."

RON SHERMAN, ATLANTA

Sherman's stock includes diverse subjects from southeast locations to university activities, to oil and gas exploration, to twin boys.

"I started selling stock photographs when I began doing editorial assignments for the wire services and national magazines in the mid-1960s. In the mid-1970s I was also doing corporate and advertising assignments, from which some stock came. Most of my current images are self-generated, and about half my time is spent shooting stock.

I'm building an extensive file of my town, the area in general, and then the entire state. I've found you don't have to travel very far to make images that sell. Specializing is becoming more important these days because clients tend to come back when they can count on a large selection of usable images.

I sell my own stock and also work through a number of regional agencies and one international agency. I have contracts with all of them. There are no conflicts since any image in one agency's catalog isn't sent to any other agency.

My stock images using professional models are usually tied into my normal assignments. Most models in my stock shoots are friends or children of friends, so model releases are easy to get and there are no problems about usage. When I photograph people, compensation is usually prints, a dollar bill, and/or a thank-you.

I shoot stock on assignments when I travel, on my own time and after the assignment is completed. Most of my stock shooting is done in and around this region on a continuous basis.

Almost 100 percent of my stock images are produced with 35mm cameras. For stock pictures I shoot only color. Most of my black-and-white images comes from assignment. I make 35mm Kodachrome dupes for show and occasional leasing. I have 4×5 dupes of special stock images made by a commercial lab.

My best suggestion for finding an agency is to ask other photographers who they trust and whose work they respect. They'll probably recommend agencies they've worked with for a while. Visit agencies if at all possible, but it may be more important to see how they respond to your request for information, how quickly they edit your first submission, and how much information they'll give you about their operation, billing, and leasing practices. Your gut feelings also count a lot.

Important points about selling your own photographs: Get your files organized for easy access and refiling. Design easy-to-use delivery memos, and use them. Make a one-page list of your best images to send

to clients. Compile a comprehensive list to remind yourself of all your images. Create a mailing list, and keep it current by doing frequent mailings. Send a good selection of images to prospective clients, but don't overwhelm them with quantity. Make sure every image is repro quality; anything else will start to build a poor reputation. Discuss research and usage fees up front, and charge research fees. You aren't a free lending library. It costs you money to pull images, send them to clients, and then refile them when they're returned. Leave a paper trail. Rights and restrictions should be printed on delivery memos and invoices.

Negotiating prices on stock usage mostly comes from experience. I currently use Jim Pickerell's *Negotiating Stock Photo Prices* to help me set fees for usage I'm not familiar with. If a client requests re-use, I am more liberal than I'd be with a one-shot request from a hard-to-deal-with client.

The few times I've had a damaged or lost image, I've negotiated a fair settlement for both the client and myself. You have to check each image for damage the moment it's returned from the client, or you can kiss the image goodbye. I'm currently using plastic covers with special stickers so if a seal is broken, I can bill a usage fee. I make sure to use this protection with new and unknown clients, so there is no doubt about the returned image. So far it seems to work rather well.

My stock files are set up with an alphanumeric system so that each category has a unique number, each year is a letter in the alphabet, each sheet of 20 slides has its own number, and each sheet is numbered from 1 through 20. For example, an Atlanta skyline image numbered 05T2015 was made in 1990, is in sheet 20 of the Atlanta category file in space 15 of the sheet. I also color-code any image out to one of my stock agencies, so that at a glance I know which agency has any image in my file. This helps when a client calls from Chicago for a particular image. If the image is already in Chicago, I can save the client time and money by giving him or her a local number for delivery of the image.

I use BOSS software to handle delivery memos and for invoicing and cross-referencing my stock files. I can find any image in the cross reference in a matter of seconds. It took my assistant a long time to do the cross-reference file, but the effort's now paying off with faster retrieval times.

All photographers want personal attention from their stock agency. I find that if I initiate letters and/or telephone calls to an agency that I haven't heard from for a while, I usually get a fairly quick response. If I send the agency material on a consistent basis, the communication is regular. Stock clients usually pay on time since all invoices state that 'usage is granted upon payment,' and a reminder of that fact if payment is late usually produces a check in short order.

Stock photography should change drastically in the next 5 to 10 years. Digital images will create photographs that were almost impossible up to now. Computers, modems, and CD-ROM units will change how images are stored and distributed. Photographers who have kept (rights) control of their images and are creating unique images will still make a living in stock photography. But ordinary images will be available in data banks for little or no cost to anyone with access. I think the specialist will thrive, but the generalist will have problems competing. I hope that clients will become more visually sophisticated and demand images they can't find in data banks. (But then if I could predict the future, I would've picked the correct six numbers in the Florida lottery when it was worth $20 million.)

In most ways stock photography is harder to succeed in than assignment photography, because you have to be more of a self-starter to get up in the morning, when you really feel like sleeping in, so that you can shoot the sunrise that may make the perfect image. You have to be more motivated to edit that last batch of images, so you can get a new selection to your agency or into your own files. No one will call you and give you hell for not getting out your promotion mailing on time. But you can also go anywhere, any time, to shoot anything your heart desires, and that is a great way to live your life—and to make a living."

JOHN SHAW, GREENSBORO, NORTH CAROLINA

Shaw has written several books, including *John Shaw's Focus on Nature* (Amphoto, 1991), and recently photographed both polar and Alaska brown bears.

"I've been shooting stock since I started freelancing in 1971. I've always worked the book and magazine editorial markets, as well as the calendar markets, by using my stock file. My first sale came from combing my stock file to see what sort of article/packages I could put together. Almost all my shooting today is for stock.

I specialize in natural-history material—in fact it is all I shoot. Virtually everything published today in this field is from stock. The day of the nature assignment is basically over. I'd suggest specializing in a broad field, such as nature or sports, as you can learn the markets and what editors want. Pick a subject area you're interested in, and stick with it.

I sell my own stock as much as I can since I hate paying that commission to an agency. Fortunately the nature editorial field is geared to individual photographers selling their own work. I also use five stock agencies, two in the United States, two in Europe, and one in Japan. I

have contracts with all of them that read that they are the exclusive agency for the photographs they hold. While I can also market these shots, no other agency holds identical pictures. Consequently, I shoot several different compositions whenever possible since my contracts don't forbid putting similar shots with other agencies, just identical ones. I edit carefully into different agency files. This has worked for me.

I don't hire models or set up stock pictures. I almost never photograph people. The few times I do, I usually trade them slides for permission to shoot. Compensation isn't tied to sales.

I'm shooting stock all the time, since that is my whole business. Basically, all nature photographers today run their own one-person stock operations. I'm on the road shooting at least half the year to build my files.

I suggest the newcomer should shoot volume and variety. See what's being published, and then go out and shoot it better. If an editor wanted it once, another one will want it sometime in the future. Do more than the standard view of subjects. The representative image sells better than the experimental.

I shoot 35mm almost exclusively, as well as some 6×7 and some 4×5. My career is based on 35mm, and most nature markets are 35mm markets. This format lets you crank out the volume you need. And I shoot 100 percent color. I can't remember the last time I shot a roll of black-and-white film. I use all transparency film, the slowest I can get away with, which is primarily Fuji Velvia right now. I make in-camera dupes and almost never have dupes made by a lab. Shoot more originals. (Author's note: these are the in-camera dupes Shaw refers to.)

Read an agency contract *carefully*. Then wait a few days, and read it again. Keep track of agency names you see credited with the type of work you do. Ask the agency for names of five or six photographers it represents, and call all of them for references. I've had one bad experience with an agent: I kept finding my photographs, usually in small magazines, for which I wasn't paid. When I confronted the agent, I kept getting the same story: 'It's just a small sale that fell through the cracks.' After several confrontations, I told him I would broadcast my perception of him being dishonest in every article I wrote, at every seminar and workshop, at every opportunity. There were no more foul-ups.

Nothing leaves my office without my delivery memo stating that all rights remain mine until we have something in writing or I've okayed it by telephone. My invoices spell out exactly what rights I'm selling. My basic phrase is 'one-time, nonexclusive, North American, English-language rights only,' and we go from there.

The best bit of business advice I was ever given: Price high, you can always come down; price low, you're stuck with it. I always ask clients what

their price range is, I compare it with ASMP survey rates, and I negotiate. (Author's note: The first edition of the *ASMP Stock Photography Handbook* in 1984 included stock-photography rates based on a survey of members.)

I keep track of published rates from the main markets in my field: the big magazines and calendars. Most nature markets say up front what they'll pay, but you can certainly negotiate from that point. I do have minimum rates, and I don't hesitate to tell clients about them. My argument to clients is that since they expect to be paid a good salary for their work, I also expect the same.

Every image in my file is assigned a unique number, and this number is on the delivery memo along with a total count of photographs. The office is totally computerized. All slides are in a database according to subject, such as mammals, insects, national parks, and flowering plants. All delivery memos are computer-generated. Any photograph is either in-house or out, and by searching the submissions file, I can track any given shot. If a photograph is lost, I can describe it from the information in my database.

I caption slides using my word-processing program, Word Perfect. The database is an old program that I love called Nutshell Information Filer. There is a new version out, Nutshell Plus II, and I recommend it highly. It is simple to use and indexes everything; consequently, I can search for criteria I didn't even consider when I set up the field. I love it!

Some of my stock agencies talk with me, and some don't. This is no big deal as far as I'm concerned. Basically, I photograph what I like and then try to figure out a way to sell it, so an agency telling me to shoot something is meaningless. Talking with agencies about what sells and what doesn't is one of the most depressing things I can think of. I'm in this business because I want to be outdoors with subject matter I like, so I try to ignore agencies telling me to go shoot other subjects.

I think stock will play an increasingly important role in the publishing business. The day of the assignment is coming to a close as costs escalate.

Have the highest technical and aesthetic standards. Don't just make do. The work you submit should always be the best possible. Edit ruthlessly. If it isn't good, don't send it out. There is enough mediocre photography out there already. Quality will become apparent, and you'll get a reputation as a quality person."

GLEN ALLISON, LOS ANGELES

Allison began shooting travel stock during a career as an architectural photographer; his work has graced more than 100 magazine covers.

"Over the years I was fortunate to receive assignments to shoot all the pictures in the now-defunct *Los Angeles Times Home Magazine* in such countries as Mexico, Australia, France, New Zealand, England, Holland,and Spain. Not only did these trips produce a ton of images for my files, but my appetite for travel was whetted. I was also married to a writer, so as a team we could produce travel-magazine articles.

After 20 years shooting architecture, I 'retired' (at the ripe old age of 45) and began shooting travel stock full-time. My interests include travel locations and any environmental subjects I might find along the way, such as agriculture, industry, scenics, energy, transportation, and communications.

I have an exclusive contract with Tony Stone Worldwide (TSW), which does allow me to make editorial sales. There are lots of pros and cons about exclusivity, and photographers should carefully make their own decisions. TSW is the world's second-largest globally distributed stock agency and makes about 80 percent of its income from only about 12,000 images in its 4×5 dupe master collection, although it has about half a million other images in its files. TSW's philosophy is to edit very tightly and to mass-distribute only the best images. Since such a high percentage of the company's income comes from a relatively small selection, I feel it wouldn't be profitable for me to try to market the rejects I get back from it to other agencies around the world and then spend time policing their operations. I take pictures and leave the marketing and distribution to trained experts.

Because of my background, I do very studied shots and don't produce a large volume of images. However, a big percentage of what I do produce is chosen for the TSW files. TSW spends a lot of time with me, giving me direction and suggestions as well as its confidential want list because it knows that I'm not going to be giving similar images to its competitors. Since I don't shoot assignments, my stock endeavors are all of my own creation. I do get lots of input from my stock agency on its current needs and follow some when they fit my interests.

If you are new to stock photography, my advice first and foremost is to shoot subjects you love and are good at. I love to travel, but agency travel-stock files are full. However, my agency tells me that it always needs new, fresh images of all the familiar subjects. Skylines change, as do weather conditions, and the lighting on the Eiffel Tower was recently revised. I examine pictures in my agency's files, and then try to shoot some of the subjects better. I'm not going to give up my dreams because there are a thousand other travel photographers. I pick subjects that interest me, then bust my rear taking the best images I can—and that I hope someone likes enough to buy.

I shoot only 35mm film. Most agencies say they want medium and large format when they can get them because sales are better. In my case, because I have a state-of-the-art duping system and a lot of experience with it, I've arranged with TSW to deliver only 4 × 5 dupes. It is my conjecture that in the near future, with the onslaught of digital technology, there will be little need to shoot larger-format pictures except in those cases in which camera manipulations and corrections are necessary to enhance the picture.

Digital enhancements and corrections as well as superb large-format digitized dupes from 35mm originals lessen the need to shoot anything larger. Besides, 35mm cameras are much easier to carry and have some very sophisticated features. One major 35mm camera manufacturer (Canon) already makes three different tilt/shift (perspective-correcting) lenses. I feel kind of sorry for photographers lugging large-format equipment nowadays.

It's getting harder to get into a stock agency because agency files keep getting fuller, which makes them more particular in choosing new photographers. Making personal visits is essential to see how each agency runs its operation and get a feeling about its professional attitude and organization.

My advice is to read 'Visiting Prospective Agencies' on page 38 of the *ASMP Stock Photography Handbook* (second edition) on what to look for and what to ask. After you're accepted by an agency, I have a few suggestions. Visit the agency as often as possible. TSW happens to have an office in Los Angeles, and I go there once or twice a week. My challenge is to be genuinely enthusiastic and positive every time the agent reps see me. They are often very busy, overworked, and tired. I make it known that I want them to get rid of my mediocre images. I'm inured to the times they don't choose images on which I might have spent hundreds of dollars in travel expenses and helicopter fees. I ask for pointed critiques of my work and don't take them personally. I need to know why some of my images don't hit the mark. I work extremely hard at becoming a shining example of what in their opinion is a great photographer to work with.

Since I don't sell my own pictures and don't have a staff, I don't need a very complicated filing system. I file by alphabetized subject order. I use BOSS studio-management computer software, which includes a very sophisticated stock-filing system. It allows me to do cross-referenced searches, and stores and produces caption labels in various formats. A bar-code system integrated into the program enables me to quickly keep track of submitted images. Other interlinked modules cover delivery memos, the client database, invoicing, and accounting.

In the future most stock photographers will probably have a difficult time making ends meet if they don't have international distribution. Likewise, successful agencies will have to develop a good system of global distribution and marketing. Many already have such systems in place. Certainly, digital technology will make a tremendous impact, not only in rapid transmission and filing of pictures, but also in terms of image enhancement, manipulation, and reproduction. I look forward to costs being reduced."

WALTER HODGES, SEATTLE

Hodges is a professional stock photographer; his working methods are discussed in Chapter 3.

"I got started shooting stock about 1985 when I felt the bottom going out of the assignment market. I wanted to sell photographs based on the quality of the photography alone, not on sales pitches, portfolio presentations, politics, luck, who you know, and 'what have you done for me lately.' I spend about 60 percent of my time shooting stock.

I shoot lifestyle photographs and transportation. I think stock is a game of numbers, and it helps to diversify your support base. Once that is done I think you need to specialize in two or three areas, so you can pretty well own a market share.

I do sell my own stock, but on a very limited basis. I also sell through two agencies. I have exclusive contracts with both, and I don't give the same images to both agencies. No one agency can sell every type of image, so there are certain styles of material that sell better at agency X than at agency Y.

I always plan stock setups; I never just take a camera out to see what will happen next unless I'm just going out for fun. I do shoot for fun and I often find stock in the progress, but that's not how I run my day-to-day operation. I hire models, find locations, get permissions, and shoot the photographs. The shoots are hardly ever tied into assignments because then I figure my client owns my time. If I have some time off, I'll shoot stock. I think, plan, scheme, scam, panic, prod, promote, and shoot stock every waking moment that I'm not eating, drinking Jack Daniels, shooting assignments, fishing, or hanging out with my wife.

I tell my models that I'll do three things in return for their time: I'll give them copies of everything I shoot, I'll do their promo pictures for free, and when it is possible to track an image, I'll give them 10 percent of my commission on a sale. One of my two agents tracks sales using the model-release number I put on my slides, so I can track every image.

I shoot 35mm slides and dupe all the best shots in the 6 × 9cm format. Very little of my material lends itself to larger camera setups. I shoot all color and I make my own dupes, though occasionally I use a lab. I make thousands of dupes, so I can save a lot of money doing them myself. I have a lab technician on staff.

You absolutely should visit with a stock agency. Go over every word of the contract. Treat it like a marriage. It won't be easy to get out of a contract, and it can cost a lot of time and money. The most important questions are: 1) How fast does my film get edited and into the marketplace? 2) How do you distribute my work, and what kind of tracking system do you have to tell me what's being distributed? 3) What is your business plan to maximize distribution of my material around the world? 4) How do I know which of my images are selling? 5) What percentage of the cost of promotion does the agency bear? 6) How many dupes do you want? 7) Can you show me some paperwork that proves that everything you've told me is true?

Keep in mind that because most agencies have so much film on file, it is hard to keep track of things, no matter what they tell you. You should visit the agency at least four times a year if it is out of town. Ask to see where your pictures are and how they're being distributed. You need to be on top of your own work, and you need one person at the agency that you can call every day if necessary, to discuss future shoots or the status of pictures in the files.

Don't sell your own stock unless you have a staff to support the function. You need to shoot. You can't make money selling. If your wife/husband can sell, file, and track your photographs, you might give it a try. I use ASMP guidelines on selling and negotiating. I agree to 'one-time use only'; I never sell exclusives.

We use a computer to file images. They're filed by model-release numbers that code the dates and numbers of the images to particular shoots. For instance, MR6/4/91-1 is the first image in a set shot on June 4, 1991. MR6/4/91-2 is the second image, and so on. We also file by subject matter with dupes cross-referenced. A specific file might be seniors/recreation, seniors/business, or seniors/grandchildren.

The stock agents I work with communicate very well, but a lot of that is because I talk to them frequently and demand responses. It is all done in a very friendly atmosphere, but there is no mistake about my need to be informed. Westlight in particular is great about communicating market trends and photo needs.

Most of us got started shooting because we loved photography. We loved images and making decisions about what to shoot. We were *artistically driven*. Then we started doing assignments, and we took our

artistic roots with us to the assignment arena. But our decisions about who, what, why, when, and where to shoot were now changed to be *client-driven*. We used what we could of our artistic roots, knowing our decisions were client-driven. Now as stock photographers we combine our artistic roots and our assignment roots, and put them in a suitcase and carry it with us. Our decisions about what to shoot are now *market-driven*. If we don't understand how to shoot what sells in the marketplace, we won't succeed. We can use all the stuff in our luggage, but if we don't start with market-driven decisions about what to shoot, we starve."

MARK E. GIBSON, SAN FRANCISCO

Gibson, and his wife, Audrey, travel and shoot extensively throughout the United States. They maintain direct sales with editorial clients, as well as contacts with several stock agencies.

"My (Mark's) professional training is in marine biology, and I bought my first camera to photograph marine life for teaching purposes. Later I began using the same slides with articles I wrote for *Skin Diver*, and eventually I developed an inventory of slides. At some point I realized that I could take photographs above water, too, so I began shooting nature photographs throughout California. When I finally organized my slide collection, I had 4,000 slides in various categories.

After shooting on a 14-month bicycle trip around the United States, I decided to concentrate on nature and travel in America and began marketing photographs and articles. Eventually my wife advised me I was a better photographer than writer, so I cut back on the articles. Audrey also likes to travel and has a natural inclination for picture-taking, so we began working as a team in 1984. On the road we work at shooting about 70 hours a week.

Our specialty is American locations, day or night, in the air or underground, moving or stationary. We shoot 35mm slides mostly for travel publications, and then for advertising and corporate clients. Within our specialty we are generalists who shoot all sorts of subjects, such as industry, recreation, parks, doll collections, cityscapes, wildlife, regional food, and good-looking people (with model releases).

We mostly sell our stock directly because I am very ambitious at marketing. We also have about 21,000 slides with two agencies, but income from them is only about 15 percent of our gross. We haven't had any conflicts resulting from similar photographs at different agencies. We do send in-camera similars to the agencies, but I figure they'd rather have those than none at all. These days we're moving away from

exclusive clauses in our agency contracts. We expect to be working with five nonexclusive agencies beginning in early 1992.

Audrey and I are principally stock shooters, and we travel year round. We make about four or five trips each year, and with our local shooting we produce about 20,000 slides annually.

Our advice for new stock shooters: Get model releases; make sure your photographic situations are very clean, or uncluttered; concentrate on graphic impact; find new perspectives; be creative with compositions and exposures; and think in terms of 'concepts' that can be illustrated. Be prepared to spend more time marketing than shooting.

Because we're constantly on the move, we work only in 35mm. As for larger formats, I think that if I have to stand in one place to make my pictures, the job isn't for me. We shoot only Kodachrome 64 or 200. We do make very high-quality dupes or selected one-of-a-kind shots that we circulate.

Today my greatest concern is discussing exact usage rights bought by corporate and advertising clients. Publications almost always want only one-time rights. Many clients choose to remain vague so they can perhaps get more use of the photograph than they agree to pay for. I believe a telephone discussion of exactly what the client's looking for is most helpful to both parties. Perseverance pays.

As a pricing guideline, because budgets vary, start high and be willing to negotiate.

The most common infractions we encounter is that clients select a photograph, go to press with it, and then try to negotiate a low rate after they've used the picture. Price, which is usually an issue, should be agreed upon *before* the client is allowed to use the image. But I'm amazed at the number of clients that get this business procedure backward. As for lost or damaged slides, most of our claims have been met. In 1988 we earned $10,000 in settlements for lost slides. We had the paperwork to back us, to substantiate the slide count and dates, as well as replacement value.

We aren't computerized. Our photo-filing system, complete with cross-referencing, is exactly the same as the Dewey decimal system used in libraries. We aren't computerized because computer applications are small-time (less costly) jobs compared with the amount of time spent in photo searching and editing. Our bookkeeping isn't complex enough to justify a computer, and having one would cause us to spend more time in the office at a keyboard and less time in the field, which is where we want to be.

Our agencies do pay us on schedule. Our direct clients, however, are frequently late with payments. Most often we call them and gently encourage them to pay in a professional manner. Sometimes we have to be stern to urge them to respond soon.

Advertising in the stock-photography market is more sophisticated, making it difficult for small-time operators to stand out in a field dominated by corporate stock agencies. You could call it 'The Battle of the Photo-Catalog Giants.' Also, concept photographs have been shot extensively by many photographers, and new illustrative approaches are difficult to design.

There is a progressive move toward electronic images, which may increase the market for picture components. But it has created difficulties in controlling usage and copyright. At some point I expect conventional film to become obsolete, and stock shooters will be shooting electronic images. I'm not very enthusiastic about electronic imaging, but anyone who wants to stay in the color-photography business into the year 2,000 needs to embrace it.

We love shooting stock mostly for the traveling lifestyle we've designed for ourselves. Being our own art directors is a heavy responsibility on one hand and a tremendous opportunity on the other. Aspiring stock shooters need to produce technically flawless images of varied subject matter in great numbers."

LARRY LEE, NORTH HOLLYWOOD, CALIFORNIA

Lee estimates that his work for energy and petroleum companies has taken him to at least 60 countries and all 50 states.

"I was deeply into industrial assignments when The Image Bank started, and Larry Fried, one of its founders, signed me up. However, I never put the effort into shooting stock at that time that I do nowadays. Assignments get you somewhere and pay the bigger bills, and you invest extra time and materials for stock. For instance, in the fall of 1990 I went to Asia for a month. I had 17 days of actual assignments and the rest was travel and shooting stock in such places as Bangkok and Singapore. Not quite half of my work time is spent shooting stock.

My specialty is petroleum subjects, oil wells, drilling, and pipelines. I think you have to specialize to make a place in the market.

In the last year and a half, 54 percent of my gross income came from assignments and 46 percent from stock. Eight percent of that was stock I sold directly, and the rest was sold by Westlight, the agency I'm connected with. I'm doing a direct-mail campaign now, and I expect stock income will soon be 50 percent. I like that ratio.

My contract with The Image Bank ended after five years, and I was with another agency a while before I signed with Westlight. I made some comparisons between agencies and decided that Craig Aurness,

who runs Westlight, was a little more aggressive. I liked the idea of a local agency where I could educate myself by going through the files and see what it might need. I've been with Westlight almost nine years. Craig is a little uncomfortable that I still sell some of my own stock, but rarely are we competing. The main reason I sell my own is that when callers ask for a shot of an oil well, I can supply it and then solicit them for assignments, especially when I'm already planning a trip abroad.

I don't do setups with paid models, but I do set up industrial situations sometimes and get model releases when I feel it will be a catalog image. I don't tie compensation for modeling into sales. I try to send people prints. Some of my stock is for advertising, and I get releases. Without a model release, sales potential is limited.

Look at agency catalogs and see what's selling. You have to follow your own style and subjects to begin with, but you also have to listen to the agency, pay attention to its want lists, and look at its promotional stuff to see what's selling. You have to educate yourself about stock subjects, but you should be flexible enough to do what it expects and do your own things, too.

Treat stock like an assignment. You can't casually spend an hour someplace and expect to get many salable shots. You have to be selective and shoot big volume as well. Put your effort into stock, make the time, treat subjects thoroughly, and get the best pictures possible.

I shoot almost everything on 35mm. I do horizontal and vertical shots whenever possible. Larger color looks better, and art directors choose it for that reason. Westlight makes numerous dupes, especially of pictures in its catalogs. I usually sell original 35mm slides myself.

Start off by studying the list of agencies in the *ASMP Stock Photography Handbook*. Try to figure which ones might have the qualifications to fit your needs. Agencies aren't so eager to sign people these days, and some are cutting back on their photographers, so you have to be prepared for some rejections. Most agencies won't accept you just on the basis of the stock pictures you have on hand—they need to anticipate what you'll shoot in the future. They're more interested in someone who's going to shoot regularly each month.

Marketing often is the difficult part compared to taking pictures. You have to promote yourself with promotion mailers and ads in the media books, such as *American Showcase*, the *Stock Workbook*, and the *Creative Black Book*. Ads there will generate calls to see what else you have, and potential clients will put you on a list for future requests.

When people ask what makes a great photograph, stock or otherwise, I explain it is one-third mechanical (camera, film, and filters), one-third artistic (composition, lighting, and color), one-third opportunity (time,

location, and permission), and one-third luck (a rainbow, clear sky, the time of day). That makes four thirds. You don't need all four to make a great photograph, but you'd better have three. Opportunity is the one people think about least, and it is a main reason I am successful in stock. As success increases, you can make more opportunities.

My favorite response when someone asks, 'What's it going to cost?' is 'As much as possible.' Then you start talking and negotiating. It is important to find a fee where you aren't giving something away and aren't losing a sale. I'm also interested in the client's potential for future assignments. I always ask what its usual payment is. If it is an ad agency, it may know more about the right price than I do. You might be afraid to ask $1,000, but the client says $1,500. I never ask what its budget is because it can tell me how tough it is to lower prices for such things as printing and space, so the photographer's price gets the axe. That is hardly fair.

You also have to take into account what the shot is and who the client is. A photograph in Saudi Arabia is worth more than one of Big Ben in London. I actually have little stock of Saudi Arabia because you just don't wander around with a camera there like you'd do in England.

Everything I shoot receives a work-order number. Stock from each job has its own envelope or display sheets. I file slides by subject, or location, or both, such as 'New York, Statue of Liberty.' Some pictures are filed according to client. I shoot a lot of similar originals and sometimes file them under different headings, such as 'Yellowstone,' 'Wyoming,' or 'trees.' I don't use a cross-reference system. I use Cradoc's Captionwriter program on my IBM computer.

The importance of being in catalogs is increasing considerably. I'd say that maybe 40 percent of my Westlight income comes from catalog images. You have to be successful to generate more success, help pay for more catalog images, and make the dupes to support them. Stock volume allows you to be more successful. People can scale down their expenses and promotions to fit their financial ability, but they have to get themselves in front of potential buyers.

I feel most photographers today can't afford not to be in stock. Otherwise they'll be left behind. Even if you do mostly assignments, remember more stock will be used in the future so think about supplying it. You have to be in ASMP or Advertising Photographers of America (APA) to meet other photographers to educate yourself, and to keep up with business and legal changes. Stock can be a major part of your effort and income."

13 ADVICE FROM STOCK AGENCIES

Stock-picture agencies vary in size, location, and styles of doing business. I say "styles" rather than "methods" because all agencies must use careful business-like methods to attract and hold both clients and photographers. "Style" here refers to the more personal side of the agency: how its staff members interact with photographers and clients. You'll sense this in the 10 interviews that follow. I sent a questionnaire to each agency, and the answers reflect a wide knowledge of the field, personal judgements, and business diversity. I chose these agencies for their varying viewpoints; some are small and new, and others are well established and large. They are situated in major cities, including New York and Seattle, and in small towns, such as Lititz, Pennsylvania, and Buena Vista, Colorado. The stock business flourishes all over the United States and is well represented here.

THE QUESTIONNAIRE

- Do you require photographers to submit a minimum number of pictures a month? If not, do you have other volume requests?
- When you look at the work of your current or new photographers, what are the leading qualities you hope to find?
- Assuming you have hundreds or thousands of subjects in your files, why do you continue to look for new pictures?
- About what percentage of images are reproduced from dupe transparencies? Are today's dupes much better than those made 10 years ago?
- What are a few things readers should know about marketing abroad through affiliate agencies or branches of your own agency?

- Do you regularly send your photographers want lists? Do you suggest special needs to more active photographers?
- What percentage of the pictures you get are set up and shot specifically for stock? Are such custom-made stock pictures often best sellers?
- Pictures of family life, couples, business, and industry are popular stock subjects. What other kinds of subjects do you encourage photographers to shoot?
- If yours is a regional agency, is that a disadvantage? How do your think location affects the success of a stock business?
- Do the ways photographers organize their work in terms of numbering and captioning pictures cause problems? What annoying *photographic* qualities or characteristics do you see too often?
- Do you prefer photographers to use copyright symbols and dates on their pictures? If not, are pictures adequately protected?
- How do you suggest that photographers avoid conflict when they submit pictures to several agencies? Are there other business practices photographers should be more aware of?
- Should photographers share the cost of producing stock catalogs? How important are catalogs in your business?
- What are your routine methods for handling lost or damaged transparencies? Are clients generally cooperative?
- What sort of changes do you anticipate in the stock photography business in the next 5 or 10 years? Is there a future for pictures shot on color negatives?
- What else would you like to add to help new photographers as well as those who have some stock experience?

ELLEN HENDERSON-BOUGHN, TONY STONE WORLDWIDE, CHICAGO, LOS ANGELES, AND 12 CITIES ABROAD

Henderson-Boughn ran the After Image agency for 14 years before merging with Tony Stone Worldwide (TSW). Henderson-Boughn was, until late 1991, president of the Los Angeles division.

"The major concern of the creative departments at TSW is with quality rather than with quantity. We have no minimum requirement for numbers of images to be submitted during any one time period. In fact, even a single image with superb style that demonstrates unique qualities might generate more income in a year through our international marketing system than hundreds of lesser images.

First and foremost, we're looking for photographs that are the very best of their kind, those with multiple-sales possibilities. We recognize that competition is stiff. We want our images to be superior, to stand out above all others when they're placed with those of our competitors on users' lightboxes. We need new, exciting treatments of eternal themes. Styles date quickly and must be updated, too.

Today's dupes are much better than they used to be—if the company making the dupes is committed to spending the time, money, and effort to produce them. TSW dupes are produced in-house at our headquarters in London by professional image technicians. They are large format and are unsurpassed in quality. (Author's note: TSW has a dupe master collection, which consists of images that are deemed to have the highest international sales potential. The whole collection consists of about 15,000 images, and they account for 70 to 80 percent of the agency's total international sales.)

TSW has five wholly owned subsidiaries in Munich, Paris, Chicago, Los Angeles, and London to serve the United Kingdom. The rest of the world is served by a network of agencies dedicated solely to supporting TSW. The exception to this exclusive service is our highly qualified Japanese subagent.

In order to ensure that images produced by TSW-affiliated photographers have worldwide marketing appeal, we collect, collate, and disseminate extensive information to our contributors. We'll assist in location and model selection. We draw information about travel images from our worldwide network to help photographers in pre-travel research. Each time we prepare a shoot list for a photographer, whether the shoot will be in a distant location or in a studio across town, we attempt to personalize the information to the style and strengths of the individual as well as to fit the marketing needs of the agency.

Because TSW sells worldwide, we find that American photographers sometimes fail to appreciate that editors in other countries don't necessarily understand even commonly used American abbreviations in captioning. Further, foreign picture users are accustomed to much greater detail in captions than we are. Photographers here tend to be too sketchy in captioning. We transfer all mount information to our computers and then print a new caption that contains the photographer's copyright symbol.

The most annoying photographic quality we see in new photographers who approach the agency, aside from a lack of understanding of what we sell, is the lack of editing ability. I feel that at least 40 percent of photographers' skills lie in their ability to edit their work. Some photographers insist on shooting vast quantities of often mediocre

images of salable subjects that might have been better if more thought and skill had been devoted to fewer images.

We require exclusivity for those images selected for our duping program, which means wide distribution. The best advice is that photographers should inform their agencies of any possible conflicts in regard to rights.

TSW subsidizes our catalogs, asking photographers to share only a nominal amount of the cost. Since we publish and distribute more than 150,000 copies of our catalog in 12 languages or editions, the cost to the photographer is a fraction of what such exposure would cost in the trade stock books (where photographers buy ads), even if those books were available in such numbers, which they aren't. We don't charge our photographers for dupes.

In order to preserve good relationships with our clients, we make every attempt to assist them in locating and retrieving lost images. However, if all else fails and the image isn't recovered, we seek compensation for the loss or damage. Many frequently circulated images are dupes so photographer and client are less exposed to the problems of loss or damage.

I suggest that stock photographers just beginning in the business have a long, hard, and honest conversation with themselves in regard to their commitment to being self-starters, and especially in regard to their strengths. A photographer today who wishes to succeed in stock needs to be every bit as good as the best assignment photographers."

JANE KINNE, COMSTOCK, INC., NEW YORK

Kinne is the vice president in charge of legal affairs and editorial development of the files at Comstock, Inc. She has been with the agency for five years. Previously she was associated with Photo Researchers from just after its founding in 1956. She is a former president of PACA.

"We're very concerned that all of our contributing photographers stay active, and we expect to see new material at regular intervals, but we don't impose quotas. In a dialogue with each photographer we work out our expectations about how much they'll produce according to the nature of the material they shoot.

What Comstock wants most is a mind behind the eyes that are behind the camera. Photographers have to be very curious animals and concerned about everything around them. We look for that, plus some very special in-depth knowledge in special fields. I see many excellent portfolios of stock images that simply wouldn't fit into the scheme of what we do,

what we need. That's partly dictated by Comstock's adhering to a philosophy that has been around since the agency's inception, which is that we haven't gathered a group of people to compete with one another. We look to each photographer to have a special area of his or her own. Then we can guarantee each a reasonable share of the available dollars.

Although we do have hundreds of thousands of images, we're still minus a great many subjects we should have, some in more depth. We're looking at new ways of seeing old things and brand new things. Some subjects are esoteric but a few are very common, and we can't find them. For instance, we're still looking for what I refer to as a "child-development" photographer. We see tons of pictures of babies and kids, many of which are very appealing and well shot, but the people taking them had absolutely no idea whether what the youngsters were doing would convey something about how children develop. Understanding a subject in depth is so important. It is the mind behind the eye.

We have our own offices abroad. We opened the first two in Paris and Berlin in 1991, and we also have a Comstock office in Toronto. There are some differences in what is needed in files for selling abroad versus selling in the United States, but there are far more similarities. We've provided each of the foreign offices with a core of photography that has sold very well here and is represented in our catalogs, so they have the promotional tools available.

The two offices in Europe (and there probably will be more) sell essentially in their own countries. Comstock chose to make a large investment in opening its own foreign offices, rather than continuing with existing agencies as affiliates. This is because we have a lot more control of rights, of copyright, and of the caliber of the service being given, which is so valued by our United States clients. The systems are the same, and the reports photographers get from sales abroad are easily understandable. (Author's note: At present most stock agencies work with agency affiliates or franchises in foreign countries.)

We tailor what we want from each photographer so there is a lot of personal one-on-one in our setup. We have only 65 photographers, and what we've done is create a mentor system where four people on our staff have divided up the 65 based on common interest and personality. Those four are responsible for feeding information to contributors on their list. We really try to keep our nine operations tailored to each photographer's talents and specialties.

We don't suggest the same subject matter to the whole group because that would be creating competition within. We do give them lists of special needs abroad, and if they are about to travel anywhere, we include the input from the two European offices and from Canada.

I think the vast majority of the images we have, because of the nature of Comstock and its photographers, was shot specifically for stock. Some of our people do assignment work, and we get a modest amount of material from that. However, most of our contributors realize that stock has its own requirements and standards, and you really have to have your mind set on that if you're going to be successful.

Some of our photographers, such as the science people, set up shots specifically to illustrate concepts we request. They may do a little bit by reportage, going into a location and simply recording what's going on. But the real meat of some subjects comes from specifically addressing the subject as stock. Custom-made stock shots are often best sellers, but I don't really know what percentage of our sales are setup pictures.

I think people photography in general is the real core of stock. But there are all the environmental subjects, the sciences, the social issues, and the socially sensitive issues, which offer a definite challenge because of the danger of defamation.

I really don't think there is such a thing as a regional agency. In today's world with 800 telephone numbers and overnight-delivery services, people who are good at researching, who really want to seek out the right image, will go everywhere and anywhere looking for it. This is one reason why, a long time ago, I became very disturbed about the nonexclusive contract. Markets overlap easily, and I don't think it does photographers any good to compete with themselves.

The biggest problem in stock is convincing photographers that each picture must have a good, complete caption. We need who, what, where, when, and how for all the material that gets into the file. We give photographers a caption sheet that indicates what we want and where we want it placed. And anyone who sends anything out without a copyright symbol on it is asking for trouble, even considering the Berne Convention, because not every country is a subscriber.

I don't believe you can submit pictures to more than one agency and avoid conflict. We require exclusive representation. I've tried over my long career to deal with nonexclusivity, and it has invariably caused trouble, if not for the agency, for the photographer. Trouble comes because most photographers aren't sufficiently in control, and it takes incredible control and recordkeeping to be able to say to a client with absolute authority, 'That is the only image from that take, and the similars are under control.' I've been burned, and it is an unpleasant experience I don't want to repeat.

Even if an agency isn't active in *every* area, the risk you take splitting up a collection can be very great indeed. I also feel that agents by and large are giving a great deal of direction to their photographers,

and I don't think photographers function well when they're trying to synchronize with several agencies.

For example, when we have material in Europe and our Paris office contacts us via our computer network and says that it just sold a worldwide exclusive to Air France for a specific image, it adds, 'Please clear it so the sale can be completed in 24 hours.' With exclusivity, that isn't difficult to do. But I don't think there are many photographers who are in immediate touch with all their outlets, who could give me an answer back immediately that there is no picture loose anywhere similar to the one Air France wants. In addition, our photographers' work is better monitored abroad, and we can see how they're doing when we look up a photograph-identification number here.

I don't see how agencies can produce catalogs or any impressive promotional material without the photographers bearing part of the cost. There isn't enough money in the agency's 50-percent take to afford such large outlays for catalogs that may cost hundreds of thousands of dollars. Agencies also bear the cost of distribution, which has become a large budget item.

To us catalogs are all important. Buyers may select directly from a catalog, but they are more apt to use it as a reference guide to who has what material in specific areas. They may say, 'I like these two items in the catalog, but I'd rather you sent me more depth; and these are horizontal, and one of the illustrations I need is a vertical.'

The only routine we have for handling lost or damaged transparencies is that every document that goes out of here carries all the proper terms about value, loss, and damage. We monitor court decisions and adjust the language as necessary. Each case of loss or damage has to be investigated to find out who is really the responsible party and whether there is or isn't insurance. I would say that we send out dupes and originals in about equal numbers.

Many changes have occurred in how images are accessed and delivered around the world, and how they're moved from access into production. It is a whole new world. Comstock is digitizing images as a separate area of marketing. The quality demands for digitization equipment are going up, up, up. It is very expensive and still experimental in some cases. You move very carefully. By the mid-1990s I anticipate a lot more digitalization activity; even now it is scary that it's happening so fast. We already have several clients who are getting all their pictures by online access. The whole technology requires a new business orientation.

The most shocking thing that I find with new photographers is they think they've looked at a lot of photography, and they really haven't. They haven't looked at even good, strong, fine art so that their sense of

composition and light is fine-tuned. They should be exposed to a great deal of fine art as well as photography. I look at so many pictures in portfolios, and often not one is right for stock. And the photographer is stunned when I say he or she is nowhere ready to get into this business.

Many newcomers have no conception of the extreme standards required by quality stock photography. And I'm not just talking about dilettantes—some of the people I meet are very serious, have taken a major in photography somewhere, but the schools don't expose them to the real world. They have to discover for themselves what is being bought and by which markets. They have to understand that stock is to some extent a numbers game as well as a specialist's game. You're going to need more than one specialty, or you aren't likely to be successful. Sometimes the only way to discover reality is to take an entry-level job in the industry or do an internship where you get a much different picture.

In each of the last several years we've taken on three new photographers, and a few have left because their careers took a different turn or they weren't producing. But Comstock feels it owes it to the industry and to ourselves to review portfolios. We ask to hold onto the material for at least three weeks because six people look at presentations here. However, I don't like to see people present work if they aren't really ready and serious about stock."

H. ARMSTRONG ROBERTS III, H. ARMSTRONG ROBERTS, INC., PHILADELPHIA

Roberts runs the business his grandfather started in 1920. Once a photographer, he was recently the president of PACA. His agency represents more than 300 photographers.

"We don't have quotas for photographers, nor do we have any other volume requests. Photography is a creative endeavor that is incompatible, I think, with the idea of quotas.

Technical excellence, originality, a creative sense of design, an ability to cast and direct talent, and a commitment to shooting stock are the qualities we look for in photographers. These add up to marketability. We want people pictures that tell stories that will work with various captions and advertising copy our clients ask us to illustrate. Symbolic photography tells a story that illustrates words visually.

We continue to look for new pictures because things change: hairstyles, clothing, and photographic approaches, for example. People are attracted to the same kinds of stories and subjects, but they want

to see them differently, better. The styles of the photographers we represent have also changed.

The first three words we hear from picture buyers on the telephone are "graphic, dramatic, and colorful." Aware photographers are consistently trying to achieve those qualities in the subjects they shoot because they realize clients want attention-getting photographs.

About 60 percent of our images are sold as dupes, the quality of which is considerably better than 5 or 10 years ago. We make 4 × 5-inch and 70mm dupes, but far more of the latter. I think there are very few photographers who can routinely make extremely good dupes. Agencies are generally happier handing the production of dupes themselves to be more in control of quality. We make dupes and process film in-house.

More and more agencies have overseas affiliations, something important to ask about when you're looking for a stock agency. If you want to market some of your work abroad, this first needs to be discussed with the United States agency. You should ask where its affiliates are located, what percentage they take, and if they stock only catalog shots. Working directly with a foreign agency, you might be able to place more images than we can, but that depends on your business and photographic style. How much time do you have to administer and monitor your work? You receive less when you sell abroad through an American agency, but if it has good relationships, that can give you peace of mind—and maybe more income.

We haven't been aggressive about sending out general want lists. We're more aggressive in talking to our more active photographers. I do more follow-up calls with active producers about their submittals. At many agencies it is probably true that the more valuable a photographer is, the more valuable the flow of prospective shooting information is going to be. The agency will be in touch more frequently. I value personal contacts.

Around here more than 80 percent of our sales are setup pictures. Photographers shoot speculatively, they hire models or they work in a studio with still lifes. More than 50 percent of what we get is made specifically for stock, and I think that is a general trend in the industry.

Pictures with model-released people, couples, business situations, industry, the whole realm of scenics, animals, and things that can be used for advertising purposes—all are popular. You have to look around and research what is in print to know the kind of things being used. Too few photographers spend time enhancing their awareness of the broad nature of stock, so they ignore a lot of potential pictures.

If you're photographing a grandparent and an infant, how often do you think of moving in close and making shots of their hands? There is

also the concept of moving the subjects around so art directors will have different shapes of space to work with. You could work quite a while to get all the possibilities from photographing a grandparent and child alone as well as together. Try not to get fixed on too simple an idea so you miss opportunities that come from *stretching* a situation.

We sell stock internationally, but certainly one of the buzzwords is *niche marketing*. A regional agency is in a sense taking advantage of a form of niche marketing if it works with photographers who understand an area well and can represent it. The agency builds on those abilities and can do well in a regional situation. Some of its sales will eventually reach nationally or internationally. So I don't see that a "regional agency" is a specific disadvantage. Nor is a subject-directed agency if its photographers realize they have to be strong in that specialty.

It is very important when photographers sign with an agency that they understand how the agency works and follows its guidelines. We have a printed folder explaining this, which we send to photographers new to us. It is annoying to us and is to the photographer's disadvantage to work at variance with what we want. Photographers often don't supply enough caption detail with specific names of locations. There is a premium on good accurate captions because they help us identify and organize pictures. Agency systems are based on minimizing costs and that takes as much skill as shooting good pictures takes. Copyright symbols should be on all pictures with your name, or follow the agency guidelines. We routinely include the photographer's name on our label.

A main failing is that photographers often fix on something worthwhile in a shot and then far too often ignore other visual distractions. You need to avoid trash on the ground and other extraneous elements. You need to be certain that pictures are straight, horizontally or vertically. Try not to get so wrapped up in what you see that is positive and attractive that you fail to be aware of a mess that needs control. The really good photographer sees and maximizes opportunities, technically and visually.

Don't send the same pictures to different agencies; avoiding agency conflicts is that simple. As for similar shots, if you've done a recognizable series of a couple walking in fall colors, for instance, don't send one slide to an agency and the very next frame to another. A good question to ask yourself is: If the two photographs ended up side by side in two ads, regardless of who the buyers are, would it embarrass both clients? The answer is easy when the shots could be interchangeable. You don't do it. Photographers have to live by the words of a contract and the *spirit* of it as well.

Another good business practice is to be meticulous in obtaining model releases that are completely filled out. Make releases quickly

available to the agency if you hold them, or send them with the pictures. Don't make the agency chase you to get releases.

Catalogs are very important. Photographers don't need to be told that financial participation in a catalog is promotion worth paying for. Nowadays photographers want as many pictures as possible in catalogs. We split the cost of production fifty-fifty.

We're aggressive in seeking financial recovery for lost and damaged slides. Where clients use stock routinely, they've usually invested in creating a system to protect the material at their end. If they screw up, they generally are more cooperative in paying for loss or damages.

In terms of the future of stock photography, there are two major areas to be watched. One is the transmission of images over telephone lines, and the other is the use of electronic images on discs. What impact will this have on stock promotion? Will the popularity of catalogs continue? Are we going toward electronic catalogs? Certainly, there will be a closer focus on a smaller number of extremely good photographs.

Agencies are probably going to become far more selective in what they keep, although there is already a premium on really good marketable photographs. Photographers need to be aware that some pictures that were acceptable five years ago wouldn't be now, and five years from now agencies will be more selective because photography will be even better. Photographers already have to work harder to get finer images. Many agencies have enough good images of a lot of similar subjects—from different sources.

Is the time of the dilettante photographer past? Although some of my colleagues think that to succeed you have to be into stock full-time, I think there will always be a place in the industry for photographers who don't approach stock as a full-time occupation but as a serious part of a total photographic commitment. Some photographers move in and out of stock depending on their annual assignment jobs. They may have a smaller output but of very high quality, and they'll be desirable contributors to an agency. Fine quality correlates in some fashion to the amount of effort, money, and other resources applied to creating photographs. Some photographers have a gift or talent or a good eye, and they do stock well. Their visual vocabulary is very strong. But they are an exception.

There is such a thing as the stock method, if you will: the styles and techniques of stock. It is important to learn and to know because it helps you make decisions before making exposures. The same applies to shooting travel scenes or people. You need a preconception of what the pictures do, how they say something to people. Is the picture of something someone wants illustrated? Regular awareness of

these things while you're shooting gives you a greater return on your investment. You must understand what good stock photography really is in order to maximize your efforts and return."

JERRY KARPF, THE IMAGE BANK, NEW YORK CITY

Established in 1974 and bought by Eastman Kodak in 1991, The Image Bank has a network of more than 50 offices worldwide, 11 of them in North America. Karpf is the vice president of marketing.

"TIB doesn't require submission of a minimum number of pictures during any set time period. We take into consideration that each photographer has a different background, and many are actively involved in other areas of photography. As our franchise network spans the globe, however, it is more advantageous for a photographer's market exposure to continually make submissions.

We're looking for technically superb images. We expect nothing less, nor do our clients. The images should have a marketability that is international in scope, and they should reflect current *and* future trends in advertising. Originality is the key component to the pictures we accept. Even if photographers are shooting an ordinary or generic scene, we expect them to be creative in a way that hasn't previously been seen.

We continually look for new pictures because images can always be presented in a new light. We want to be able to offer our clients as many variations of a scene as possible. Also, some pictures become dated and need to be updated, especially when they include people. Even travel imagery needs to be continually photographed because city skylines evolve and change in appearance.

Approximately one percent of our images is put into our duping program, not including our catalog images (they are all available as dupes). The technical quality of dupes has already improved in the past 10 years. We've spent 16 years continually improving this quality and will continue in the future.

The greatest advantage a stock agency can have is an international marketing network. It is obviously easier for a photographer to get wide exposure with an agent who offers a worldwide marketing service. However, if photographers have images marketed internationally through more than one agency, they should be aware of the geographical territory each agent represents, especially if a local agency requires exclusivity in its territory. Also, if a photographer provides the same or similar pictures to more than one agency, an image could be sold for

a particular use in a specific category and territory, and at the same time, another international agency could sell the same picture for exactly the same usage, but to a competitor.

We communicate with all of our photographers on a regular basis, informing them of our current needs. We encourage TIB photographers to keep in touch with headquarters so we can customize shooting lists for them based on their particular style and our needs, before going on a trip or starting a self-assignment.

The percentage of images we receive that are shot particularly for stock is increasing every day. Even photographers shooting assignments spend more time shooting for stock through their assignments or via individual stock setups. The current economic climate and its effects on the advertising market are illustrating to photographers that stock requires more than just their extras.

While we encourage photographers to shoot family life, couples, business, and industry, many other subject areas are continually in demand. Sports, wildlife photographed in natural environments, futuristic subjects, background images, still lifes, and more artistic imagery are much requested by our clients. Of course, it is very important for photographers to remember that pictures with any recognizable people or personal property must have proper model releases for stock use.

As an international agency, our success derives from being able to market our photographers' images around the globe. Our franchise and satellite offices are located in strategic areas with strong advertising needs, and in the vicinity of the local advertising community.

We have very specific requirements for our photographers in regarding proper image captioning. Caption requirements are designed to assist both our sales personnel and clients in locating the most appropriate imagery for a particular usage. We add an internal numbering system to the images that are disseminated to our offices for proper recordkeeping.

When we review the portfolios we receive, the most annoying photographic characteristics are images either out of focus or with exposure problems. All photographers should present only the best of their images, because clients want only the highest quality. Our signed photographers (those with contracts) are aware of this requirement.

We ask photographers to put a copyright symbol and date (preferably in Roman numerals) on their picture mounts before submitting their pictures to us. (Author's note: Roman numerals may call less attention to the date.) We check continually to be sure images aren't sold without proper prior authorization. If we become aware of any copyright

infringement of any of our photographers' images, we take strong measures to rectify the situation immediately.

When photographers submit pictures to several agencies, they always take a risk of conflicts arising if these images are the same or similars. It is impossible for an agency to maintain proper rights control on leased images when other agencies are marketing the same pictures.

Photographers should be aware of the workings of all the agencies where their work is on file. They should have a written agreement that clearly explains the terms and time limit of their association, compensation, breakdowns, any fees to be incurred by the photographer, and procedures for retrieving images after the agreement is no longer in effect.

Stock-photography catalogs are the strongest marketing tool available to present a large selection of an agency's files to established and prospective clients. Catalogs result in approximately half of all sales made by TIB. In addition to clients actually selecting images from the catalogs, they are able to use catalogs as a starting point for their creative needs from our file pictures not in the catalogs.

The costs to produce a high-quality catalog, which calls for good paper stock and printing, a large print run, and international distribution (if applicable), are high. Since catalogs result in sales for photographers and business for an agency, it is acceptable for photographers to pay a portion of the costs, which should be a fifty-fifty split.

We charge clients set fees for lost or damaged transparencies. We take great efforts to protect the rights and work of our photographers, and we stress this belief with our clients who do cooperate with us regarding loss and damage. We handle each case individually.

We expect stock photography to change in the next 5 to 10 years with the development of electronic imaging. As technology develops and changes every day, it is premature to forecast what the changes may be.

A photographer's best tool for creating successful stock images, whether to submit to an agency or to market independently, is to have a comprehensive knowledge of the current advertising and editorial markets and the changing stock-photography trends in these markets. Photographers should do as much research as possible to learn what is currently being used, and understand why such images are sold. Photographers should 'previsualize' how an image could be sold for stock while they're shooting and should concentrate on creating upscale commercial images that won't become dated quickly and will be international in their marketability. Images that are conceptual in nature (generic) will be most successful in stock because they have many different uses."

SUSAN TURNAU, SHARPSHOOTERS, MIAMI

Sharpshooters, owned by Turnau and her husband, Jeff, was started in 1984 and is what they call a "boutique" stock agency for advertising, with a specialty in model-released people.

"We don't require a minimum number of pictures a month, but if it looks like a photographer is slacking off and just dumped a first submission on us and is never submitting again, we drop that person. The qualities we look for in a photographer are: technical excellence, originality, creativity and design sense, excellent ability to cast and direct talent, and commitment to shooting stock.

We need new images because a stock agency is a hungry monster that has to be fed. Pictures continue to age and look dated so we need replacements. We figure our photographs have a 4-to-5 year lifespan. Our library is 85 percent people, and we go through the files continually. As we see a dated picture, we pull it out, send it back, and ask the photographer to shoot a new version.

Dupes are less than 1 percent of our sales. We don't have enough of them, although we have our own duping department. The quality of dupes is definitely better than it was 10 years ago. I do see a lot of bad dupes circulating because they get returned to us by accident from other agencies. They are mostly bad 35mm dupes. Ours are 70mm.

If you're marketing through foreign agencies, you should be careful about who they are, and you should visit their offices if possible. Meet the people before you tie yourself into an affiliation. If your United States agency uses affiliates abroad, you need to trust that it has done the best it could to find the right people and agency in another country. We make an extensive search. The way we monitor them is to get a sense of whether what they say they're selling is appropriate to what we expected them to do. We also make sure that the reports that come back include all the information we expect, and that they are consistent.

We make regular want lists to send to our photographers and do special ones for more active photographers. About 60 percent of our pictures were shot as setups for stock, and they are often best sellers. There is a tremendous trend toward setups, and we've noticed that a lot of people don't know how to do them properly. The images look too set up. More successful setup images don't look contrived. Setups need a sense of realism that not all photographers can achieve.

In addition to the main important stock subjects you've mentioned, I would add agriculture, sports, science, celebrities, human interest, and still life.

Although we're located in the South, we aren't a regional agency. Our clients are nationwide, no different than if we were in New York, Chicago, or Los Angeles.

We've had no trouble with our photographers' numbering systems and since our photographs are primarily of people, we don't really use captions though we do label them with the identities of certain places. We ask our photographers to tell us what and where a subject is, and we create captions when needed. Photographers can put their own file numbers on the back of the mount if they wish. We prefer photographers to stamp their mounts, always in the same place, because we want a uniform look to the slides. We have name stamps in our office and if the pictures are remounted, we stamp them.

As you know photographs are now copyrighted under the Berne Convention whether or not they're stamped with a copyright symbol. If somebody's going to use a picture or copy it without authorization, he or she will do it stamped or not.

Our agency contracts are exclusive. Whether or not we're typical depends on the kind of agency and the kind of market others have. I think that in general those agencies marketing primarily to advertising clients have exclusive contracts, whereas selling to editorial markets may not require them. Photographers don't share the cost of our catalogs because we don't feel they should.

We bill clients for loss and damage, and they are usually cooperative. Advertising clients seem more aware of the value of transparencies than editorial clients are. Because of previous losses, a lot of ad agencies have very strict guidelines for handling pictures, and there is less loss or damage.

The future is here in terms of electronic transmission and manipulating transparencies; composition can now be changed electronically. Electronic cameras with images on discs will influence the business, but we have yet to know how much.

I'm convinced that for stock or assignment work you need to develop a style, and you must reach for the top in excellence. People who are just functional photographers aren't going to be able to compete in stock. The market is glutted with 'average' pictures, and to make a real living today, excellence is necessary.

Price-cutting can also be a problem. When you feel a client might choose somebody cheaper than you, make sure that the pictures you have to offer are some the client can't get elsewhere. When people say they can get a shot from another agency for less, all I can say is they can't buy *our* pictures for less at that agency.

I think there is a place for everyone, including part-timers and generalists, in stock as long as their product is competitive with what is in the marketplace. Part-time people often aren't in the mainstream, and they don't know what else is being sold. They may shoot something they think is wonderful, but they have no good way to compare it with top-notch work. They need to study the marketplace. They may also need a specialty approach to build on their talent and move into a category of excellence, rather than taking a shotgun approach: shooting a little of this and a little of that. Part-timers especially need to do particular subjects better than anyone else. They also need to spend enough time and effort to make some serious money."

MARK KARRAS, WEST STOCK, INC., SEATTLE

Karras is the chairperson of the agency that he bought with Rick Groman in 1988. Founded in 1976, it was the first stock agency in the Northwest under its previous owners.

"We have no minimum monthly requirement for pictures. However, we do require that our photographers submit on a regular basis, which to me means at least quarterly. Nothing is more frustrating to an agent than to have a photographer submit pictures and never hear from that person again. Photographers should keep in mind that stock is a volume-oriented industry. If a photographer submits only 500 images to an agency, the odds of making a quick stock sale are virtually nil, especially since West Stock has more than 500,000 photographs.

Refreshing imagery is of utmost importance. West Stock derives 85 percent of its income from advertising clients, and we must skew our collection in that direction. I look for photographers and photography that don't mimic others. I look for new views of a tired theme. For example, we're no longer impressed with the traditional postcard views of the Eiffel Tower or Big Ben. We look for photographs with special angles that still say 'Paris' or 'London.' Essentially I look for images to evoke memories or specific responses.

I also search for perfect 'people' photographs, since we are primarily a people agency. I look for pictures that show unique moments between a mother and child or a grandparent and grandchild. These are usually very simple themes with little or no propping but ever so difficult to photograph successfully.

Stock photography has a shelf-life. Although we have half a million images on file, we've also returned hundreds of thousands of photographs

to photographers because we believe they've outlived their usefulness. All pictures can get dated. Even shots of Yosemite from the 1970s look poor today compared to those taken with present-day photographic methods and films.

Additionally, some subjects aren't nearly so popular today as they may have been 10 years ago. For examples, our customers are more interested in the subject of "walking" than they are in "running." Trends come and go, often quickly in the world of advertising.

Today's dupes are definitely better than they were 10 years ago. Nevertheless, West Stock is proud to possess original photography in more than 95 percent of its collection. The only photographs that we duplicate quite heavily are those from our catalogs and special ones that are distributed to our overseas subagency network.

It is essential to market abroad if you want to help insure against hiccoughs in the industry. West Stock has never disapproved of photographers selling stock overseas through their own offices as well as through our agency. Doing it yourself means that you can get up to a 50-percent commission, versus a 30-percent commission through the stock agency. However, many overseas agencies aren't working with individual photographers as much as they used to. Sometimes a photographer's only access to a foreign market is through his or her stock agent in the United States. While you get a reduced commission on foreign sales working through an American agency, you're also relieved of the headaches of international shipping, cancellation of monies, and monitoring your material.

Want lists are dangerous. West Stock has a database want list that is more than 50 pages long but we send it out only when we think the photographer thoroughly understands how the photograph should be set up. To say that we want older people bicycling is easy enough. But we want more. We want to describe or script the situation with the photographer to make it just right. That is where the telephone personal contact with the photographer is essential.

If we do send out our want list, we key it to print out all material related to a specific subject. For example, if one of our photographers is going to Southern Europe for an extended period, then we'll print out our needs just on that region.

It is hard to give percentages, but the majority of our new stock photography is specifically set up for stock. These photographs bring a higher return and often sell over and over again. I'll refrain from saying that they are our best sellers, however, because best sellers are often a surprise. For example, we recently sold a photograph of a boy watering a tree for $12,000. We knew it was a good photograph, but we had no

idea it would command that high a price. Though I prefer specially
setup stock, nothing is more satisfying than a 'grab shot' that is a real
surprise. This perhaps is why so many of our customers say that our
catalog is a 'refreshing difference in an industry that is too full of clichs.'

West Stock is a general agency so we encourage our photographers
to shoot all subjects and all situations. What I discourage, however, are
shots when a photographer is on vacation. Stock photography doesn't
mix with fun in the sun. It is a job, and a tough job at that.

I'm not sure what a regional agency is. West Stock tries to market
effectively within the northwestern United States, but only 30 percent of
our business comes from that area. We strongly feel that it is best to
have a broad customer base geographically. That way we can ensure
that our business remains stable even though our region may suffer
from a recession. In addition, West Stock markets its catalogs and
photography to more than 20 countries. This is another way of putting
our eggs in many different baskets.

I do think that location affects a stock agency's business a great deal.
West Stock will never be the size of the "big five" New York stock
agencies primarily because we aren't located in New York City. However,
I might add that I believe our collection is qualitatively competitive.
People realize Federal Express has made the world a smaller place, but
customers still tend to shop locally.

Since we are an advertising-based agency, I think we get
photographers who caption too much and too loosely. For example, we
don't need a caption like, "Beautiful woman in red on sandy tropical
beach." That is self-explanatory. Otherwise we try to remain flexible with
the photographer regarding captioning and numbering. Photographers
should always put a copyright symbol and date on their pictures. It
would also help to print 'All rights reserved.'

West Stock is a strong believer in nonexclusive contracts. If
photographers submit their pictures to several agencies, we ask that
they submit to us first. (Just kidding!) Photographers should be careful
to choose an agency that will communicate closely with them. If the
agency sells a photograph for an exclusive usage, then the agency must
alert the photographer immediately. This is no problem for our agency.

West Stock couldn't afford to do quality catalogs without the help of
our photographers. However, the stock agency should always pay the
lion's share of the costs. It would be unprofessional and immoral for the
stock agency to actually make a profit on catalog production alone. And
this is happening in a few American stock agencies.

Catalogs are extremely important to stock agencies. They increase the
odds of a photograph selling to virtually 100 percent. Our photographers

also know the importance of catalogs, and it is our problem when too many photographers want to place too many images.

We charge our clients $1,500 for lost transparencies, and we never negotiate. We also charge $10 for a lost dupe. Clients are often slow in paying for losses of originals, but they are generally cooperative. If they refuse, we have enough legal precedent to get payment.

I am an optimistic stock agent, but I am also brutally honest with many new or hopeful stock photographers. Stock isn't easy and often it isn't even that much fun. If you aren't a truly gifted photographer, then you have a slim chance making a living from stock.

I want to tell hopeful and existing stock photographers to never rest on their laurels. The best stock photographers today know the market very well. And they keep their egos under control. No photographer is indispensable—but then again the same rules apply to stock agents."

MARTHA BATES, STOCK, BOSTON, INC., BOSTON

Established in 1970, Stock, Boston, Inc., is well known in the editorial field and is a large supplier of photographs for textbooks. Bates is the director of the agency that represents about 300 photographers.

"Although we have no formal submission requirements, we tell each photographer who is accepted as a contributor that we hope and expect to be able to file 1,000 of his or her images the first year. Basically we say, 'Until you have 1,000 on file, you're just fooling around.' This usually means that photographers will have to submit 8,000 to 10,000 photographs the first year. We don't expect them to necessarily maintain that level, but often photographers already have established files of work from which to pull submissions.

We're always looking for the two big factors: technical excellence and salable subject matter. By this we mean proper exposure, perfect sharpness, controlled depth of field, good composition, appropriate film choice, and natural-looking lighting, and we mean subject matter that our clients will probably need. Although some sunsets sell well, there are so many sunsets available that each one has a minimal chance of selling. On the other hand, a radically mixed, model-released, interesting classroom scene doesn't have very much competition. The more thoughtful and observant the photographers are about actual usage, the more salable stock they usually produce.

Some pictures sell well for years, while others become dated in a matter of months. Styles of photography change, films age, and fresh material is always needed, even of timeless subjects.

Many clients prefer using duplicates because of the lower liability; about 8 percent of our sales are of dupes. Other clients prefer to choose from duplicates but reproduce from originals. This seems to be fading as the quality of the dupes improves.

We are a general stock agency and have only experimented on a limited basis with foreign subagents. Our experiences haven't lead us to increase our efforts in that direction. The best and most worthwhile foreign sales seem to be of stories.

We send want lists to our photographers about four times a year. A continuing surprise is that they don't pay much attention to them. We seldom receive the pictures we specifically ask for on our want lists. If active contributors ask for more detail or a list of needs in a particular area, we are, of course, happy to help them structure their project.

We think that the less posed and contrived a situation looks, the better it will probably sell in our market. In the best cases we can't tell that it is a setup shot. I've been surprised by model-release indications that denote a setup. Our most active categories are business, computers, education, family, government, medicine, and parenthood.

Although we are in Boston, our largest client this year will probably be in California. In the past our largest clients have been in Chicago and New York as well. During the last five years we've seen stock become a much more national market.

Most photographers do a wonderful job with captions. It seems like people who like camera equipment also like computers, and we get lots of very neatly captioned material. Problems that come up: too little caption data (we need the essentials); too much caption data (we need two sides of the mount for our information, and no one needs a caption that says, 'Happy teens smile at camera'); photographers want us to put their unique 5-digit identifier on our invoice (very unwieldy and expensive to trace back); and worst of all, photographers who forget to mark 'model release' on a shot that is released.

We would like photographers to put their names and a copyright notice on photographs. We encourage the use of Roman numerals for the year so that material doesn't seem to become unnecessarily or prematurely outdated.

Photographers whose work appears in our major ads share the cost but they also share the income, which can be substantial. We try to listen closely to their concerns, and we describe to them which pictures we would like to promote and listen to their comments. The field of photography is very competitive, so it simply is important to let your clients know that you want their business, that you have good fresh material, and that you are accessible.

We have very good follow-up procedures that help us minimize the number of losses and damages that occur. When one does occur, we find that clients are generally knowledgeable and responsible.

Honestly, the future is hard to predict. It looks like a digital delivery system is almost inevitable, but laserdiscs looked promising too, and they are dinosaurs now. There is a lot of technology just coming out that's very promising, and the issue of granting electronic rights is becoming vital. Photographers should also consider that if digitizing images becomes widespread, the question of exclusivity is going to be increasingly important. We feel that photographers shouldn't submit duplicates or similars of the same picture to different agencies. Now is a good time to pick one agency that you are comfortable with and stick with it.

I can't emphasize too much that shooting stock is a continuing commitment. If you aren't really prepared to put time and effort into it and making a year-long commitment in your shooting schedule, you're probably never going to make any serious money and the agency that represents you is probably never going to consider you a particularly valuable asset to its efforts. To think that you can do what you love and sell it as stock is true only if what you love is shooting stock. More often, shooting stock is a matter of self-assigning difficult and repetitious work to yourself and pursuing this self-discipline for years. According to one survey, more than 70 percent of stock photographers make less than $5,000 per year from any one agency. I think this is strongly indicative of high hopes and high goals that met difficult reality head on and were later abandoned."

GRANT HEILMAN, HEILMAN PHOTOGRAPHY, LITITZ, PENNSYLVANIA

Heilman specializes in agricultural and natural-science photography, and his agency represents only a few other photographers. Most images in the file were shot by Heilman and his staff. Although this agency is atypical, he is very knowledgeable about the stock business.

"Since we really don't operate as a conventional stock agency, and other photographers' work represents only about 6 percent of our annual sales, I've refrained from answering a few questions so that my views won't conflict with those of the regular stock agencies whose sales are almost entirely of work by commission photographers.

We need our photographers (most of these are staff people) to be consistent producers who keep up with changing subject needs as well

as improving techniques. We produce new pictures continually for two reasons: 1) Existing pictures get 'worn out,' particularly for us because our specialized clients are frequently competitive with each other, so we don't want to present the same pictures, used by themselves or others, over and over. 2) There are always gaps in our files, and it takes time and technical research to study what they are and how to fill them.

I am of the opinion that dupes can't be as consistently good as originals. We want our clients to have the very best material so we try to avoid dupes and use them only when we have only one great transparency. Likewise we avoid 35mm when possible and routinely settle on $2\,1/4 \times 2\,3/4$, which is more expensive and more of a nuisance to catalog, but gives us better results. However, each of our staff photographers may decide on the format for a particular shoot—from 35mm to 4×5—and we're equipped for all of them. Since we produce almost all of our pictures in-house, when possible we shoot multiple images for dupes and in case of losses. We do have some subjects in which the dupes are better than the originals, particularly aerials, and I recall one subject where the originals faded away but the dupes carry on. This was back in the early days of fading color film.

We market abroad through existing photo agencies based in foreign countries, but this amounts to only about 8 percent of our net sales. There is a great feeling of loss of control, but our experiences have been very positive and we plan to increase our foreign sales. Foreign agencies spend time only with consistent producers, and they want to avoid handling tiny packages of transparencies.

Our staff photographers and the few commission photographers we represent get regular want lists. Our staffers talk over needs with researchers almost daily. Researchers, who often have a highly technical background when it comes to subject matter, sometimes go into the field with our photographers.

We do only setup work, often in the studio, of subjects such as insects or plants. Our few royalty people vary in their approach. I travel a lot and plan to be at the site of harvests, planting, and fall colors, as phenomena allow. Our emphasis is on agriculture, horticulture, nature, scientific/technical subjects, and animals, and we always need *better* examples of most of these. Increasingly I like to spend time filling subject gaps that may not be best sellers but are likely to be subjects no one else has.

This isn't a regional agency, but it is a specialty-subject agency. Location negatively affects us only because we can't pound the pavements as often in New York looking for clients. On the other hand, the farm country of Pennsylvania (where the office is) and Colorado

(where I live) make life worthwhile. We can operate with lower overhead and more convenience, and we have direct availability of much of our subject matter.

The most annoying photographic problem we see is poor attention to quality. Among ourselves (our office personnel and staff photographers are all part owners of the company) there is constant study of quality photographic approach and editing. We are damned proud of what we do but recognize we need to improve—and that is where the fun is also.

One of the reasons we don't deal much with royalty photographers is because we insist on being the only people who have the pictures we have. I think it is impossible to get royalty photographers to submit similar things to only us, exclusive contracts or not. So far we've been able to avoid the whole mess by having our own photographers, which costs money upfront, but works wonders.

For agencies handling general subjects, catalogs have apparently become a costly but useful necessity. A European agency we deal with tells us that it seldom sends out shipments, only catalogs. So far we haven't produced a catalog, but we do send out sheets of catalog-type pages, mostly from our advertising in the *Creative Black Book* and the *Stock Workbook*. We may have to have a catalog, but it is also possible that some electronic technique may replace catalogs along the way. Stay tuned; those developments are moving fast.

Lost and damaged transparencies are our single biggest annoyance. They create immense friction between photographers and their photo agencies, and between photo agencies and clients. The best answer I have is continuing education of users and their color-separation people. Unfortunately, the best education may come from the client being socked with large charges when loss or damage occurs.

Our own situation is defused a little since we own most of our images, and only have to hear clients complaining that they want to pay less for loss or damage, which can be quite uncomfortable. We don't often have to tell commission people we're negotiating with a negligent client because we represent so few photographers.

There is a tendency, as yet not widespread, on the part of clients to demand only dupes from photographers or agencies, and to guarantee replacement costs for dupes only. The photographer who uses originals if at all possible (as we do) may be put into the position of not being able to deal with clients unless the photographer is willing to accept only dupe values for original film. The situation hasn't gotten to that yet, but it is one to think over.

Crystal balls are cheap but not very clear. The whole question of electronically duplicating transparencies is in the process of changing

the entire stock-photography ball game, and it isn't entirely clear yet where we're going. I'm convinced we'll be accepting the new technologies, but I'm not sure what they'll mean to us. Changes will be massive, and doubters will be left in the dust.

Some random thoughts: Photographers are inclined to think of themselves as artists not subject to the laws of business. Forget that. They may well be fine artists but if they expect to make a living, they must also be fine business people. This includes not only driving fair bargains in contracts and sales but also in producing work on time, to a schedule, and taking their careers seriously. A lot of people trying to sell stock should be making a living elsewhere and having fun with photography as a hobby.

If you can't solve problems with an agency or client in an agreeable fashion, then I feel you need to be looking elsewhere for your business, and this applies to agents as well as photographers. Life is too short to be tangled up with people, photographers, photo agencies, or clients who aren't trustworthy, dependable, and pleasant.

TED STRESHINSKY, PHOTO 20-20, BERKELEY

This two-year-old agency was started by Streshinsky using his own extensive files as a nucleus. I've included his responses because although the agency represents only 20 photographers, Streshinsky's experience is extensive and a new agency is relatively rare.

"We don't require a minimum submission on a regular basis, but we do impress on photographers that the more they submit, the more productive their files will be. Technical proficiency is a must. We expect a serious approach and honesty. We don't sign on a photographer until we've established that there is positive chemistry between us. Then we discuss subject matter that we know we can market. We want to see an individual point of view that shows imagination in its approach to a cliché subject because clichés are what sell most of the time.

The need for updating and having new and more images stems from the fact that many clients ask for the same subjects over and over. An example is a textbook publisher who does psychology books. You can't keep sending the same photograph of, say a child bonding to a parent. If you do, you lose the client. In addition, you never know when two or three clients will make similar requests.

Today's dupes, if you go to the right sources, are superb. Still I understand that only about 10 percent of reproduction in this country is from dupes. Overseas the story is different. The printing quality there is

better than ours, and they do magic with dupes. One of the problems in submitting dupes is in the area of reimbursement for loss or damage. You must state on the delivery memo and the mount that the photo is a dupe, and if it is lost or damaged, you can't expect more than $50. What is to prevent an unscrupulous client from claiming that a photo was lost, pay the $50 fee, and put the slide in the files for future use or reference? Monitoring such cases would not only be difficult but costly as well.

If any of our photographers want to market abroad, we say, 'Bless you.' However, we feel that for an individual to go up against some of the foreign agencies is fraught with risk. We know of some real horror stories. At present we market in the United States, Japan, and France.

We send want lists to our photographers and because our relations with them are so close, we meet with all of them (at least those in the San Francisco Bay Area) on a regular basis. Those who are more active follow up nicely on the information we provide and are more successful than those who just file the want lists away. Invariably photos that are produced for stock sell better than others. They comprise about 5 percent of our sales.

Because we do a large volume of editorial and corporate work, all the subjects you mention are best sellers with us. Travel pictures are another big seller; we market pictures from all over the world. Strong ethnic and gender mix is important in most situations. Our society is undergoing important sociological changes. You can no longer publish exclusively for an upward-bound WASP readership.

The days of the regional agency are fast coming to a high-tech end. Some may call ours a regional agency but the bulk of our clients are on the East Coast and our shipments of submissions go all over the country. Today with Federal Express, faxes, and telecommunications, we don't feel at a disadvantage in being regional. After all, you can say New York is also a region.

We work very closely with our photographers and are able to arrive at mutually satisfactory numbering and captioning practices. However, every once in a while we run into a problem when photographers' captions are too sparse, or they mount large-format color in ways that don't harmonize with our filing system. Those photographers are overseas, and we try to understand their individual problems. All our photographs have to be *stamped* on the narrow side of the mount with the name, copyright symbol and date (in Roman numerals). We also require an 'R' or 'NR' in red on those photographs that show any person or private property of any kind.

We have no objection to nonexclusive contracts. However, we impress on photographers that they may create problems by filing similar images

with different agencies. There seems to be a new 'ethic.' Some agencies encourage photographers to file anything and everything and to hell with the consequences. If we know of an image filed with another agency, we return the image to the photographer.

Photographers shouldn't share the cost of producing catalogs but catalogs aren't important in our business. We send out many promo pieces with well-credited images, and these serve as examples of material in our files. We don't charge photographers for promotions.

In most cases clients are very cooperative about compensating for lost or damaged pictures. Only twice have we had to resort to legal pressure (correspondence from our lawyers), and in both cases we got fast resolution.

What is on the horizon and very close to home is the advent of digital images electronically transmitted to clients. Fast strides are being made in this area, and reality is ahead of the talk about protecting copyrights.

There is a very great potential in the stock-photography business. But as has been said over and over, if you don't approach it as a full-time career and business, treating it as a sideline may be very disappointing. I know photographers all over the world who are making large six-figure incomes by doing only stock."

ALLEN RUSSELL, PROFILES WEST, BUENA VISTA, COLORADO

ProFiles West represents about 50 photographers and specializes in the American West and its people at work and play. Owner Russell shoots for the files as well as acts as the director of photography.

"We don't set minimums. However, while our main criterion is quality, there's no getting around stock being a numbers game. The more quality images you shoot or offer, the better. Photographers with a specialty require fewer images. What we don't want is a generalist who shoots 500 pictures a year. We look for originality, proper lighting, current trends or timelessness, appropriate facial expressions, images that reflect emotions, and appealing color. In new images we hope to find new approaches to old subjects, new subjects, trend and style changes, and current topical subjects.

About 5 percent of the pictures we sell are from dupe transparencies. Today's dupes are superior, especially 70mm. I fought using dupes because quality was often poor, but it is necessary for today's market.

Marketing abroad means a loss of personal contact. If you have a say in choice of images to send to a foreign agency, choose those with higher-volume sales potential. Be prepared to receive a lesser percentage

of sales. Most important, define the rights available to your images. Are you letting numerous agencies sell rights without a business plan to monitor rights?

We send out a general want list, but we prefer to discuss with individual photographers what is best for them. I seldom ask photographers to shoot something they don't enjoy. A multitude of subjects are good stock if shot in an extraordinary manner. The problem I find with want lists is that, for instance, when I ask for day-care centers, photographers who don't normally photograph children stop by a playground to grab a few shots. This is a waste of their time and ours because they just can't compete with the person who has access to organizing a day-care shoot properly and the expertise to shoot it.

Access is extremely important. I suggest that photographers never do a major shoot without first asking their agency if it needs that subject. The most popular subjects are: agriculture, lifestyles, recreation, generic nature situations, wildlife, domestic animals, children, racial mixtures, upscale minorities, social issues, and the environment.

Fifty percent of the pictures we get are set up, and the number is increasing. Setup pictures are often best sellers, but we also find that some are quite sterile. Still if a photographer's goal in stock is to shoot the most cost-effective images, this is far and away the best approach. How you do it is integral. Take hiking shots, for instance. It is foolish to actually go on a hiking trip to shoot hiking stock. The usual result is that you get mediocre images and don't have fun on your trip either because you are uptight about shooting and bugging your friends to be models. Instead, find a great background with easy accessibility, set your models up under ideal conditions, and blast away. Then put your cameras aside, go hiking, and enjoy yourself.

Don't get me wrong. There is nothing better than those magic moments that life presents us, captured on film. But in reality there isn't enough of them to make a living on. Also, reality often isn't quite right. For example, recently from a friend's kitchen window I watched a young boy with a hand-picked bouquet bashfully giving it to an equally shy young girl. The emotion almost knocked me down. Immediately I headed for my camera, but then I took a closer look. It was late dusk, the good light was gone, and the children were wearing dull-colored, unattractive clothing. Not to mention that I would've scared them when I came around the corner with a camera. Certainly, there would've been little chance of capturing the magic moment I had witnessed. But I had the emotion, captured within myself. The next week I put the emotion on film with the use of models under ideal conditions and have made a nice profit from my awareness and efforts.

Our agency isn't regional, and I believe promoting being a regional agency is a terrible disadvantage in today's market. Few clients place importance on dealing locally. With current technology, where you're located is of little importance and it will increasingly be so. This is why we're located in a small mountain town. Our overhead would make our major city competition weep with envy, yet we're dealing with the same clients and offering the same service.

We do all numbering and captioning for our photographers from caption sheets they provide. We go to this trouble because we think thoroughly organized captions are important, and our photographers should spend their time shooting, not captioning slides. This also gives our submissions a uniformity that clients appreciate.

A common mistake photographers make in captioning is assuming that others have knowledge of the image. If you say only 'Lake Tahoe,' the researcher or person doing captions may not know that it is in both Nevada and California. Also, an average mountain shot may be turned down unless you let it be known that it is the highest mountain in Montana. Latin names for flowers are important. Captions make sales, especially in the editorial market. We prefer the year in Roman numerals because they aren't as likely to date the image.

To avoid conflict between several agencies that represent you, be upfront about what you are doing. Fully discuss and agree in a contract what rights of exclusivity you're giving your agencies. If you're giving the same images to several agencies, be certain that they understand they can't sell any exclusive rights. The last thing you should do is to assume that if one agency sells exclusive rights, you'll contact the others and tell them to abide. I often hear this concept from photographers, and it is extremely foolish and naive to believe it'll work. How exclusively you deal with agencies is a very personal matter. Some photographers work better with the personal attention they have a right to expect from an exclusive agency. If you choose to have multiple agencies, you can't expect the same degree of attention and must be prepared to have a more extensive bookkeeping system.

Photographers do share the cost of producing our catalogs. Although I believe the days of catalogs as a primary marketing tool are numbered, they are currently a valuable tool.

We charge clients $1,500 for each lost or damaged chrome and actively pursue payment. To date we haven't failed to collect. Photographers should be aware of how difficult it is for them to know when images are lost, and when they're collected for (seldom).

The electronic media and digitized images will become the standard for transmitting stock sales, although conventional photography will be

around quite a while. We've contracted with Microsoft for a very lucrative electronic-image project, and we're negotiating with others. We are very excited about the possibilities of this new market for stock. Of course, like any new opportunity, it carries with it possibilities of abuse, but they can be overcome with good business practices.

Some photographers and agencies cry that this new technology could ruin the business as we know it now. I feel the industry could well use some drastic changes, and rather than fearing change, we want to be part of setting standards of change. What I don't want is to be the farmer standing in the middle of the field with my old plow horse saying, 'I'll never buy one of those darn tractors.' We'll enter this new technology under our own terms or under terms that we've helped determine. To drag our feet rather than become an active participant striving for a positive position for our industry is folly.

There'll be a weeding out of photographers who fail to accept that they are small business people who must adhere to a certain level of business practices. Fewer photographers will be able to obtain representation by reputable agencies as fewer agencies accept the challenges of the future and produce more and better images. Technology will enable agencies to do more with fewer images, using more efficient operations and marketing. In addition the cost of this technology will make it impossible for all but a select few superachievers to sell their own stock. These factors will bring about a market in which some agencies will surface to prey upon would-be stock photographers by charging high fees to catalog and market their images, and making more money from business with photographers than from selling pictures.

Photography is truly magic. However, the business of photography isn't. Accept the difference. You are a small businessperson with primarily the same problems, challenges, and rewards as others who are self-employed. Just as you have to perfect your skills as a shooter, you must study and learn current business practices. Unless you want to go past basic understanding to become a skilled businessperson, you should find a reliable, honest stock agency.

And while dealing with all this, you must also take extraordinary images. Good luck. You'll need it. Only a handful of skilled, devoted stock photographers are making a good living."

RESOURCES

CATALOGS

Light Impressions
439 Monroe Ave.
Rochester, NY 14607
1-800-828-6216

20th Century Plastics
3628 Crenshaw Blvd.
Los Angeles, CA 90016
1-800-767-0777

Vue-All
1020 Northeast 16th St.
Ocala, FL 32670
904-732-3188

COMPUTER SOFTWARE

Cradoc Captionwriter
Perfect Niche Software, Inc.
7100 B. East Main St.
Scottsdale, AZ 85251
602-945-2001
Easy-to-use program for slide
captioning

FotoFindr
Franklin Service Systems
P. O. Box 202R
Roxbury, CT 06783
203-354-8893
Very thorough program for
slide captioning, indexing,
and tracking; available in two
versions

Photo SBM
Micro Software Solutions
P. O. Box 851504
Richardson, TX 75085
214-276-4347
Full-featured program for stock
filing and caption labeling

Pic Trak
Glacier Software
P. O. Box 3358
Missoula, MT 59806
406-251-5870
Filing systems for stock
collection and slide captioning

Slidebase
Multiplex Display Feature Co.
1555 Larkin Williams Rd.
Fenton, MO 63026
314-343-5700
Program for slide filing, tracking,
and captioning

Slide Label System
Photo Assist
P. O. Box 50406
Santa Barbara, CA 93150
Program for slide captioning

Stock Photo
The Wyoming Naturalist
P. O. Box 863
Douglas, WY 82633
307-358-4127
Program used with Ashton Tate
Dbase IV for slide filing and
captioning; inexpensive

Superset
Rock Creek Software
P. O. Box 7892
Missoula, MT 59807
406-728-5105
Easy program for slide filing
(by categories) and tracking

ORGANIZATIONS

Advertising Photographers
of America (APA)
27 West 20th St.
New York, NY 10011
212-807-0399

American Society of Magazine
Photographers (ASMP)
419 Park Ave. South
New York, NY 10016
212-889-9144

Picture Agency Council of
America (PACA)
4203 Locust St.
Philadelphia, PA 19104
215-386-6300

PRODUCTS AND SERVICES

Photographic Solutions
(for slide-cleaning solutions)
7 Granston Way
Buzzards Bay, MA 02532
617-759-2322

Stock Solution
(for slide-mount seals)
307 West 200 South, #3004
Salt Lake City, UT 84101
1-800-777-2076

Superdupe (slide duping)
c/o Vince Streano
P. O. Box 488
Anacortes, WA 98221
206-293-4525

PUBLICATIONS

ASMP Stock Photography Handbook
American Society of
Magazine Photographers
419 Park Ave. South
New York, NY 10016
212/889-9144

*Business and Legal Forms
for Photographers*
(by Tad Crawford)
Allworth Communications, Inc.
10 East 23rd St., Suite 400
New York, NY 10010
212-777-8395

Creative Black Book
115 Fifth Ave.
New York, NY 10003
212-254-1330

ExpressLine
Telephoto
307 West 200 South, #3004
Salt Lake City, UT 84101
801-363-9700

The Green Book
AG Editions, Inc.
142 Bank St.
New York, NY 10014
212-929-0959

The Guilfoyle Report
AG Editions, Inc.
142 Bank St.
New York, NY 10014
212-929-0959

*How to Shoot Stock
Photos That Sell*
(by Michael Heron)
Writer's Digest Books (distributor)
1507 Dana Ave.
Cincinnati, OH 45107
513-531-2222

*International Stock
Photography Report*
c/o Westlight
2223 South Carmelina Ave.
Los Angeles, CA 90064
213-820-7077

Legal Guide for the Visual Artist
(by Tad Crawford)
Allworth Communications, Inc.
10 East 23rd St., Suite 400
New York, NY 10010
212-777-8395

Literary Marketplace
Audio Visual Marketplace
R. R. Bowker
121 Chanlon Rd.
New Providence, NJ 07974
908-665-2815

Negotiating Stock Photo Prices
(by Jim Pickerell)
110 Frederick Ave., Suite E
Rockville, MD 20850
301-251-0720

PACA Directory
Picture Agency Council of America
c/o H. Armstrong Roberts
4203 Locust St.
Philadelphia, PA 19104
215-386-6300

Photobulletin
PhotoSource International
Pine Lake Farm
Osceola, WI 54020
715-248-3800

Photo District News
949 East 21st St.
New York, NY 10010
212-677-8418

Photographer's Market
Writer's Digest Books
1507 Dana Ave.
Cincinnati, OH 45207
513-531-2222

Photoletter
PhotoSource International
Pine Lake Farm
Osceola, WI 54020
715-248-3800

Photomarket
PhotoSource International
Pine Lake Farm
Osceola, WI 54020
715-248-3800

Pro-Fax
Telephoto
307 West 200 South, #3004
Salt Lake City, UT 84101
801-363-9700

Sell & Re-sell Your Photos
Writer's Digest Books
1507 Dana Ave.
Cincinnati, OH 45107
513-531-2222

Standard Directory of
Advertising Agencies
(Agency Red Book)
3004 Glenview Rd.
Wilmette, IL 60091
1-800-323-6772

Standard Directory
of Advertisers
(Advertiser Red Book)
3004 Glenview Rd.
Wilmette, IL 60091
1-800-323-6772

Stock Direct
10 East 21st St., 14th floor
New York, NY 10010
212-627-7058

Stock Photo Report
7432 Lamon Ave.
Skokie, IL 60077
708-766-7887

The Stock Shooter
c/o Jim Pickerell
110 Frederick Ave., Suite E
Rockville, MD 20850
301-251-0720

Stock Workbook
Scott and Daughters
940 North Highland Ave.
Los Angeles, CA 90038
213-856-0008

INDEX